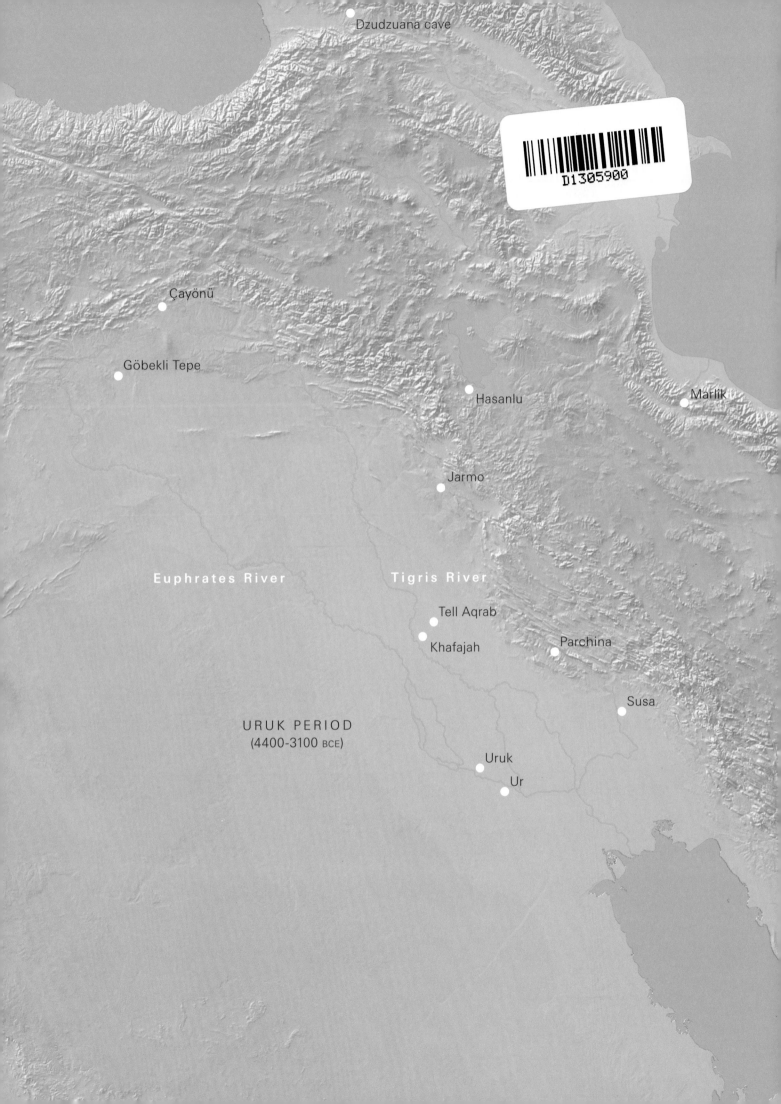

Dzudzuana cave

Çayönü

Göbekli Tepe

Hasanlu

Marlik

Jarmo

Euphrates River

Tigris River

Tell Aqrab

Parchina

Khafajah

Susa

URUK PERIOD
(4400-3100 BCE)

Uruk

Ur

Masters of Fire: Copper Age Art from Israel

**Edited by Michael Sebbane,
Osnat Misch-Brandl, and Daniel M. Master**

Including contributions by Thomas E. Levy,
Daniel M. Master, Osnat Misch-Brandl,
Yorke M. Rowan, Michael Sebbane, Dina Shalem,
and Orit Shamir

Institute for the Study of the Ancient World
at New York University
February 13–June 8, 2014

Legion of Honor, Fine Arts Museums
of San Francisco
June 28, 2014–January 4, 2015

Published by

Institute for the Study of the Ancient World
at New York University

Princeton University Press
Princeton and Oxford

This publication has been made possible by a generous
grant from Michael and Judy Steinhardt. Additional
funding has been provided by the David Berg Foundation
and Jonathan and Jeannette Rosen, with support from
Furthermore: a program of the J. M. Kaplan Fund.

Published by the Institute for the Study of the Ancient World at New York University and Princeton University Press on the occasion of the exhibition *Masters of Fire: Copper Age Art from Israel,* February 13, 2014–June 8, 2014, at the Institute for the Study of the Ancient World and June 28, 2014–January 4, 2015, at the Legion of Honor, Fine Arts Museums of San Francisco, and distributed by Princeton University Press.

Institute for the Study of the Ancient World
New York University
15 E. 84th Street, New York, NY 10028
isaw.nyu.edu

Princeton University Press
41 William Street, Princeton, NJ 08540
press.princeton.edu

Lead Exhibition Sponsor: David Berg Foundation

Masters of Fire: Copper Age Art from Israel is organized by the Institute for the Study of the Ancient World and the Israel Antiquities Authority in collaboration with the Israel Museum, Jerusalem, and has been made possible by the Leon Levy Foundation. Major funding provided by the David Berg Foundation and Michael and Judy Steinhardt. Additional funding provided by the Selz Foundation, Jonathan and Jeanette Rosen, Frederick and Diana Elghanayan, the Achelis Foundation, and Furthermore: a program of the J. M. Kaplan Fund.

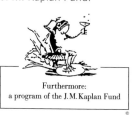

Furthermore:
a program of the J.M.Kaplan Fund

Managing Editor: Julienne Kim

Copy Editor: Mary Cason
Designer: CoDe. New York Inc., Mischa Leiner, Susanne Schaal, and Blerta Kicaj
Color Separations and Printing: GHP, West Haven, CT

Copyright © 2014 by the Institute for the Study of the Ancient World at New York University and Princeton University Press

The book was typeset in Linotype Univers and Caslon GraD and printed on Diamond Silk.

Library of Congress Control Number: 2013955943
ISBN: 978-0-691-16286-7

Printed in the USA

Contents

Shuka Dorfman
Director General
Israel Antiquities Authority

Israel's long and rich history has left a wealth of remains, each level layered on top of the previous one. The excavation, study, conservation, publication, and exhibition of the remains and the excavated objects is the mission of the Israel Antiquities Authority. The preeminent organization in the field of Israeli archaeology, the Israel Antiquities Authority is in charge of all matters of archaeology in the country and custodian of millions of objects and tens of thousands of archaeological sites. Our work is universal in preserving the cultural heritage of all humankind in the land of Israel.

The first archaeological excavation in Israel was conducted by Sir Flinders Petrie in 1890. This was followed by excavations conducted by German, American, French, and British missions. In 1948, with the founding of the state of Israel, the Department of Antiquities and Museums, precursor to the Israel Antiquities Authority, was established. Together with the departments of Archaeology at Hebrew University and Tel Aviv University, and later the Ben Gurion and Haifa universities, archaeologists from the Israel Antiquities Authority began excavating and exposing the cultural-heritage remains of the land of Israel.

The fascinating Chalcolithic culture was first exposed by Israel Antiquities Authority archaeologists and a number of archaeological missions working in Israel beginning in the 1950s. Excavations in Wadi Be'er Sheva, Bir Ṣafadi, Matar, and Hirbet Betar uncovered a complex and unique culture that thrived in the land of Israel between the second half of the fifth millennium and the first half of the fourth millennium. Over a sixty-year period, archaeologists exposed hundreds of Chalcolithic-period settlements and burial caves from the Golan Heights in the north to the Arava in the south. Excavations yielded thousands of finds that are rare for their high levels of technological, artistic, and iconographic qualities. We are delighted to showcase some of them in this exhibition, including copper objects produced in the lost-wax technique from the Cave of the Treasure in the Judean Desert; bone, stone, and pottery idols from Gilat; painted ossuaries from Peq'in; textile, wood, and leather objects from the Cave of the Warrior; and more.

Since its establishment the Israel Antiquities Authority has shared selections of intriguing and mysterious Chalcolithic-period artifacts from our national treasures through loans to museums in Israel as well as through exhibition and long-term loans to museums in the United States. But it is through the vision, efforts, and imagination of Shelby White, Chairman of the Friends of the Israel Antiquities Authority, and Dr. Jennifer Chi, ISAW Exhibitions Director and Chief Curator, that the American public has an opportunity to see *Masters of Fire: Copper Age Art from Israel*, an exhibition devoted to Chalcolithic objects excavated in the land of Israel and representing the entire range of regions, materials, and styles of this fascinating period.

I wish to express the gratitude of not just the Israel Antiquities Authority, but the entire archaeological community in Israel, to our dedicated and professional colleagues in the Institute of Advanced Studies, and to the curators, conservators, and archaeologists of the Israel Antiquities Authority and the Israel Museum, Jerusalem. It is through these exhibitions that we share the cultural heritage of the land of Israel with audiences around the world.

James S. Snyder
Anne and Jerome Fisher Director
The Israel Museum, Jerusalem

The Israel Museum is proud to collaborate with the Institute for the Study of the Ancient World (ISAW), together with our partners at the Israel Antiquities Authority, on *Masters of Fire: Copper Age Art from Israel*, the latest in a series of impressive international loan exhibitions organized by ISAW during its short six-year history. And, for us, this joint enterprise is especially notable for the opportunity that it provides to introduce audiences outside of Israel to the little-known history of Chalcolithic civilization.

The Chalcolithic period and the Israel Museum share a special bond. In 1961, just a few years before the Museum's official opening, a spectacular hoard of 426 Chalcolithic ritual objects, most of them breathtakingly crafted from copper, was discovered in the remote Cave of the Treasure, some 10 km south of En-Gedi in the Judean Desert. These objects, the likes of which had never been seen before, had lain hidden in the cave for more than six thousand years. It is likely that they were the property of the temple at En-Gedi and were buried by its priests for safekeeping in the face of impending danger—a fortuitous precaution that proved to be to our benefit. This discovery astounded the archaeological community and sparked a new interest in the Chalcolithic period. Until that time, no one had realized the technological proficiency of Chalcolithic metalworkers, nor, and perhaps more importantly, had anyone understood the extent to which their exceptional skills were put to the service of their rich spiritual world.

This historic discovery could not have been more timely. When the Israel Museum opened its doors in 1965, the Chalcolithic hoard from the Cave of the Treasure was the highlight of its first permanent archaeological display, and it continues to occupy a place of honor in the recast narrative of the galleries of the new Samuel and Saidye Bronfman Archaeology Wing, inaugurated as a part of our renewed Israel Museum in 2010.

The truly notable achievements of the inhabitants of the "Chalcolithic Land" would not have been possible without the oversight of a highly proficient central governing authority that coordinated the agenda for this complex society's many branches, from its innovative farmers and herdsmen to its inspired artisans and priests. So, too, the achievement of *Masters of Fire: Copper Age Art from Israel* may be credited to the vision and skillful execution of our colleagues at ISAW, guided by Jennifer Chi, Exhibitions Director and Chief Curator, and supported by the insightful professionalism of Osnat Misch-Brandl, Curator of Chalcolithic and Canaanite Periods at the Israel Museum, and Michael Sebbane, Chief Curator of the National Treasures at the Israel Antiquities Authority. Our greatest thanks are due to all of them, as well as to Shelby White for her vision in founding and then shepherding ISAW to the stature that it has achieved today.

Roger S. Bagnall
Leon Levy Director
Institute for the Study of the Ancient World (ISAW),
New York University

The Chalcolithic period in the Southern Levant was a time of great innovation. The metallurgical revolution witnessed in this region would set the stylistic and technical stage for the whole of the Ancient Near East for millennia to come, and I am delighted to see this phenomenon fully explored in *Masters of Fire: Copper Age Art from Israel*, the sixth international loan exhibition at the Institute for the Study of the Ancient World (ISAW) at New York University. The extraordinary finds from the Naḥal Mishmar hoard form the center of our narrative, with the individual pieces not only expressing the technological virtuosity of their makers, but also indicating a more organized society where hierarchical status came clearly into play. These settled societies also produced intriguing anthropomorphic and zoomorphic ossuaries, intricate human figurines perhaps representing gods, and beautifully woven textiles. Examples of all these categories can be found in our two galleries on East 84th Street.

In putting this exhibition together, ISAW partnered with two Israeli institutions, the Israel Antiquities Authority and the Israel Museum, Jerusalem. Their combined generosity means that *Masters of Fire* is the first international loan exhibition to provide a comprehensive overview of the major categories of objects from this seminal period in Ancient Near Eastern history. At the Israel Antiquities Authority, we are grateful to Shuka Dorman, Director General, and Jacob Fisch, Executive Director of the American Friends of the Israel Antiquities Authority, for their guidance and dedication throughout the project. Dr. Michael Sebbane, Director of the National Treasures Storerooms, was the Israel Antiquities Authority curatorial team member; James Snyder, Anne and Jerome Fischer Director at the Israel Museum, Jerusalem, granted ISAW several outstanding loans that ensured the richness of this period would not go unknown by our visitors, and made possible unlimited input from his curatorial staff, most notably from Dr. Osnat Misch-Brandl, Curator of Chalcolithic and Canaanite Periods.

At ISAW, Jennifer Chi, Exhibitions Director and Chief Curator, worked tirelessly with her team to ensure another visually and academically stimulating exhibition project. And our Guest Curator, Daniel Master, worked collaboratively with both his New York and Israeli colleagues to create a unique experience for visitors to the exhibition and readers of the accompanying catalogue. Major funding for this exhibition was provided by the David Berg Foundation and Michael and Judy Steinhardt. Additional funding was provided by the Selz Foundation, Jonathan and Jeanette Rosen, Frederick and Diana Elghanayan, the Achelis Foundation, and Furthermore: a program of the J. M. Kaplan Fund. We are grateful for the vision of all our donors. And finally, our gratitude goes out to the Leon Levy Foundation, which makes these exhibition projects possible.

Foreword

On March 22, 1961, Pessaḥ Bar-Adon lowered himself into an unexplored cave in the cliffs high above the Dead Sea. "Looks like objects of copper!" he underlined in his journal. His team began to investigate. They found the first fifty copper vessels, then textiles, then the number of copper vessels exploded to more than four hundred; he struggled to even describe, much less comprehend, all that he was finding. In this moment Bar-Adon and his team had discovered what would come to be known as the Cave of the Treasure, one of the great hordes of antiquity. The copper vessels of this cave were so spectacular that they define an era, a Copper Age (4500–3600 BCE) when the first smiths spurred a "metallurgical revolution" that changed all of society. Today, scholars also refer to this Copper Age as the "Chalcolithic" (literally, copper-stone) period in order to encompass the full range of innovations that mark the end of Stone Age society. In this time, families moved to organized villages headed by tribal chiefs. They pooled their resources and sustained specialists in agriculture, crafts, and ritual. They irrigated fields and, for the first time, cultivated wool, cheese, olives, and dates on a large scale. They dedicated sanctuaries, and imported raw metals from great distances. In this period, known to scholars as both the Chalcolithic period and the Copper Age, an innovative society invented a way of life that would support the entire Near East for six thousand years.

For the last century, archaeologists working in and around the modern state of Israel have been discovering who these innovators were, how they were organized, and what they believed. The search has been encouraged by stunning archaeological discoveries—anthropomorphic and zoomorphic ossuaries (containers for the skeletal remains of the deceased), basalt stands with human faces, technically elaborate linen and wool textiles, monumental wall paintings, and, of course, the masterful copper objects of the Cave of the Treasure. Many of these are intensely visual objects with the human figure as core subject. But this is still a prehistoric world without written texts; the remains are frustratingly mute. Those who study this period must walk a difficult line, attempting to explain the human story behind the brilliant finds while avoiding mere speculation to fill the gaps.

In the Be'er Sheva Valley to the south, distinct cultures allow scholars to speculate about the political organization of the period. Thomas Levy argues in his essay that the settlement patterns provide a key clue. The small sites interspersed with larger villages located along seasonal riverbeds mark the patterns of a hierarchical society. These were not just pastoralists happening upon one another for temporary sustenance. They built intricate institutions and dependent relationships that point to a new economic and social order. But the details lie just beyond our grasp. Levy has been the leading voice behind viewing these groups as chiefdoms, an anthropological model that might further explain trade, economy, and religion.

Osnat Misch-Brandl argues that this was the moment when religion moved from primitive to complex, as worshipers changed from a vague shamanism to a more explicit "religion," and began to construct models of "gods" and "goddesses" in central sanctuaries. The very presence of distinct places of worship is new and leads to speculation over how a "worshiper" or "priest" would encounter the new sacred spaces. And in the shrines themselves, vivid wall paintings and intricately decorated figurines mark spaces as the setting of distinct ritual acts. In the most extensively excavated temple at Gilat, supplicants brought miniature clay vessels and violin-shaped figurines from great distances, a pilgrimage act that points to the importance of the shrine in the life of the region.

For Yorke Rowan the "religious" symbols, even at Gilat, are intricately linked to care of the dead. In Chalcolithic society the dead were remembered on at least two occasions, each with separate accompanying rituals. First the newly deceased were laid out in pits or caves, and then, somewhat later, the defleshed bones were gathered in clay ossuaries whose form and decoration frequently incorporated zoomorphic and anthropomorphic elements. They are often painted and crowned with sculpted faces, some naturalistic and others strikingly abstract, many featuring a prominent nose and wide eyes. Dina Shalem explores these motifs in the ossuaries with a particular focus on the outstanding finds from a burial cave at Peqi'in in the Galilee. She examines the meaning of faces with prominent noses and the horns of the ibex. Since motifs on the burial ossuaries also appear in temple figurines from Gilat and on household stands from the Golan Heights, they point to a common world of Chalcolithic symbols that permeated all of life.

In the Jordan Valley, Jordanian researchers have uncovered the longest-lasting and most complex settlements in the region. Special buildings at Tuleilat Ghassul, the largest site, are described by Misch-Brandl as domestic shrines that contained elaborate paintings on wall plaster: small and large individuals, masked processions, wild animals, and an elaborate painting of a polychrome star. Like so much in the Chalcolithic repertoire, the images are both evocative and mysterious. Scholars wonder if the elaborately dressed humans were shamans, priests, rulers, or deities. They ask whether the star motif was an indication of the observations of the heavens or instead an early exemplar of the later sign of the Mesopotamian goddess Inanna as per Shalem (p. 74).

But the clothing of Chalcolithic individuals is not only available to us in images. The Jordan Valley's arid climate preserves organic material that would not normally survive, and caves in the nearby cliffs conserved reed and palm mats, wool and linen textiles, and leather shoes. Orit Shamir discusses these Stone Age textiles and shows how the technology that produced these fabrics was the foundation of production in the region for millennia.

Finally, in a cave just south of the Jordan Valley settlements, the Cave of the Treasure represents a degree of aesthetic and technical sophistication previously unseen in human history. Michael Sebbane describes this deposit as the ritual apparatus of a sanctuary—with hundreds of mace heads and elaborately worked ceremonial scepters, all made using the lost-wax casting technique—and shows how this hoard serves as prime evidence for breakthroughs in social organization, artistic complexity, international trade, and metallurgical expertise. The polished copper mace heads are a ritual nod to the warfare of the period, which, as Steven LeBlanc of Harvard University has demonstrated, was a constant feature of prehistoric societies living in proximity to one another. The other objects, the crowns and scepters, tie into the symbolic world of politics and religion, picking up motifs and themes found in other media and instantiating them in stunning elite objects that represent the culmination of labor across the spectrum of Chalcolithic society. Perhaps more than any other find, these spectacular items have kindled the imagination of all of who have seen them, and all marvel at a Stone Age society that could construct such works of art. In the end, it is clear that this was the moment in which ancient craftsmen became *Masters of Fire*.

Daniel M. Master
Guest Curator, Institute for the Study of the Ancient World
Professor of Archaeology, Wheaton College

Acknowledgments

Masters of Fire: Copper Age Art from Israel has been a collaborative project from its inception. In the summer of 2011, I was invited by Shuka Dorfman, the Director General of the Israel Antiquities Authority (IAA), and Jacob Fisch, Executive Director of the American Friends of the Israel Antiquities Authority, to visit the IAA's storage facilities and meet with many of its curators. Shuka and Jacob made it possible for me to view the full range of exceptional archaeological material under their care. The result of that trip was the decision to focus an exhibition on Copper Age (4500–3600 BCE) material, as this was a period of extraordinary innovation in the Ancient Near East yet it had received little attention with international audiences. We are extremely grateful for the IAA's leadership, for its support and guidance throughout the project, and for allowing ISAW to exhibit material that has never left Israel before.

During my team's visits to Israel, we were welcomed by IAA colleagues at Beth Shemesh. Hava Katz, Chief Curator Emerita, ensured that from the start of the project we received exceptional attention. Michael Sebbane, Chief Curator of the National Treasures, was the IAA curator for this project, and was seminal in the choice of material for display and for organizing a myriad of important details around our research trips. Orit Shamir, Curator of Textiles and Organic Material, was extremely enthusiastic about the project, and worked to make certain that ISAW had a comprehensive selection of organic material to display in our galleries. Uzi Dahari, Deputy Director of the IAA, and Helena Sokolov, Director of International Exhibitions, provided organizational support. We are grateful for their shared enthusiasm and expertise.

The Israel Museum, Jerusalem (IMJ) was also our partner in this exhibition project. From the very beginning, James Snyder, Anne and Jerome Fisher Director, expressed his support for and scholarly commitment to the project. We are extremely grateful for his vision, for making the Museum's collections readily available to our research team, and for the loan of several Copper Age treasures that form part of the permanent display in IMJ's newly renovated galleries. Osnat Misch-Brandl, Curator of Chalcolithic and Canaanite Periods, served as the IMJ curatorial team member and was always willing to share her wide-ranging expertise with ISAW colleagues, ensuring that the object list reflected a comprehensive presentation of Chalcolithic culture as well as an aesthetic focus. Haim Gitler, Tamar and Teddy Kollek Chief Curator of Archaeology and Curator of Numismatics, welcomed us to the IMJ and helped to facilitate a number of key requests. Bella Gershovich, Associate Curator of Chalcolithic and Cannanite Periods, and Noga Raved, Shipping and Loans Officer, provided organizational guidance at critical stages. Elie Posner, Head of Photography, provided beautiful photography of the IMJ objects on display. Nancy Benovitz, Senior Editor of English Publications, and Aviva Schwarzfeld offered invaluable support along the way. We are grateful for their collaborative efforts.

At ISAW the curatorial team included myself, Peter de Staebler, Assistant Curator in the Exhibitions Department, and our guest curator, Daniel Master, Professor of Archaeology at Wheaton College. Peter provided important checklist support in the exhibition's early stages. Daniel drove the narrative of the exhibition, helping to organize its key themes, and guided decisions related to the structure of the exhibition catalogue. His enthusiasm for the material was infectious, and we are grateful for his commitment from project inception to completion. Roberta Casagrande-Kim, Post-Doctoral Fellow, supported the final curatorial stages of the project, including writing some gallery didactics. Julienne Kim, Managing Editor, with the support of Brooke Norton and Lisa Macabasco, produced a first-rate catalogue and saw the department and the curatorial team through a number of intense deadlines. We are grateful for her unwavering commitment to publications of the highest quality. Narges Bayani, Exhibitions Department Intern, performed a number of important tasks related to completion of the publication. We thank Mary Cason for her exceptional copy-editing skills. Irene Gelbord, Department Manager, and Anna Sharane Schwartz, Temporary Department Manager, provided internal organizational support for a myriad of important details. Abby Lepold, Registrar, ensured that the exhibition was received and installed in a seamless manner. We are also grateful to our dedicated design team, Mischa Leiner and Susanne Schaal, both of CoDe. New York Inc., who consistently create exceptional exhibition designs for ISAW, matching the aesthetic standards of our installation to the quality of our exhibition narrative.

This exhibition would not have been possible without the support of the Leon Levy Foundation. *Masters of Fire* also received generous support from a number of foundations and individuals. We are grateful to the David Berg Foundation, our lead sponsor for this exhibition project. Additional exhibition funding was generously provided by the Selz Foundation and Frederick and Diana Elghanyan. We also express our gratitude to our main catalogue sponsors, Michael and Judy Steinhardt. Additional funding for the catalogue was generously provided by Jonathan and Jeannette Rosen. We are grateful to Furthermore: a program of the J. M. Kaplan Fund for also supporting the publication. Public programming for the exhibition was made possible by a grant from the Achelis Foundation. To all, thank you for your visionary support.

Jennifer Y. Chi
Exhibitions Director and Chief Curator
Institute for the Study of the Ancient World

Mediterranean Sea

Byblos

Tel Dan

Tel Te'o

Golan Heights

Kabri

Peqi'in

Seluqiyye

Rasm Harbush Ein el-Hariri

Sea of
Galilee

Mugharet el-wad

HaZore'a

Tel esh-Shunah
Gesher
Neve Ur

Megiddo

Gan HaShlosha

Hadera

Beth-She'an

Pella

Meser

Jordan valley

Ma'abarot Tell es-Saf

Taiyiba Tell Balatah Abu Hamid

Nahal Qanah

Bene Berak

Tel Aviv Qula

Azor Givat Ha-oranim

'Ain Ghazal

Ramla

Ben Shemen Ai

Cave of the Warrior
Cave of the Sandal

Palmahim

Jericho Adeimah

Nahal Sorek

Jerusalem Tuleilat Ghassul

Horvat Qarqar

Giv'at Ha-Oranim

Qiryat Gat Gath-Govrin Umm Qatafa cave

Murabba'at caves

Horvat Qarqar

Dead
Sea

Moringa Cave

Qatif **Kissufim** Nahal Gerar *Nahal Mishmar* En-Gedi

Nahal Patish Gilat Lahav

Nahal Besor Shiqmim *Nahal Beersheba* Cave of the Treasure

Nahal Ze'elim Nevatim Nahal Lahat

Abu Matar Beit Eshel Nahal Hemar
Neve Noy Horvat Betar
Bir Safadi

Negev

Makhtesh Ramon *Feinan*

Timna

0 50 100 Kilometers

0 25 50 Miles

Tell el-Magass

Aqaba

The Discovery of the Chalcolithic Period

Daniel M. Master
Wheaton College

Crown with building-facade
decoration and vultures. Copper,
Naḥal Mishmar. IAA: 1961-177,
exhibited at IMJ. Checklist no. 44.

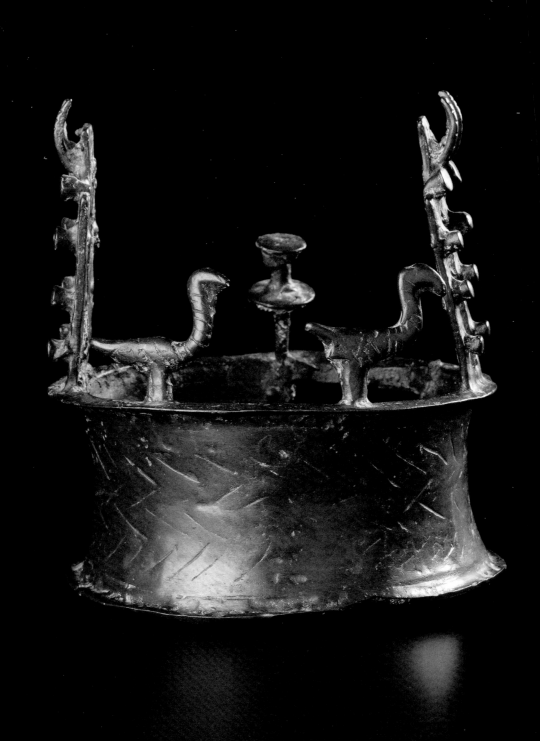

In 1931, William Foxwell Albright, the preeminent archaeologist in British Mandatory Palestine, encountered some surprising new discoveries that would change the prehistory of the Southern Levant.[1] Albright's brilliance lay in his ability to place scattered collections of artifacts in proper chronological order. As he examined recent excavations, he realized that the sites in the Southern Levant mirrored the patterns of change elsewhere in prehistory. Albright was the first to use technological markers to arrange these archaeological sites in order. In the process he noticed artifacts between the latest Stone Age (or Neolithic, 8300–4500 BCE) and Bronze Age (3600–1200 BCE) that belonged to an era when metalworking in copper had started to replace stone but traditional tin-bronze was unknown.[2] He knew that this period of copper production had been called "Chalcolithic" (copper-stone age) in Egypt since the turn of the century,[3] and he became the first to apply the term to the Southern Levantine sites.

At the same moment, the social consequences of the prehistoric changes were on the mind of V. Gordon Childe.[4] In his influential study of human social evolution, Childe argued that the Stone Age domestication of crops and animals was a "Neolithic Revolution" that, like the modern industrial revolution, changed all facets of life and society, ultimately as part of a Bronze Age "Urban Revolution." Every archaeologist read Childe's work, so others soon mimicked his nomenclature to highlight key moments in Chalcolithic prehistory. They described the Chalcolithic period as a "metallurgical revolution" when specialists created the first artifacts by melting copper (see Levy, this volume). For others, the Chalcolithic period was the key moment in the "secondary products revolution."[5] For the first time flocks and herds were managed for milk, wool, and traction, not just for meat (fig. 1-1).

In either of these frameworks, the Chalcolithic period stands as an important watershed in human development, as it was the moment in which so much of the potential of domestication and sedentarization was achieved, allowing for complex social and technological advancements that could never have been realized in previous periods. Reliable agricultural surplus allowed specialists to concentrate on pottery, metal, or textiles; fixed settlements allowed neighbors to move goods across the length and breadth of the country; and larger villages necessitated the creation of more complex social relationships. Moreover, all of these things were happening in the Southern Levant. For a brief period of time, the lands that are today known as Israel, Palestine, and Jordan were at the forefront of global human development.

Chalcolithic Regionalism

When Albright wrote his first summary, he was familiar only with the excavations of the Pontifical Biblical Institute at Tuleilat Ghassul. The distinctive pottery from the site was labeled "Ghassulian," but it was considered so odd at the time that there was controversy about where to place it chronologically (fig. 1-2). Albright was insistent, and correctly so, that the stone tools from the site fit typologically between the Neolithic and the Bronze ages.[6] The French archaeological team first excavating there also uncovered stunning wall paintings that showed masked figures, some larger and some smaller, mixed with animals and astral imagery (see figs. 4-13, 4-14, 4-15). One of the first paintings to be discovered, the so-called "notables" painting, even showed small humans facing larger seated figures.[7] I would argue that it stands as one of the first examples of social rank clearly displayed in art. Over the intervening years, the Jordan Valley has remained a key location for the study of the Chalcolithic, with some of the largest, longest-lived settlements and the greatest continuity with the Neolithic period. More wall paintings were discovered at the site in the 1960s and 1970s,[8] and very small fragments of wall paintings have even been found farther to the

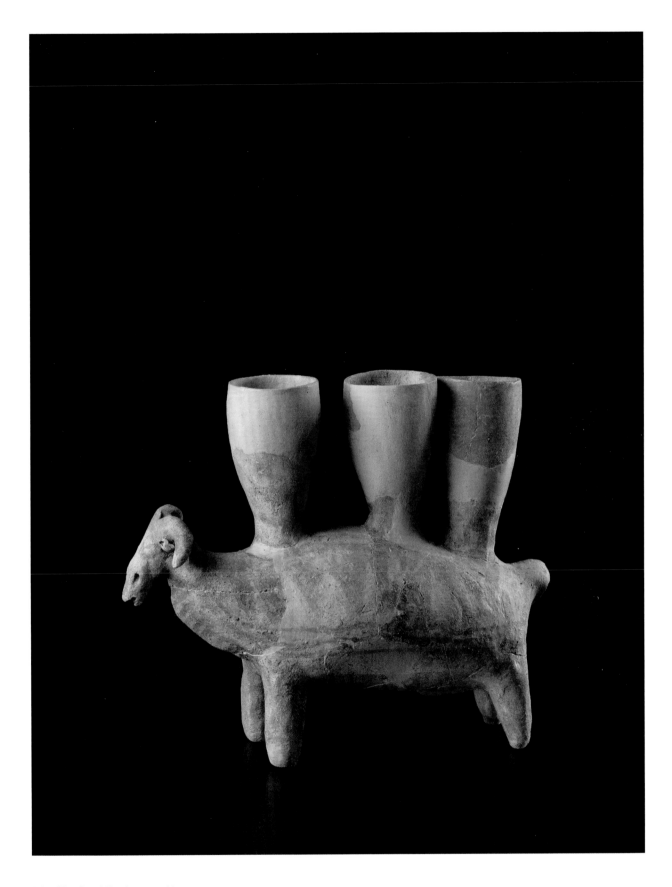

1-1. "Gilat Ram" libation vessel in
the shape of a ram carrying cornets.
Clay, Gilat. IAA: 1976-53, exhibited
at IMJ. Checklist no. 11.

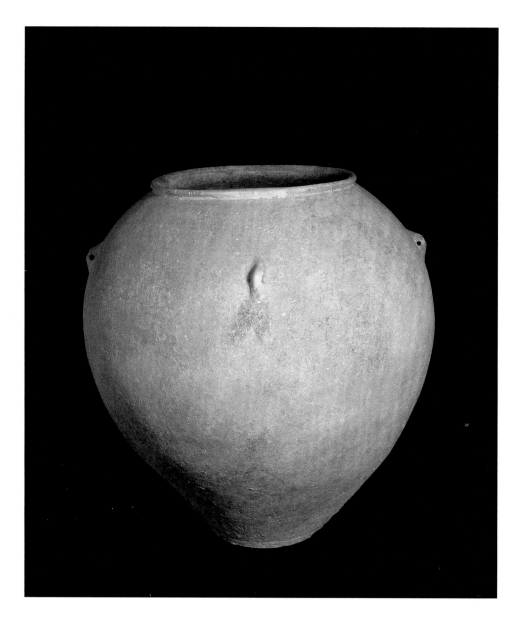

north at Abu Ḥamid.[9] In addition to these exceptional finds, excavators uncovered artifacts of daily life that show Tuleilat Ghassul was part of a community of Jordan Valley settlements extending far to the north, perhaps even beyond the Sea of Galilee.[10]

Soon after these discoveries, similar pottery was found in new regions. Sukenik, excavating on behalf of Hebrew University, found a cave near Ḥadera on the Mediterranean coast that contained ossuaries, box-shaped ceramics used to house human bones.[11] In one stroke Sukenik had expanded the geographic

reach of the Chalcolithic while at the same time introducing a new class of burial customs. Other caves with other ossuaries of many shapes and sizes were soon uncovered (including miniatures), making this type of burial a hallmark of Chalcolithic society in the coastal plain. In many ways Sukenik's excavation was the beginning of a trend in Chalcolithic research—archaeological sites would often contain several artifacts that allowed scholars to forge a chronological link to Tuleilat Ghassul, and at the same time would reveal regionally distinctive ways of life. In this case, the ossuary was the characteristic

1-2. Hole-mouth jar with painted decoration. Clay, Giv'at Ha-Oranim. IAA, Tel Aviv University: 2000-480. Checklist no. 55.

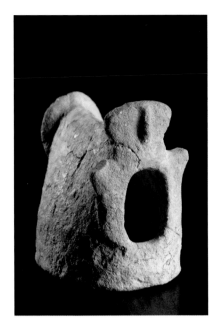
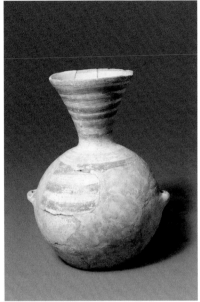

form of Chalcolithic burial practice for settlements near the Mediterranean coast (fig. 1-3).

The excavations of Perrot at Abu Matar and Bir Ṣafadi near Be'er Sheva revealed another Chalcolithic world. The pottery and stone tools (figs. 1-4, 1-5) from the south were similar enough to those at Tuleilat Ghassul to establish that these were Chalcolithic settlements (they were in fact called the Ghassul-Be'er Sheva culture at one point).[12] Even some of the local pottery fabrics, including a well-levigated "cream ware," reminded ceramicists of the finest Ghassulian ceramics.[13] However, in the southern sites inhabitants spent some considerable portion of their time living in subterranean caves. At the same time, their relatively humble dwellings produced some of the first evidence for on-site metallurgy.[14] Because many of these archaeological sites were not covered by later occupation, this region became the center for scholars interested in uncovering the Chalcolithic. Particularly notable in this regard is the work of Levy (see his essay, this volume) and Gilead.[15] Their individual projects were able to outline microregions, showing how the minor ecological or chronological differences between the Be'er Sheva Valley and the Naḥal Gerar caused nearby

societies to have quite different daily existences (figs. 1-6, 1-7).[16]

In the late 1960s, Epstein found yet another distinctive Chalcolithic way of life in the Golan Heights. She discovered sites including Rasm Ḥarbush with houses linked together in long strings of rooms. These rooms were inhabited by olive oil producers who carved unique objects out of the local basalt. The most elaborate stone vessels, anthropomorphic or zoomorphic stands (see Shalem, this volume), were found so frequently that it is thought that every house must have had one or more, either resting in a corner or, in the case of the miniatures, sitting on high shelves (fig. 1-8).[17] Stone tools and large storage jars linked the Golan inhabitants to the original Ghassulian discoveries, but in many other respects their lives were markedly different.[18] The Golan artifacts are also found in the highlands south of the Yarmuk River canyon in Jordan. Several have argued that the Golan and the Yarmuk sites were agricultural and pastoral satellites of the Jordan Valley settlements. This theory has been investigated most thoroughly by scholars working in Jordan who have access both to the Yarmuk sites and to Jordan Valley sites such as Abu Ḥamid.[19] Similarly, in Israel

1-3. Miniature ossuary with modeled nose and arms. Clay, Bene-Berak. IAA: 1951-50, exhibited at IMJ. Checklist no. 37.

1-4. Cream ware juglet with red painted bands. Clay, Gerar. IAA: 2004-2846. Checklist no. 56.

1-5. Polished mace head. Limestone, Abu Matar. IAA: 1994-1199. Checklist no. 100.

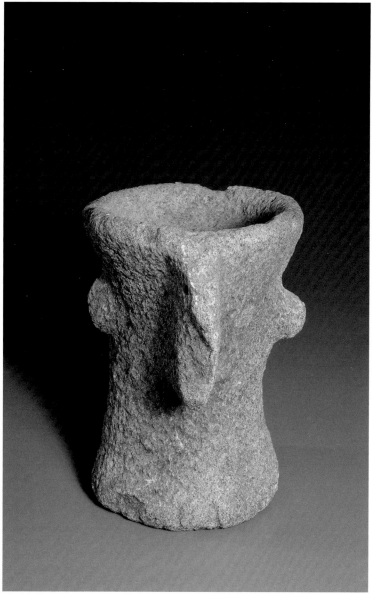

investigators have outlined links between the Golan sites and Tel Te'o in the Huleh basin.[20] Despite possible interregional connections, the artifacts from the Golan/Yarmuk region stand out as distinct enough that life on the plateau must have had its own unique rhythms (fig. 1-9).

Chalcolithic Chronology

The question of when Chalcolithic societies flourished has been the subject of considerable discussion over the last eighty years. The presence of two "revolutions" within the Chalcolithic period has added to the confusion for those attempting to define precise chronological boundaries, because each "revolution" highlights a different facet of Chalcolithic life as the core feature of the period. The "secondary products revolution," in which domesticated animals were progressively exploited for purposes other than food, was a long, gradual process beginning in the seventh millennium BCE.[21] Many other ways of life show similar gradual change across a long period, including ceramic- and

1-6. Pointed bowl. Clay, Bir Ṣafadi. IAA: 1982-1473. Checklist no. 49.

1-7. Goblet. Clay, Gilat. IAA: 1912-333. Checklist no. 57.

1-8. Anthropomorphic stand. Basalt, Rasm-Ḥarbush. IAA: 1981-3016. Checklist no. 67.

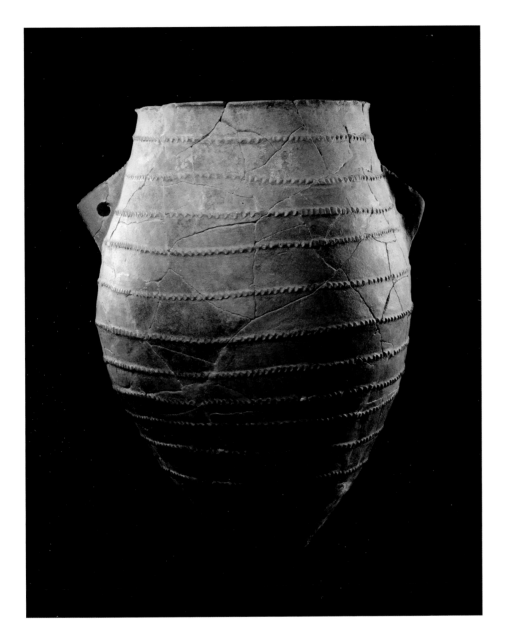

stoneworking traditions. If these long-term traditions provide the definition of the period, then the Chalcolithic was a long era indeed. Garfinkel, basing his studies on gradual ceramic development, describes the Chalcolithic as a period extending from 5800 to 3600 BCE. Within this epoch he describes early (5800–5300), middle (5300–4500), and late (4500–3600) Chalcolithic ceramic assemblages.[22]

However, if copper defines the Chalcolithic, as the name suggests (fig. 1-10), then only Garfinkel's last period, from 4500 to 3600 BCE, is relevant. Prior to this, few sites preserved examples of metal-bearing ores, and there is no evidence of ore extraction or metal tool making.[23] The "metallurgical revolution" was a burst of innovation with no apparent precursors. For that reason, this volume will classify Garfinkel's earlier periods under the Late Neolithic or under the more specific nomenclature of regional ceramic assemblages,[24] and will treat the Chalcolithic as a period extending from 4500 to 3600 BCE.[25]

1-9. Pithos decorated with rope motif.
Clay, Rasm-Ḥarbush. IAA, Katzrin
Museum: 1990-2144. Checklist no. 51.

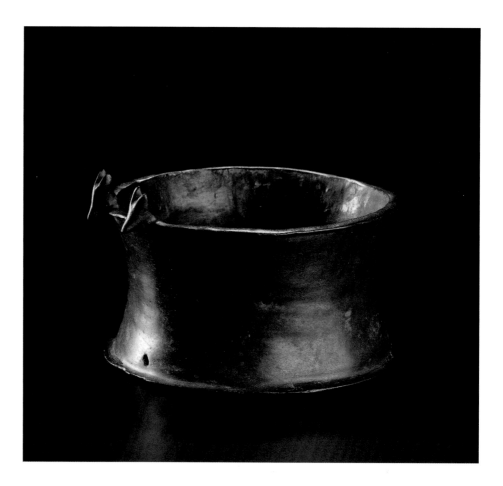

Within this period the most pressing chronological question is whether it is possible to describe a chronological progression during the Chalcolithic. In the south, for instance, there are two distinctive sets of Chalcolithic sites within a region that is a mere 25 miles across: a first set often called the Besor-Gerar cluster[26] (Gilat, Gerar, Abu Hof Village) and a second set in the Be'er Sheva Valley (Shiqmim, Abu Matar, Neveh Noy). The Besor-Gerar sites generally produce Carbon-14 (^{14}C) dates early in the Chalcolithic.[27] They also engaged in the exploitation of pigs for subsistence,[28] lack evidence of on-site metallurgy, and have ceramic forms similar to the Jordan Valley settlements. In contrast, the Be'er Sheva sites produce some of the latest ^{14}C dates,[29] practiced extensive metalworking,[30] and lack typical Jordan Valley ceramic forms such as the cornet.[31] One approach is to place these sites in sequence: the Besor-Gerar cluster from 4500 to 4200 BCE and the Be'er Sheva cluster from 4200 to 3800 BCE.[32] The earlier sites have ceramic cornets, the later sites, advanced metallurgy. This chronological synthesis would provide some sort of framework for the growth of metallurgy, from simple to complex.[33]

However, this neat sequence runs into problems at several points. Shiqmim, from the Be'er Sheva cluster, is a multiperiod site with ^{14}C dates that span the entire period of the Chalcolithic without showing the characteristics of the Besor-Gerar cluster.[34] Likewise, Tuleilat Ghassul in the Jordan Valley has all the hallmarks of the Besor-Gerar cluster but lasts until 4000 BCE according to the latest ^{14}C results.[35] Neither of these critical stratified sites supports the idea that chronology is the key to understanding cultural differences. Nor does such a chronological progression clearly work for the history of metalworking. A mat

1-10. Crown with plain walls and two horned animal heads projecting from the rim. Copper, Naḥal Mishmar. IAA: 1961-175, exhibited at IMJ. Checklist no. 108.

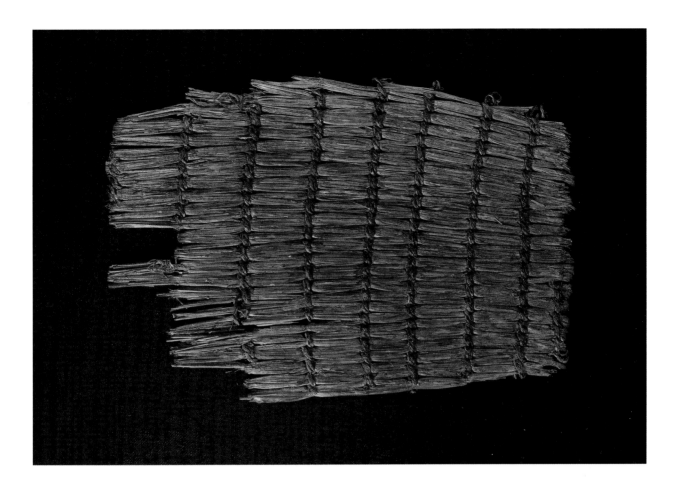

that accompanied the Naḥal Mishmar hoard, the most advanced metallurgy of the period, was reanalyzed in 2001 and produced [14]C dates in the middle of the fifth millennium BCE, relatively early in the Chalcolithic (fig. 1-11).[36] At the moment, it appears that the core of the Chalcolithic period, for all regions, spans the period between 4500 and 4000 BCE. During these five centuries, there was plenty of time for ceramic styles to come and go, but the details of these changes are beyond the chronological resolution of current archaeological tools.

Still, even with these caveats, it is generally agreed that several sites in the Be'er Sheva Valley persisted somewhat longer than other Chalcolithic sites, until around 3800.[37] This cannot explain the variation between the earlier sites, but it does provide insight into the end of the Chalcolithic period. In these centuries after 4000 BCE, pottery and architecture quite

similar to that from the Be'er Sheva Valley cluster are found in Egypt at Buto.[38] This assemblage provides some indication that late in the Chalcolithic—if not earlier—groups from the Southern Levant took the lead in establishing relationships with Egypt. There had long been evidence for trade in trinkets from Egypt,[39] but the evidence from Buto shows a range of Chalcolithic forms actually being made in Egypt. For a moment the Chalcolithic societies might have been able to make a real contribution to Egyptian development, yet within a century the Chalcolithic settlements were gone. The only occupation was in the deep southern deserts, where isolated villages continued as they had since the Neolithic.[40]

The connection with Egypt highlights the big picture. The Chalcolithic was ending in the Southern Levant as the Naqada period in Egypt and the Uruk period in Mesopotamia were gaining momentum. Egypt was

1-11. Mat fragment. Straw, Naḥal Mishmar.
IAA: 1961-208. Checklist no. 138.

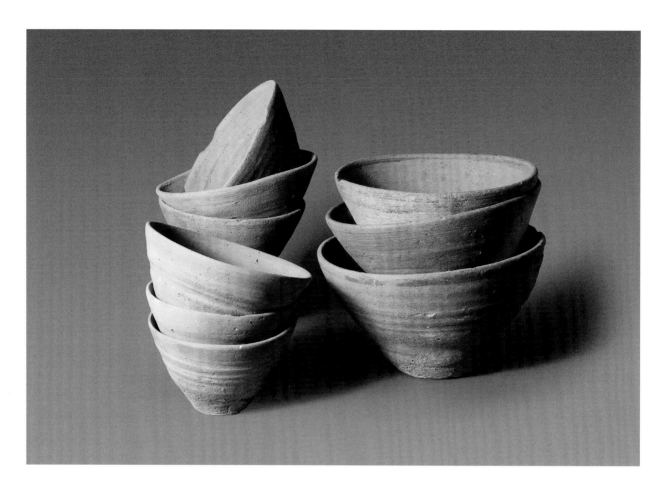

in the process of unifying the Nile Valley into a state.[41] At the same time, the inhabitants of Uruk were building a city of fifty thousand and inventing the concept of writing in order to manage it. Whatever the direct causes for the decline of the Chalcolithic, it was already doomed to fall behind as the great civilizations of the Bronze Age Near East surged. The Chalcolithic period marks the end of the era when the people of the Southern Levant were among the leaders in technology or social development; at the end they had been completely surpassed.

Chalcolithic Artifacts

The Chalcolithic period was first defined based upon distinctive ceramic and stone objects that appeared between the end of the Neolithic and the beginning of the Early Bronze ages. For the archaeologists of the last three decades, this typological approach begs all sorts of key ecological and social questions (see both Levy and Rowan, this volume), but from an introductory standpoint it remains a convenient way to link sites from the same era.

The most common Chalcolithic form was the simple V-shaped bowl (fig. 1-12). In many ways its ubiquity makes it the ceramic hallmark of the period.[42] Some potters finished the V-shaped bowl on a slow wheel (tournette), some used finer clays, some even added paint around the lip. Underneath all of these variations, the basic shape of the bowl, as one of the core utilitarian devices of the society, remained the same. The bowl can be seen as an illustration of Chalcolithic daily life. All Chalcolithic settlements emphasized domesticated plants and animals in the diet.[43] Hunting and gathering played only a minor part. The V-shaped bowl was the basic serving dish for the meals that came from fields and herds.

1-12: V-shaped bowls. Clay, Shiqmim
and Bir Ṣafadi. IAA: 1982-1613, 1992-1136,
1992-1248. Checklist nos. 50, 52, 53.

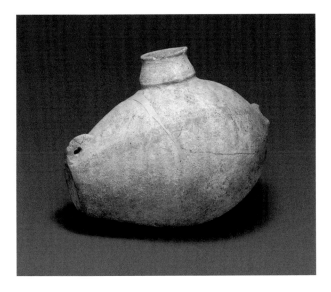

Chalcolithic potters also constructed ceramic churns,[44] a form unique to the Chalcolithic and emblematic of larger ceramic trends (fig. 1-13). The churn itself is a strange object: an asymmetric oblong form with a neck/opening in the middle. Often, it has handles at one or both ends. All of these stylistic features are an interesting example of technological momentum. The shape of a goat skin churn was imported into a pottery form with little thought given to the way in which the ceramic medium might allow for a different design. This stylistic choice is typical of a whole class of vessels in the Chalcolithic that use other materials as the template for ceramics. In the Chalcolithic, leather burial coffins (fig. 1-14), straw baskets (see fig. 7-23), and thick ropes all find expression in pottery form. It might be said that the many examples of human and animal reproductions in pottery belong to the same tradition of ceramic imitation.

The concept of ceramic imitation is particularly interesting in the case of the basalt V-shaped bowls (fig. 1-15) and fenestrated stands (fig. 1-16), so named because the base uses a series of pillars that create the appearance of windows (Latin: *fenestrae*). No one knows if the ceramic vessels imitate basalt or vice versa, but even though the pottery and stone vessels have the same shape, the artifacts were not precise equivalents in terms of function. Despite the difficulties of importing igneous rock from the Golan or outcrops in Jordan, stone bowls and stands were important enough that some were recovered from just about every Chalcolithic hamlet. The rare stone bowls had a particular role in Chalcolithic life that could not be completely filled by their ceramic twins.

Other types of pottery are distinctively Chalcolithic, but not uniformly distributed (fig. 1-17). The cornet is one of the easiest forms to recognize from fragments because of its long handmade base, which is unlike anything in the later ceramic repertoire of the region (see fig. 4-21). For instance, sites such as Tell Dothan or Tel Ashkelon, which have unreachable exposures of Chalcolithic strata beneath extensive later occupation, can be identified as having Chalcolithic occupation because of the Chalcolithic cornet bases that appear residually in later strata. Due to its easy identification, the cornet was one of the key markers for archaeologists, particularly at Tell Ghassul. Conversely, the lack of cornets in the Be'er Sheva Valley and in the Golan is equally notable. Some have suggested that the cornet had a particular cultic significance that was not required at every site. For instance, at the "temple" of Gilat and in the "domestic shrines" at Ghassul, the cornet is represented in unusually large quantities (see Misch-Brandl, this volume). At the same time, the cornet is found at many sites with no particular cultic centers, and it is found in domestic contexts frequently enough that it cannot be purely a cultic object.[45] Others have speculated that the form may belong to a specific moment earlier in the Chalcolithic period during which certain sites were not occupied, though this seems an unlikely explanation for its absence at long-lived sites (see above). Perhaps this form was the hallmark of specific regional groups. In any case, no solutions fully explain the uneven distribution of cornets across the Chalcolithic landscape.

1-13. Churn. Clay, Giv'at Ha-Oranim.
IAA, Tel Aviv University: 2013-1031.
Checklist no. 58.

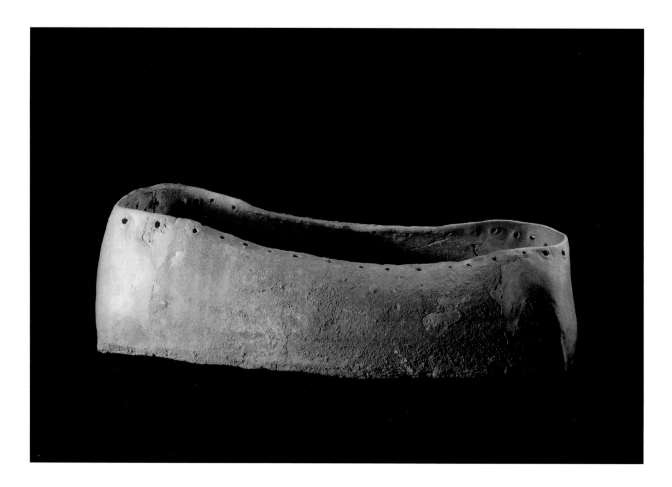

Other forms are far more limited in geographic distribution. Large, deep, spouted bowls were used for separating olive oil in the pressing process, and these forms are clustered in the olive-producing regions of the Golan Heights and Cisjordanian Hills.[46] Miniature vessels, such as tiny churns (see fig. 4-19), are found in cultic contexts such as those at Gilat. Gilat is also the only site with the so-called "torpedo" jar, a form from the central hills and lowlands that was brought to the Gilat temple, probably filled with oil (see Misch-Brandl, this volume). In addition, the sites of the Golan Heights and Jordan Valley also have enormous vessels (pithoi), often sunken into the floor of houses for internal storage.[47] Each of these forms provides a distinctive local flavor to Chalcolithic life in a variety of ecological niches.

Chalcolithic Treasures

If these regional societies were the only contribution of the Chalcolithic, the period would be of local interest but hardly of international significance. Functional, pure-copper tools were a common feature of the Southern Levant from their Chalcolithic invention through the Late Bronze Age,[48] and the pure-copper tools of the Chalcolithic were not particularly innovative compared to copper work in Egypt, Mesopotamia, or Iran.[49] However, several outstanding discoveries have demonstrated that the Southern Levant was experimenting with more than just new subsistence patterns.[50] Bar-Adon's discovery of the Cave of the Treasure in Naḥal Mishmar changed the conversation entirely.[51] This find (see the extensive discussions by both Levy and Sebbane, this volume) turned the Southern Levant into the ancient center of metallurgy. The diverse elemental recipes and advanced castings showed

1-14. Ossuary with pierced rim. Clay, Peqi'in. IAA: 2007-1750. Checklist no. 72.

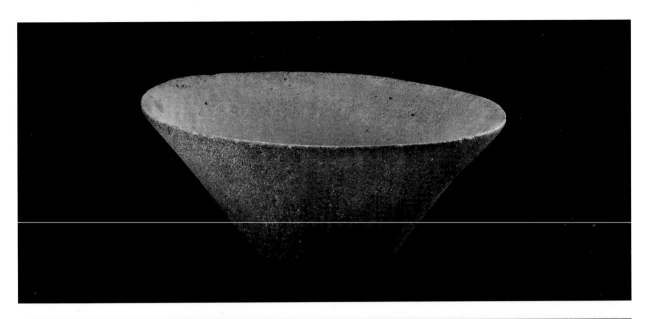

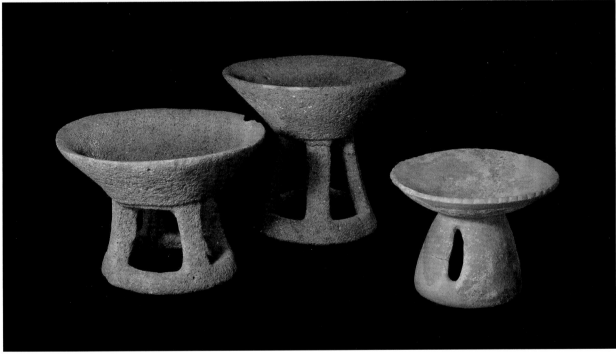

1-15. V-shaped bowl. Basalt, Bir Ṣafadi. IAA: 1963-485. Checklist no. 48.

1-16. Fenestrated and pedestaled bowls. Basalt, Giv'at Ha-Oranim and Peqi'in. IAA, Tel Aviv University: 1997-3460, Checklist no. 54. IAA: 2007-1733.

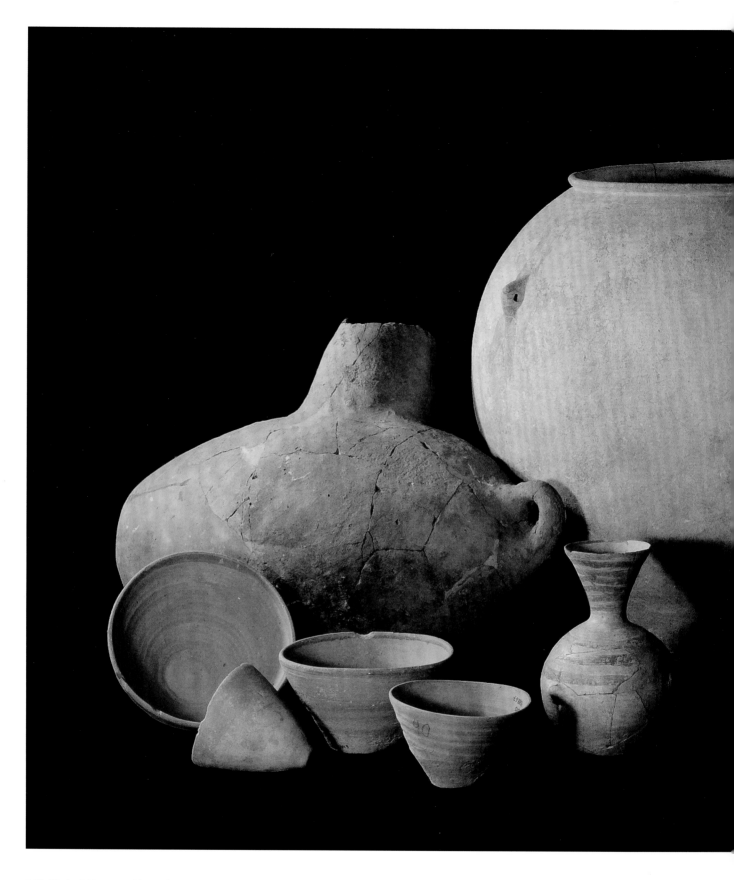

1-17. Chalcolithic assemblage of pottery.

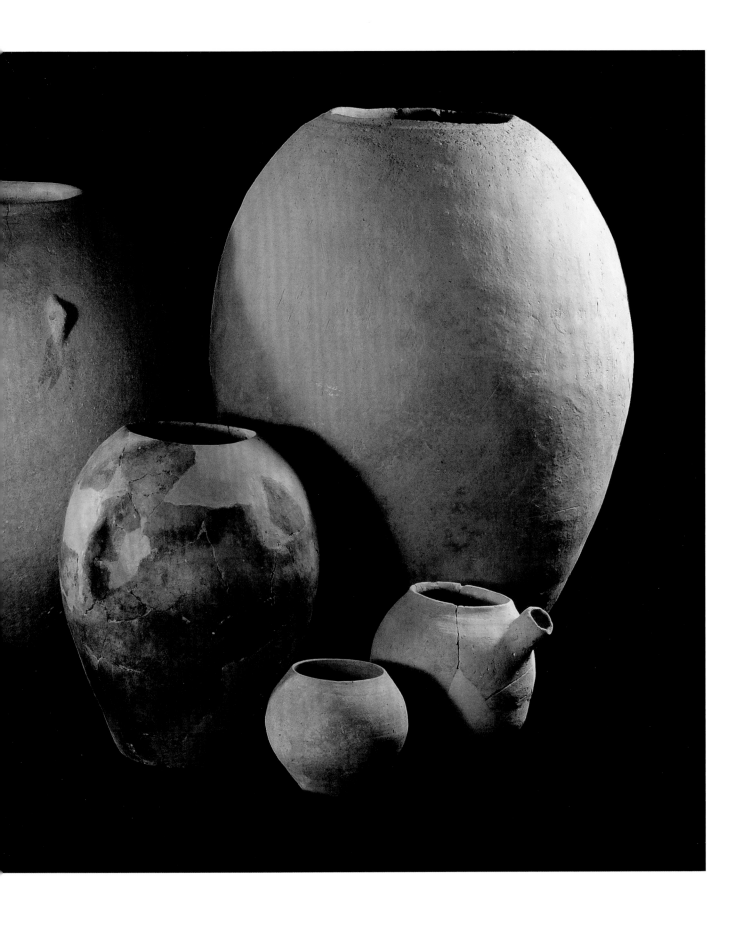

that the Chalcolithic of the Southern Levant had some chemists with an ability to differentiate ore types and to mix them brilliantly.[52] From the many excavations of Chalcolithic villages in the Southern Levant, it is not clear who could have made such pieces. The evidence of basic metallurgy at sites in the Be'er Sheva Valley is as close as anyone has come to describing the construction of such treasures, and yet there are still many missing steps between the basic extraction of copper from ore[53] and the artistic wonders of Naḥal Mishmar (fig. 1-18).

In 1995 the chance discovery of a burial cave at Peqi'in in Galilee further changed Chalcolithic history. The cave contained an unrivaled collection of decorated ossuaries, stands, and chalices, some of which had been disturbed by grave robbers in the Chalcolithic period itself (fig. 1-19). In addition to being an unequaled resource for our understanding of iconography and burial customs (see the discussions by both Shalem and Rowan, this volume), this tomb also modified the understanding of Chalcolithic regionalism. Before this discovery in the high hills of Upper Galilee, the ossuary had been an artifact of the coast, with Sukenik's original discoveries at coastal Ḥadera coming close to the northern boundary. Further, the Peqi'in Cave included figurines and ivories typical of the Be'er Sheva Valley, pottery with affinity to the Golan culture, and a small number of metal objects made from Jordanian copper. The finds are diverse enough that the Peqi'in Cave has caused many to reconsider the whole idea of regionalism in the Chalcolithic.[54] This is an overreaction; there are still marked regional distinctions,[55] though interregional exchange was robust enough that we should not expect small prestige goods to be confined to any one place.

Finally, the cave at Giv'at Ha-Oranim was excavated in 1996–97 in preparation for a new highway in the western foothills of Israel. The excavation team discovered at least nine natural caves that had been modified for human habitation. Inside, in addition to

typical Chalcolithic pottery and stonework (fig. 1-20), the excavators uncovered the largest cache of finished copper objects outside of Naḥal Mishmar (fig. 1-21). These twenty-five objects included stands and crowns and even lumps of alloyed copper not yet fashioned into objects.[56] While the finds from Giv'at Ha-Oranim are amazing in their own right, they are also harbingers of more to come. Rather than uncovering hoards in the isolation of the Judean Desert, these discoveries were within the context of a network of sites in the foothills, and the unfinished alloyed lumps show that archaeologists are closer than ever to unlocking the metallurgical mysteries of the Chalcolithic period. As much as archaeologists have learned in the last eighty years of Chalcolithic research, new worlds are still being uncovered.

The Chalcolithic period was a brief moment when the Southern Levant was at the forefront of human technological and artistic development. This moment

1-18. Horn-shaped object with bird finial.
Copper, Naḥal Mishmar. IAA: 1961-167,
exhibited at IMJ. Checklist no. 106.

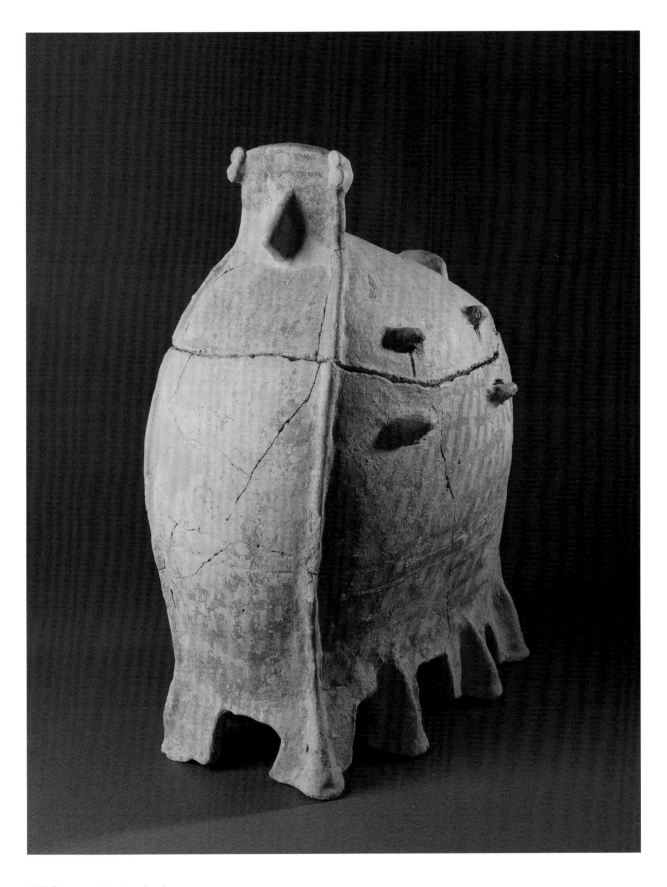

1-19. Ossuary with painted and
sculpted facial features. Clay, Peqi'in.
IAA: 2007-1850, exhibited at IMJ.
Checklist no. 62.

is important for innovations in metallurgy, textiles, horticulture, and animal husbandry. But to the modern eye, it is stunning that a group encountering so many ways of life for the first time had the ability to create objects of such enduring artistic interest. As this catalogue describes, it is not just innovation in metallurgy; it is the treasures of the Naḥal Mishmar hoard. It is not just the milk or wool of animal husbandry; it is the Gilat Lady and the Gilat Ram. It is not just new looms; it is the quality and variety of textiles from the Cave of the Warrior. It is not just an awareness of death; it is an attempt to connect the bones of the dead with the face of humanity. The people of the Chalcolithic did not just play a role in human development, they marked their contribution in style.

1-20. Jar with painted vertical bands and rope motif. Giv'at Ha-Oranim. IAA, Tel Aviv University: 2000-476.

1-21. Axe. Copper, Giv'at Ha-Oranim. IAA: 1997-3463. Checklist no. 152.

Notes

1. Albright 1931, 15.
2. These dates reflect the current consensus. Albright's own absolute dates for the Chalcolithic (4000–3000 BCE) are obsolete.
3. The first reference to the Chalcolithic, in the *Oxford English Dictionary*, is in connection with a 1902 review of Budge's *History of Egypt*; "The History of Egypt," *Nature* 67 (1723): iii. This is not the first usage in English, but it shows the term in common usage in Near Eastern Archaeology well before Albright. See *OED Online*, s.v. "chalcolithic," adj. (accessed September 2013).
4. Childe 1951, 59, 114.
5. Sherratt 1981.
6. Albright 1932; Mallon dated the Ghassulian assemblage to between 3000 and 1900 BCE (Mallon 1931, 261).
7. Mallon, Koeppel, and Neuville 1934, pl. 66.
8. North 1961; Cameron 1981.
9. Dollfus and Kafafi 1993, 250, 253.
10. See the discussion of Pella and As-Shuna in Bourke 2001, 125–27. For the Hula Basin see Eisenberg, Gopher, and Greenberg 2001, 206.
11. Called an "Ossilegium" by Sukenik, who thought that these were "Soul Houses" (Sukenik 1937).
12. Amiran 1969, 22.
13. Lovell 2001, 8.
14. Shugar 2001; Golden 2010.
15. See summary with bibliography in Gilead 2011.
16. Levy 1987b.
17. Epstein 1998, 232–33.
18. Ibid., 333–37.
19. Dolfus and Kafafi 1993, 246.
20. Eisenberg, Gopher, and Greenberg 2001, 205–7.
21. Evershed et al. 2008.
22. Garfinkel 1999.
23. Golden 2010, 13.
24. Following Gilead, we would date the Wadi Rabah ceramic culture to 5800–5100, followed in some regions by the Qatafian (5400–4900), Besorian (4900–4600), and a variety of other subgroups (Naztur 4, Tell Tsaf). Gilead 2011, 14–19.
25. The latest studies of the beginning of the Early Bronze Age (Regev et al. 2012) and the end of the Chalcolithic (Burton and Levy 2011) have yet to be woven together, but it is likely that when they are, the terminal date for the Chalcolithic will be raised somewhat, to around 3800 BCE.
26. Gilead 1995, 473–75; Rowan and Golden 2009, 15.
27. These Carbon-14 summary statements are made from averaging the various samples after Gilead 2011, 18–19. This method is problematic, as noted by Burton and Levy 2001 (p. 1244), and it is more sound, from the standpoint of appropriately using Carbon-14 results, to leave the dates as individual ranges. If left as individual ranges, the sites overlap.
28. Originally Hesse 1990. For an excellent visual summary see Golden 2010, 83–84.
29. Burton and Levy 2011.
30. Golden 2010, 108–49.
31. See the very small number of cornets in Commenge-Pellerin 1990, 21; see the complete absence of cornets in Levy and Menachem 1987, 319.
32. Gilead 2011, 18.
33. Golden 2010, 72.
34. Burton and Levy 2001.
35. Bourke et al. 2004, 318–20.
36. Two key chronological studies focused on metallurgy attempt to ignore these dates, given that they are so different from the earlier dates. See Golden 2009, 62; Shugar and Gohm 2011, 140. Neither, however, provides any rebuttal to Aardsma's cogent defense of the technical superiority of his new dates. In the case of Shugar and Gohm, this oversight is less critical to their chronological framework. See Aardsma 2001.
37. Burton and Levy 2011 (p. 179) use the term "final" Chalcolithic for this phase.
38. Braun and van den Brink 2008.
39. Faltings 2002, 166.
40. Rosen 2011.
41. For the most recent Egyptian dates, see Dee et al. 2013, 8.
42. Garfinkel's "late Chalcolithic," in Garfinkel 1999, 210–13.
43. Rowan and Golden 2009, 23–24.
44. See Burton 2004, 594–95.
45. Namdar et al. 2009 (p. 635) suggest that these were used as the base of wax candles, based upon the discovery of beeswax through residue analysis.
46. Epstein 1998, 164; Scheftelowitz and Oren 2004, 42 (fig. 3.5).
47. Epstein 1998, 162–63.
48. Graham 2008, 208–10.
49. Thornton 2009, 56.
50. It is notable that all of these exceptional sites have been excavated under the auspices of the Israel Antiquities Authority and its precursors. The quality of these finds is a testament to the responsible work of the Authority in caring for the cultural heritage of this region.
51. Bar-Adon 1980.
52. Stager 1992 (p. 28) discusses discoveries of traded arsenic from Bronze Age contexts and connects those discoveries to Chalcolithic metallurgy. *Contra* Tadmor et al. 1995, 143. The interest in using alloys to change the appearance of metals has a long later tradition as *chymistry*; see Principe, 2013, 10. Though Principe's scope of inquiry is much later, he highlights the combination of successful experimental chemistry and premodern conceptions of matter.

53 Golden 2010, 108–49.

54 See, e.g., Gilead 2011, 15

55 See, e.g., Burton and Levy's analysis of the difference between the Wadi Fidan 4 Village and Negev sites for a fine-grained analysis demonstrating considerable regionalism. This type of study could be extended further to highlight systematic and sharp differences among the Jordan Valley, Be'er Sheva Valley, Golan Heights, and Coastal Plain. Burton and Levy 2011, 181.

56 Scheftelowitz and Oren 2004, 72, 81.

Cultural Transformations: The Chalcolithic Southern Levant

Thomas E. Levy
University of California, San Diego

Head of a figurine wearing an
elaborate headdress. Ivory, Bir Ṣafadi.
IAA: 1958-580, exhibited at IMJ.
Checklist no. 4.

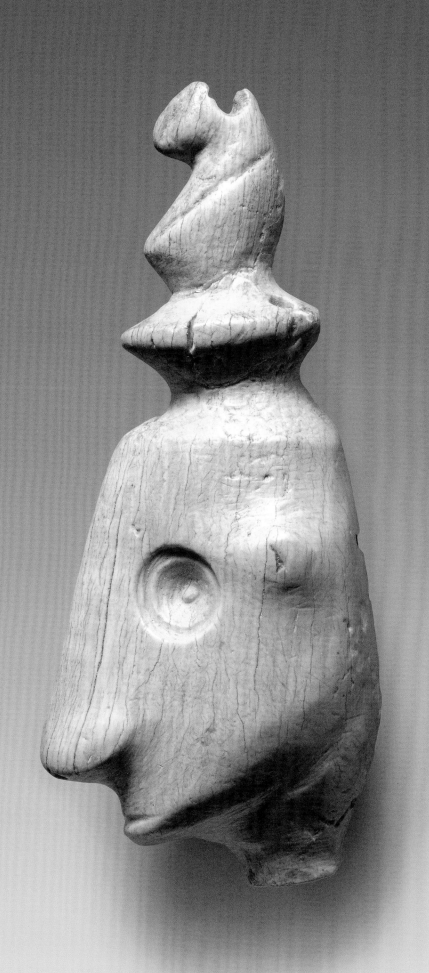

During the late fifth–early fourth millennium BCE, societies in the Southern Levant crossed a socio-economic "Rubicon," setting in place the foundations for many of the social organizations and subsistence systems that still characterize the Middle East today. The wealth of objects on display at this special exhibition, at the Institute for the Study of the Ancient World at New York University, are a testament to the cluster of new social systems, ideologies, technologies, subsistence practices, and exchange systems that emerged after the Neolithic Revolution. Scholars refer to this new period as the Chalcolithic (Greek: χαλκός, khalkós, copper + Greek: λίθος, líthos, stone) because the introduction of metal production is the factor that most distinguishes its material culture from earlier periods. Based on radiocarbon dates from sites throughout the Southern Levant, the period lasted from about 4500 to 3600 BCE. The impact of the invention and adoption of metallurgy on social evolution in the Southern Levant was profound; it has led me and others to describe this development as a "metallurgical revolution" of no less importance in Old World pre- and protohistory than Childe's notion of the Neolithic and Urban revolutions.[1] As will be discussed in this essay, based on recent research during the past ten to twenty years, it is important to pause and reconsider the application of the term *revolution* to some of the socioeconomic developments that have been linked to this period. However, as will be seen in the exhibition and the essays in this book, there are a number of interconnected developments that crystallized during the formative Chalcolithic period and helped to institutionalize social inequality and the Mediterranean subsistence base, and that, for this region of the Ancient Near East, were indeed revolutionary. These changes were coupled to innovation and a degree of intensification in the following areas: metallurgy, craft specialization, regional settlement systems and territoriality, agro-pastoralism, and temples.[2] This is not to suggest that all of these developments occurred for the first time during the Chalcolithic period in the Southern Levant. However,

the integration of all these cultural elements came together during the late fifth–early fourth millennium to set the stage for the Urban Revolution that occurred in the following Early Bronze Age throughout the Ancient Near East. Over the past two decades, a wealth of new research concerning the Chalcolithic period has taken place. Certain "bursts" in new discoveries can be identified concerning mortuary archaeology, specialized flint workshops (fig. 2-1), new village sites, bedrock mortar/cup marks that may be related to the processing of horticultural products such as olives, and other products. Like many of the archaeological periods researched in Israel, Palestine, and Jordan in the recent past, the Chalcolithic period has also seen an increase in the application of science-based methods, including archaeometallurgy,[3] archaeobotany,[4] residue analysis, gas chromatography [GC], GC/mass spectrometry [GC/MS],[5] optically stimulated luminescence dating [OSL dating],[6] high-precision radiocarbon dating,[7] and other approaches.

Over the past decade a focused research group has developed in Israel called the Forum for the Research of the Chalcolithic, spearheaded by Ianir Milevski, and which has held six annual meetings to date. Some of the topics have included: interpretations of anthropomorphic and zoomorphic figurines, "Northern Israel during the Chalcolithic Period—Ghassulian or Independent Cultures," and "Celebrating 50 Years Since the Discovery of the Naḥal Mishmar Hoard." These highly focused meetings highlight the vibrancy of research activity and debate surrounding the Chalcolithic period. One of the longest debates, still ongoing, concerns my own research, which has argued for the emergence of chiefdoms during the Chalcolthic period,[8] and the work of Isaac Gilead against it.[9] Detecting the origins of hereditary inequality is a highly debated topic in anthropological archaeology on the world scene,[10] and the case of the Southern Levant is an important locale for investigating this problem. Briefly, a chiefdom may defined as "an autonomous political unit

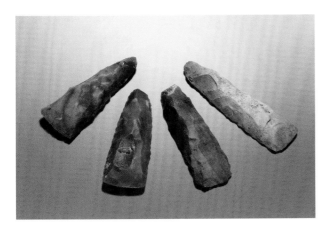

system or several linked drainages had the potential to house a localized Chalcolithic cultural system. This is certainly the case for the northern Negev Desert, where the Be'er Sheva Valley culture was markedly different from the Patish and Gerar drainages, less than 20 km to the north. Thus, the term Ghassulian is apropos for the southern Jordan Valley around the type-site of Tuleilat Ghassul, but is inappropriate for the Negev, Judean, and southern Jordanian deserts, as well as most other regions in the Southern Levant.

comprising a number of villages or communities under the permanent control of a paramount chief."[11] As described below, there is no question that two-tier settlement hierarchies evolved in some regions of the Southern Levant during the Chalcolithic period and reflect this type of social organization. However, as Flannery[12] points out, one of the reasons it is more difficult to identify social rank in the Near East than in Mesoamerica may be in part because Near Eastern societies were less flamboyant. Personal display (which would be evidenced by prestige burial goods) was simply not as important to high-ranking Chalcolithic elites as to their Mesoamerican counterparts. D'Altroy and Earle[13] have suggested that Chalcolithic Near Eastern rank societies relied more on "staple finance" (that is, accumulation and redistribution of foodstuffs) than on "wealth finance" (in other words, control of prestige goods) to secure and enhance their social position. However, my own work along the Be'er Sheva Valley suggests a combination of these two types of finance to promote, maintain, and enhance chiefly power. As will be seen below, the evidence comes from widespread subterranean storage facilities used for storing staple goods and advanced copper metallurgy that together fueled a "wealth finance" economy in the northern Negev Desert. In fact, the data described in this volume and on view in the exhibition highlight the need to examine Chalcolithic culture on a regional scale, as every wadi (seasonal drainage)

The results of new discoveries and science-based studies have given more precision to anthropological interpretations of the Chalcolithic archaeological record, confirming the fundamental social transition from egalitarian societies to chiefdom-level ones, but also bringing to light the highly localized regional nature in which these societies emerged in the Southern Levant. The following discussion will provide a contemporary, broad-based review of the available data given the limitations of space in this book.

The Metal Revolution and the Chalcolithic Period

During the "Golden Age" of biblical archaeology between the two world wars, from 1929 to 1931, Pere Alexis Mallon of the Pontifical Biblical Institute in Jerusalem carried out large-scale excavations at a series of low mounds called Tuleilat Ghassul, situated about 5 km northeast of the Dead Sea.[14] The distinct material culture—so-called fan-scrapers and bifacially flaked chisels, a distinctive pottery assemblage that included cornet-shaped cups and "bird-shaped" containers (later identified as churns), and spectacular frescoes with geometric patterns, a procession of individuals with "spook" masks, and imaginary creatures, all found in four relatively homogenous strata spanning over 5 m in depth—led archaeologists to refer to this as the new Ghassulian culture.[15] There was considerable controversy over the dating of the Ghassulian culture when it was first

2-1: Axes and adzes. Flint, Gilat and Rasm Ḥarbush. IAA: 1976-1688 (second from right), 1987-1536 (far right). Checklist nos. 142, 150.

discovered. Mallon, who died in 1934, maintained that Ghassul dated to shortly before 2000 BCE, a date that was certainly influenced by his belief that the massive ash deposits at the site corresponded with the area where Genesis 13:12 and 19:25 locate the destruction of Sodom and Gomorrah around the Dead Sea.[16] During the late 1920s and 1930s, excavations carried out at a number of sites in Palestine brought to light strikingly similar assemblages, including those in the northern Negev Desert,[17] a cave site in the Galilee in the Wadi Shallaleh and a pottery-bearing level at the Mugharet el-Wad Cave in the Carmel Mountains, a necropolis site in Ḥadera along the coast,[18] and rich deposits at Megiddo in the Jezreel Valley,[19] Beth-Shean near the northern Jordan Valley,[20] and Jericho in the lower Jordan Valley opposite Ghassul.[21] After synthesizing these data, coupled with the discovery of unique copper "fish hooks" and copper awls in the Ghassul assemblage, William F. Albright, then director of the American School of Oriental Research in Jerusalem, suggested that the newly discovered "Ghassulian" phenomenon be referred to as the "Chalcolithic" period.[22]

By the 1950s it was clear that the Chalcolithic period was widespread and found in virtually every geographic zone in the Southern Levant (modern Israel, Jordan, the Palestinian territories, the Sinai Peninsula, southern Syria, and Lebanon). While the Chalcolithic period may have been first identified with the Ghassulian phenomena in the lower Jordan Valley, opportunistic surveys in the northern Negev Desert by Alon[23] shortly after Israel's War of Independence brought to light extensive evidence of Chalcolithic settlement on the major wadi systems, including the Wadi Be'er Sheva, Wadi Gerar, and Wadi Patish. However, it was the large-scale excavations of sites around the city of Be'er Sheva by Perrot that began to demonstrate strong regionalism in the Chalcolithic of Palestine, based on his work at Bir Ṣafadi and Tell Abu Matar.[24] Remarkable subterranean rooms and tunnel complexes came to light at the Be'er Sheva sites, and many contained copper artifacts. For

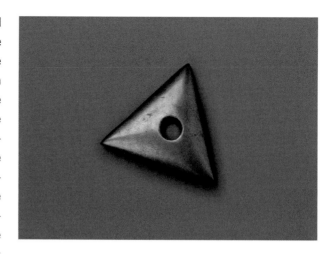

example, at Abu Matar copper artifacts included pear-shaped mace heads, pins, a cylinder, rings, and metal fragments. Initial metallurgical analyses showed that these objects were made of unalloyed copper. Fragments of malachite ore were found in all levels of the site; several kilograms of ore were found in one semisubterranean house (no. 218) near two large grinding stones with evidence of pulverized ore, leading Perrot to suggest that these were anvils used to crush the ore; the presence of small furnaces and crucibles in three areas of Abu Matar led Perrot[25] to suggest that smelting was done at the site in three different areas in specially constructed ovens associated with small crucibles.

However, the magnitude of Southern Levantine copper production and its contribution to late pre- and protohistoric archaeology in the ancient Near East did not come to light until 1961, when as part of the Judean Desert Expedition—whose initial goal was primarily to locate more Dead Sea Scrolls—Pessaḥ Bar-Adon's team surveyed the Naḥal Mishmar (Arabic: Wadi Mahras) and found an astonishing hoard containing 429 remarkable objects (see fig. 6-3). This included eighty copper standards, ten copper crowns, 240 copper mace heads (fig. 2-2), six hematite mace heads, one stone mace head, five large sickle-shaped objects made from perforated hippopotamus tusks, a concave box made of elephant tusk, and twenty copper chisels and axes.[26]

2-2: Triangular mace head. Copper, Naḥal Mishmar. IAA: 1961-121, exhibited at IMJ. Checklist no. 79.

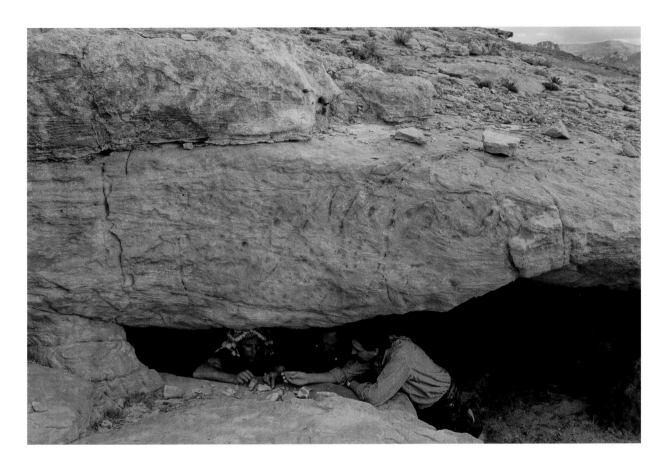

This discovery was and remains the most spectacular and impressive copper hoard dating to the late fifth–early fourth millennium to have been found in the Middle East. The pottery found with the hoard was more similar to examples found at Be'er Sheva Valley sites that Perrot had excavated than to the Ghassulian assemblage, with its characteristic elongated cornets, found at Tuleilat Ghassul.

The Naḥal Mishmar discovery has become known as the Cave of the Treasure. When the Cave of the Treasure was published in full,[27] preliminary metallurgical studies by Key[28] suggested that the high arsenic content of many of the metal objects found in the hoard (crowns, scepters, mace heads) was nonlocal. This metal came from sulphide ores, which lack zinc as a trace element, and thus could not have been made with local Southern Levantine copper ores from the Arabah Valley (fig. 2-3)—which separates modern Israel and Jordan (the Timna

and Feinan regions)—Sinai, Syria, or Cyprus. Key also noted that the elaborate objects found in the Naḥal Mishmar hoard were made with the lost-wax (cire perdue) method of casting with copper metal that came from the regions of Armenia or Azarbaijan, both of which are known for their arsenical copper ores and over 1,000 km northeast of the Dead Sea region where the hoard was discovered. While the elaborately shaped cast objects contained high quantities of arsenic, the simple "tools" such as axes and chisels were shown to be pure copper. At the time it was also not certain that local Wadi Arabah ores were used to cast the so-called tools. Interestingly, one standard (no. 80, reg. no. 61-52) was identified as made of pure copper. While the ornate objects made primarily with arsenical alloys were cast with the lost-wax method, the "tools" were cast in open molds with a different technology, suggesting to Key[29] that there may have been two different kinds of workshops—one for secular

2-3: A shallow mine excavated by Chalcolithic miners in the Wadi Khalid, Feinan, Jordan. Left to right: experimental archaeologists Thomas Levy, Mohammad Najjar, and Andreas Hauptmann.

"tools" and one for ritual objects. However, it was not until the late 1970s and early 1980s that the social significance of this metallurgical revolution came to light for the Chalcolithic period. The present essay concludes by examining this issue in relation to the role of craft production in general for Chalcolithic societies.

The Rise of Regional Polities

If one looks at the distribution of archaeological sites through time in the Southern Levant, the first "population explosion" occurred in the Chalcolithic period. This can be measured by an increase in both the number of sites and the growth in the size of settlements in different geographic regions. Data for this come from the large number of archaeological surveys carried out since the 1930s in the full range of geographical zones in the region, especially in areas that had very little occupation evidence in the preceding Neolithic period. At the apex of Neolithic settlement in the Southern Levant, the middle to late Pre-Pottery Neolithic (PPN) B–period (ca. 10,500–8,900 cal BP), large village settlements existed on the order of up to 5 ha.[30] These large sites, most of which have been documented in Transjordan, can best be described as autonomous village settlements. While preservation is impressive, there is little evidence for social hierarchy. Instead, as Twiss[31] points out, there is "escalating social regimentation" reflected in increasing architectural elaboration that may be related to a transition from the nuclear to the extended family as the principal social organization through the PPNB and PPNC periods.[32] On the eve of the Chalcolithic period, during the Pottery Neolithic period (ca. 6000–5300 BCE), while there are a handful of relatively large sites,[33] there is a general impoverishment in the level of pyrotechnology control (as seen in the widespread production of lime in the PPNB period) and other aspects of the material culture. Compared with the PPNB, the general pattern of Pottery Neolithic settlement is defined by small, scattered farmsteads and villages with poorly constructed architecture, ad hoc lithic production, and rather poorly fired pottery assemblages. Major surveys that have produced significant Chalcolithic-settlement pattern data have been carried out in the northern Negev;[34] the upper and lower Jordan Valley;[35] the Beth Shean Valley;[36] the Israel coastal plain;[37] the Golan Heights;[38] and other regions.

The northern Negev Desert was perhaps the most densely settled area during the Chalcolithic period, with subregional cultural groups living along different seasonal river beds (wadis). Settlement-pattern data collected along the Wadi Be'er Sheva show a two-tier settlement hierarchy with four large village centers, each over 10 ha in size and surrounded by smaller satellite sites.[39] Many of these sites have been the focus of large-scale excavations, providing rich data sets to investigate the nature of Chalcolithic societies. These centers include, from east to west: Nevatim,[40] Bir Ṣafadi,[41] Shiqmim,[42] and Ẓe'elim.[43] A similar two-tier settlement hierarchy was identified along the Naḥal Patish, approximately 15 km north of the Be'er Sheva Valley.[44] The largest site on this drainage was Gilat, an area of roughly 10 ha that has also been extensively excavated.[45] On the Naḥal Gerar a similar hierarchical settlement pattern exists,[46] with Gerar dominating the drainage.[47] As I have argued before,[48] the rank-size distribution of settlement along the Be'er Sheva Valley is clear indication of the emergence of a regional polity stretching over 40 km along the drainage system, with centers that functioned as social, religious, and economic centers of redistribution—what anthropologists refer to as chiefdom-level societies.[49]

According to Bourke,[50] the recent excavator of Tuleilat Ghassul, the settlement-pattern situation in the lower Jordan Valley is equivocal in terms of hierarchy. Although Tuleilat Ghassul is approximately 20 ha in size, for Bourke[51] the size of sites is correlated to the size of the available floodplain areas suitable for farming around settlements. He points

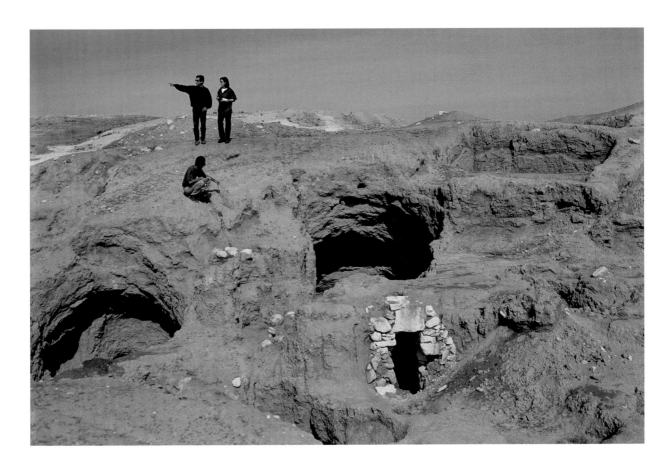

out that 90 percent of the sites in the lower Jordan Valley are less than 2 ha in size. Local land resources may indeed be a factor that influenced site size, perhaps highlighting multicausal factors that promoted social inequality in settlement at this time.

In the Be'er Sheva Valley a unique settlement system evolved at village sites up and down the drainage system. Sites with networks of underground room-and-tunnel complexes formed "human ant farm–like" dwellings that characterized the earliest settlement in the valley, sometime between about 4500 to 4000 BCE. Scholars debate the function of these enigmatic subterranean features and suggest they may have been used as houses, for defense, for storage, or for combinations of these. First discovered by Perrot at Abu Matar and Bir Ṣafadi around Be'er Sheva in the early 1950s, these subterranean features were also identified at Ḥorvat Betar and more recently at Shiqmim (fig. 2-4), some 16 km

downstream.[52] At Shiqmim geophysical investigations led by Witten demonstrated with geophysical diffraction tomography (GDT) that the underground complexes literally honeycombed the site.[53] Ground-truth tests confirmed this and showed that many were used for storage and probably facilitated the principle of "staple-finance" in the redistributive chiefdom economy at Shiqmim. Accordingly, chiefs would collect foodstuffs such as barley and wheat and redistribute it at times of need, resulting in enhancement of their power.[54] In the late stages of Chalcolithic settlement in the Be'er Sheva Valley, new well-planned open-air village settlements were established that continued to use the subterranean complexes. Finally, some of the large (10 ha or more) Chalcolithic settlements in both Jordan and Israel, such as Tuleilat Ghassul and Gilat, were also the loci of the emergence of some of the earliest temple complexes in the Southern Levant. This was a process that took place during the Chalcolithic period

2-4: Selection of subterranean rooms, with ceilings removed, that were part of an underground complex similar to a "human ant farm" (note the three people standing on the site surface for scale).

and an indication that the sacred and profane should not be separated when examining the role of chiefdoms in Levantine society during this formative period.

Regional Temples

While the earliest temple in the Near East has been discovered in Turkey at Göbekli Tepe and dates to the early Neolithic period,[55] the situation for the establishment of Neolithic temples in the Southern Levant is equivocal.[56] However, it is possible to identify three sites dating to the Chalcolithic period with unequivocal data indicating that they functioned as panregional ritual centers. These include: Gilat in the northern Negev Desert,[57] Tuleilat Ghassul in the southern Jordan Valley,[58] and En Gedi in the Judean Desert.[59] The growth of human population in the Southern Levant during the late fifth–early fourth millennium BCE, in addition to

changes in the socioeconomic and agro-pastoral systems, opened new opportunities for elites to use ritual and ideology to achieve, maintain, and manipulate social power. During the 1929–32 excavations at Tuleilat Ghassul, excavators found spectacular large wall murals with paintings showing what appear to be temple structures, masked individuals, and a geometric star feature.[60] Later excavations produced paintings of processions and animals.[61] According to Seaton,[62] the Area E sanctuary at Tuleilat Ghassul emerged in response to a variety of socioeconomic factors, especially those for coping with conditions of environmental stress and the uncertainties of agricultural production though the construction of storage facilities associated with the temple. I described the centrality of the development of risk-management strategies by Chalcolithic elites in the Be'er Sheva Valley chiefdom in detail in the early 1990s;[63] however, a link was made with sociopolitical activities as there was little evidence

2-5: The En-Gedi temple is located near a freshwater spring that drains through the Judean Desert on the western shore of the Dead Sea, seen here in the distance.

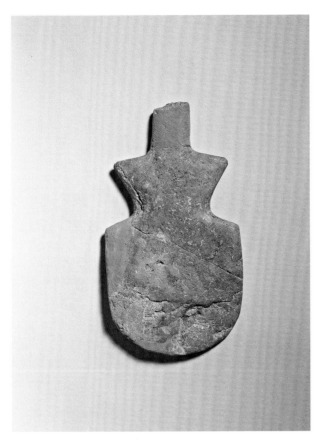

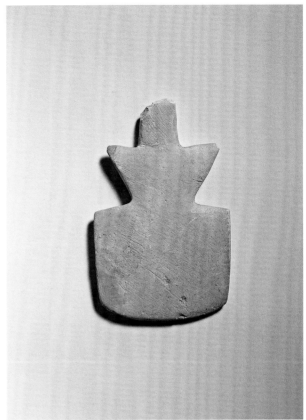

for a connection with ritual in terms of the Be'er Sheva Valley data. The temple at En-Gedi has been closely linked to its location near two freshwater springs (fig. 2-5).[64] Ussishkin closely links the Naḥal Mishmar hoard with the temple at En-Gedi, but there are no data to support this. Petrographic data from En-Gedi that have been analyzed by Goren[65] suggest that its interaction sphere was centered in the Judean Mountains, with little panregional interaction, supporting the centrality of the freshwater springs to the emergence of this ritual center. As discussed by Ilan and Rowan,[66] new discoveries have influenced interpretive models of Chalcolithic religion throughout the twentieth century.

Of the three Chalcolithic sanctuaries, Gilat has been most extensively excavated and published.[67] The wealth of portable ritual artifacts—including anthropomorphic and zoomorphic vessels, violin-shaped figurines made of stone (figs. 2-6, 2-7), human burials

surrounding the cult center, dog burials, and a ritual enclosure similar to those found at En-Gedi, Area E at Tuleilat Ghassul—as well as Early Bronze Age temples—makes Gilat a critical source for understanding the link between ritual and social organization during late prehistory in the ancient Near East. The spatial distribution of Gilat's ritual artifacts has played an important role in understanding the place of pilgrimage and production in the emergence of this northern Negev sanctuary center. By 2006 a total of 106 violin-shaped figurines were found at sites from Byblos in Lebanon to Tell Qatif in Sinai,[68] and 50 percent of these came from Gilat. A wide range of local and nonlocal rocks were used to produce these figurines, including limestone (northern Negev, ca. 20 km east of Gilat), and chalk and marl (near Lahav, ca. 20 km to the east); and sandstone, granodiorite, and talc-schist (Feinan, Timna, southeastern Sinai). However, it is not certain[69] where these figurines were manufactured. Gilat is a well-stratified site, with the main sanctuary

2-6: Violin-shaped figurine. Stone, Gilat. IAA: 1975-1041. Checklist no. 17.

2-7: Violin-shaped figurine. Stone, Gilat. IAA: 1975-1034. Checklist no. 16.

complex appearing in Stratum IIC, where Room 3 was the main locus of ritual activities, dating to 4689–3938 BCE.[70] The Gilat Lady and Gilat Ram were found in this room along with 42 percent (n=19) of the violin-shaped figurines from this stratum, most of them complete specimens. Room 3 has been interpreted as a "holy of holies" with only limited access, presumably to elites in charge of the sanctuary. There is a fall-off pattern, with the largest, best-preserved figurines housed in this room suggesting their value as rare ritual objects. According to the Gilat study, earlier Pottery Neolithic figurines may have presented a dual-gendered system, whereas Chalcolithic violin-shaped figurines appear to symbolize a unique, perhaps "hegemonic (female) entity."[71] As males seem to be ascribed with the most wealth when it comes to burial at sites such as Shiqmim, Nahal Qanah, and the Cave of the Warrior (fig. 2-8), there may have been multiple gendered pathways for religious identity and social status in Chalcolithic societies.

While there are only a handful of sanctuary sites dating to the formative Chalcolithic period, they are all physically related to natural resources. As noted above, En-Gedi is critically situated near rare freshwater springs in the Judean Desert; and the sanctuary at Tuleilat Ghassul, located on a rich alluvial plain connected to farming activities, played a key role in risk-management strategies. Similarly, Gilat was located in an ecotone setting where the relatively rain-rich Negev coastal plain meets the more arid northern Negev foothill zone. Gilat's unique location controlled access to the annual grazing lands along the coastal plain, helping to explain the wealth of imported artifacts found there that demonstrate interaction with the southern Judean foothills and many of the more arid zones in the Negev and Transjordan. In addition to the exchange of nonlocal rocks used for violin-shaped figurines and palettes (fig. 2-9), unique pottery vessels used to store olive oil were brought to Gilat as offerings.

2-8: View onto the Chalcolithic caves by Wadi el-Makukh, in the Judean desert. The entrance to the Cave of the Warrior is in the foreground. (Photo Thomas E. Levy)

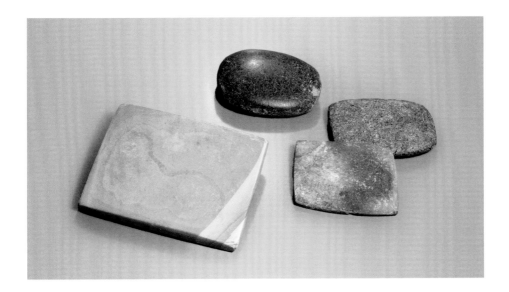

These rare objects and materials, together with lipid analyses of the unique "torpedo" jars used to store olive oil,[72] indicate that Gilat was a center of pilgrimage and interconnection with different regions. The large number of human burials in different strata at the Gilat sanctuary[73] also points to its importance as a sacred center that functioned like the tombs of saints in different periods in the Negev and throughout the Middle East.[74] Finally, the main iconographic representations at the site, the Gilat Woman with a large churn on her head and the Gilat Ram with cornet cups embedded in its back, reflect concerns with milk and herd fertility and help to explain the growth and maintenance of this northern Negev sanctuary.[75] What then were some of the changes in agro-pastoralism that led to more general Chalcolithic concerns with insuring the fecundity and stability of the subsistence base throughout the Southern Levant during the late fifth–early fourth millennium BCE?

Agro-Pastoralism Developments— Amplification and Consolidation

Several decades ago, I suggested that a "secondary products revolution" took place during the Chalcolithic period in the Southern Levant.[76] According to Sherratt,[77] during approximately this same period throughout southern Europe and the Near East, this was the first time the secondary products of domestic herd animals were exploited for their hair, wool, milk, and traction. This development represents a radical shift from earlier Neolithic consumption patterns, which focused mostly on using animals for meat products. Archaeozoological studies support the view that the "package" of herd-management strategies aimed at maximizing milking were much like those of contemporary herders in the Middle East.[78] More recent research, especially molecular analyses of lipids found in Neolithic ceramics from around the Middle East, show that systematic-milking animals (based on reduced lactose concentrations reflecting production of cheese or yogurt) occurred earlier than the Chalcolithic period.[79] However, Sherratt's notion of the secondary products revolution was indeed a "package deal" that went beyond the "milk revolution" that has now been documented as occurring earlier in the Pottery Neolithic period. For example, large-scale agro-pastoral settlement began for the first time during the Chalcolithic period in the more arid, trough-shaped valleys of the northern Negev, far from the annual grazing lands of the Negev coastal plain,[80] pointing to transhumance-herding practices more specialized than those in the preceding Neolithic. The centrality of the churn in both Be'er Sheva (fig. 2-10) and Ghassulian ceramic

2-9: Palettes. Limestone (1), stone (1), and granite (2), Abu Matar and Gilat. IAA: 1958-578, 1975-1044, 1975-1046, 2000-1844. Checklist nos. 14, 18, 19, 27.

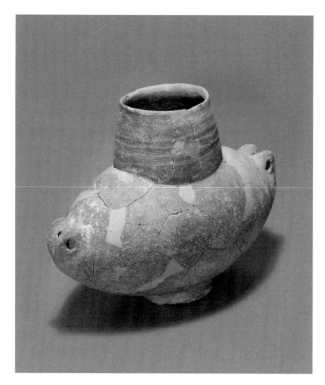

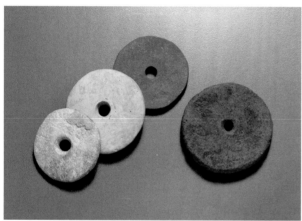

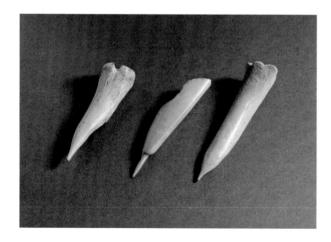

assemblages is another indicator of the consolidation of milking and milk production in the Chalcolithic.[81] The intensification of textile production is also evidenced during the Chalcolithic period based on widespread spindle-whorl (fig. 2-11) and weaving finds (fig. 2-12) from sites throughout the Southern Levant.[82]

New developments in agriculture also crystallized during the Chalcolithic period. According to Weiss,[83] while wild olives (*Olea europaea*) were certainly collected before they were domesticated, as early as the Epipaleolithic (ca. 22,000 BP–9,500 BCE) and during the Neolithic periods (9500–4500 BCE)],[84] definite signs of olive domestication come first from Chalcolithic sites in Israel and Jordan, such as Tuleilat Ghassul,[85] Tel es-Saf,[86] Tell esh-Shuna North, and Tell Abu Ḥamid.[87] The date palm (*Phoenix dactylifera L.* [Palmae]) is one of the first fruit trees brought into domestication in the Old World, and this too first appears in the archaeological record at Tuleilat Ghassul.[88] High temperatures, rainless summers, and very low humidity around the Dead Sea were perfect for desert horticulture. The first small-scale terrace farming systems, suitable for growing fruit trees, were identified in the Negev Desert at Shiqmim.[89] In addition, larger-scale diversion walls that could be used in the main Wadi Be'er Sheva drainage were also recorded. Thus, the Chalcolithic period saw the crystallization of today's Mediterranean agro-pastoral system, with the intensification of the exploitation of secondary animal products, different kinds of terrace farming, and horticulture. As described above, the ramifications of these changes were also seen in Chalcolithic iconography and ritual practice.

Regional Cemeteries, Regional Polities

The earliest cemeteries with grave goods in the Levant have now been dated to over 16,500 years ago, during the Epipaleolithic period.[90] However, widespread use of cemeteries on a regional scale, many of them isolated from habitation sites, became prevalent during the Chalcolithic period.

2-10: Miniature churn. Clay, Peqi'in. IAA: 2007-2133. Checklist no. 40.

2-11: Spindle whorls. Clay (1) and stone (3), Rasm Ḥarbush and Patish (Gilat). IAA: 1975-1061, 1975-1064, 1975-1065, 1981-3009. Checklist nos. 139–41, 143.

2-12: Awls (3). Bone, Bir Ṣafadi. IAA: 2007-1598, 2012-782, 2012-1621. Checklist nos. 153–55.

Chalcolithic cemeteries often reflect links to regional polities that developed in different environmental zones throughout the Southern Levant.[91] Chalcolithic burial practices vary widely. Along the coastal plain in the kurkar ridges and in the hills of Galilee, burial caves such as that at Peqi'in have been found with numerous clay ossuaries, constructed mostly in large rectilinear and jar forms and decorated with applied and painted anthropomorphic and zoomorphic designs.[92] Caves such as Naḥal Qanah have been found with rich burial offerings, including the assemblage of gold rings associated with an elite male. At Shiqmim[93] an extensive burial ground stretching for over a kilometer was found with numerous circular monuments that included multiple burials with grave offerings, including V-shaped bowls, fan scrapers, jewelry, and other objects (see fig. 1-12). Embedded in this cemetery were many semisubterranean paved and stone-lined cist graves. The Gilat sanctuary had a wealth of human burials in and around the sanctum sanctorum that may reflect the site's use both as a sanctuary and for mortuary rituals by the local inhabitants and/or pilgrims to the site.[94]

Newly discovered Chalcolithic cemeteries have come to light mostly as a result of emergency excavations undertaken because of the massive national road and security construction activities carried out throughout Israel and the Palestinian territories since the Oslo Accords initiated in 1993. At Ḥorvat Qarqar South, some 8 km southeast of Qiryat Gat bordering the northern Negev, a series of caves with different burial assemblages, doves, and gazelles have been excavated by Peter Fabian and Isaac Gilead, and described by Scheftelowitz.[95] On the coastal plain 15 km east of Tel Aviv, Milevski[96] excavated eight burial caves around Qula and found a unique male fertility figurine inside a ceramic ossuary in Cave K-1. The head and face are similar to anthropomorphic motifs from Shiqmim and from Peqi'in Cave in the Upper Galilee. This type of iconographic find highlights the "transregional" aspects

of some Chalcolithic ideological systems, much like the violin-shaped figurines found throughout the Southern Levant. Further north on the coastal plain, Avrutis[97] excavated a Chalcolithic cemetery near the quarries around Ramla. The Chalcolithic excavations northeast of Kibbutz Palmaḥim, some 20 km south of Tel Aviv, continue to reveal extensive mortuary monuments, including massive undisturbed rectangular and circular enclosures with different kinds of interments. This "necropolis" had many standing stones and stone ossuaries, and included both the stone-built round or oval structures found in the northern Negev and Transjordan as well as natural burial caves typical of the central coastal plain and Shephelah—a region delineated by the Ḥadera and Soreq river systems.[98] Palmaḥim includes a unique type of ossuary system referred to as a Jacob's Ladder—these are mostly semisubterreanean rectilinear stone-slab-lined installations, two to four in number, that are attached to each other and contain the bones of the deceased. In general, regional Chalcolithic cemeteries, whether visible on the surface or underground, demonstrate an effort to mark territory and recognize social rank within the regional polities that buried their dead at these sites, through investment in the construction of burial facilities (graves and ossuaries) and the differential allotment of grave goods.

Conclusion: Amplification in Craft Specialization

The Chalcolithic period witnessed a boom in craft production that focused on a wide range of materials, including ivory (see page 41),[99] lithics,[100] ground stone,[101] ceramics,[102] and metal. Over the past two decades, there has been increasing attention to the context in which artifacts are found, the acquisition of raw materials, production systems, use and reuse of objects, distribution of finds, and their deposition in the archaeological record—most often referred to as the *chaîne opératoire*[103]—for understanding technological systems. The aim of these studies is to use technology as a lens for investigating the

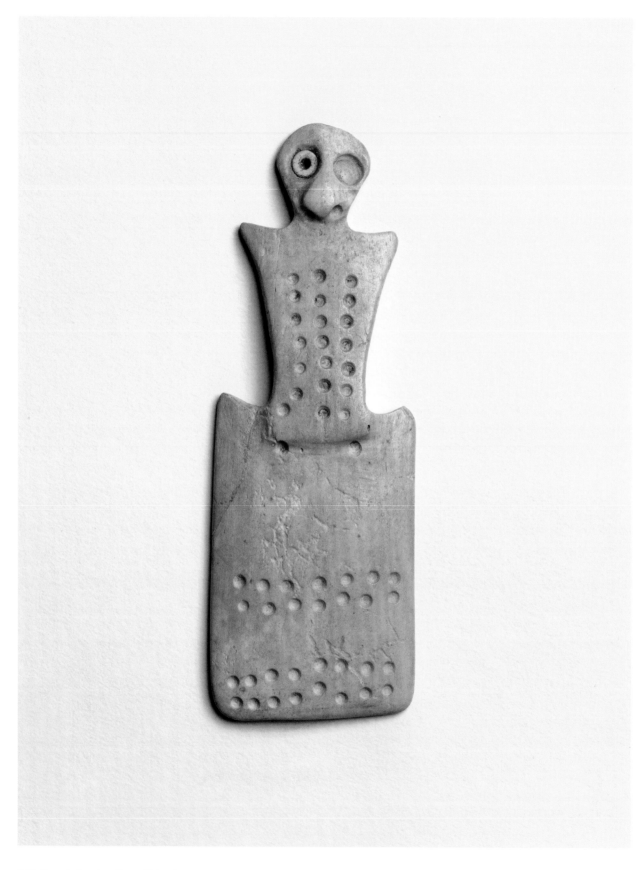

2-13: Female figurine. Bone, Shiqmim.
IAA: 1996-3495, exhibited at IMJ.
Checklist no. 6.

social and cultural dimensions of Chalcolithic societies. What is interesting about Chalcolithic craft production compared with earlier periods is the flowering of technological and artistic expression during this formative period using so many kinds of materials—flint (fig. 2-15), ground stone from a variety of rock types, clay, ivory, and of course metals. While control of the *chaîne opératoire* of metal production can be directly linked to a hierarchical elite, less structured control may have operated within other realms of material culture. This debate is reflected in the analysis of the Beit Eshel flint workshop near Be'er Sheva.[104] In closing, we will consider how studies of Chalcolithic metallurgy have informed researchers about social evolution during the late fifth–early fourth millennium BCE.

The metal revolution noted above was played out primarily in southern Israel and Jordan near copper-ore sources in the Arabah Valley (Feinan and Timna). Its emergence coincided with the development of craft specialization using other materials. This included the production of Be'er Sheva ivories, exquisite basalt vessels and "pillar figurines" found in the Golan Heights, violin-shaped figurines made of a variety of rock types and found at settlements in the Negev and Galilee (figs. 2-13, 2-14, 2-15, 2-16), V-shaped bowls made on the "slow wheel" for mass production in the northern Negev and Judean deserts, and even specialized pastoralism and arid land agriculture methods, as noted above. After more than twenty years of survey and excavation throughout the Southern Levant, it still appears that smelting in workshops was controlled mostly by the Chalcolithic polity in the Be'er Sheva Valley. Archaeometallurgical studies by different researchers have demonstrated through lead-isotope and other studies that copper from Feinan was mined there and transported to the workshops in northern Negev settlements such as Shiqmim, Bir Ṣafadi, and Abu Matar, with no evidence of workshops near the copper mines.[105] This northern Wadi Arabah production "monopoly" seems to be mirrored in southern

Arabah at the recently excavated site of al-Magass near Aqaba, which imported copper from Timna, about 40 km to the northwest.[106] Feinan is the largest copper-ore source in the Southern Levant, and by controlling access to it, the Be'er Sheva polity used the distribution of copper objects to create a system of "social debt"[107] that promoted the growth and stability of the chiefdom there.[108]

As noted above, two systems of prestige and utilitarian copper-object production were defined over thirty years ago based on the distinction between the inclusion of high-arsenical copper in complex castings.[109] Based on ethnoarchaeological research directed by the author among hereditary bronze casters in southern India,[110] it is possible to hypothesize that beeswax was a critical part of the lost-wax method used during the Chalcolithic period. The development of the lost-wax method of casting in the Southern Levant may also be connected to the beginnings of horticulture described above. Recent molecular analyses of Chalcolithic cornets from five sites suggest that they contained beeswax.[111] These data coincide with the metallurgical revolution that occurred in the Southern Levant and that may have helped facilitate the development of the lost-wax method of casting and copper specialization.

As Shugar[112] recently pointed out, it is now clear that complex castings were occasionally produced with relatively pure copper, especially late in the period. An experimental archaeology project led by the author[113] that involved the extraction of copper and its transport over 150 km from the Feinan copper-ore source to the Be'er Sheva Valley supports Shugar's observation. The experiment showed that to produce 10 g of copper would have taken an hour. Therefore, to produce enough copper for a 350-g axe like those found at Shiqmim and other Chalcolithic sites, it would have taken thirty-five hours of smelting time. If charcoal production, furnace and crucible construction, casting, and finishing is added to the production process, it would

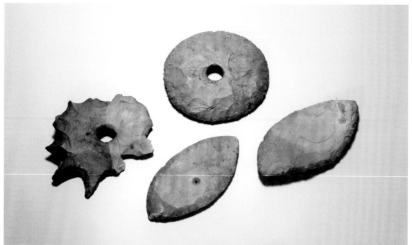

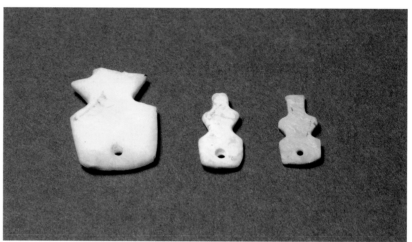

2-14: Violin-shaped pendant. Shell, Peqi'in. IAA: 1982-1412. Checklist no. 21.

2-15: Mace heads (4). Flint, Rasm Ḥarbush and Majami-El. IAA: 1987-1523, Checklist no. 109. IAA: 1987-1526, Checklist no. 110.

2-16: Violin-shaped pendants. Stone (2) and turquoise (1), Peqi'in. IAA: 2005-1309, 2005-1310, 2005-1312. Checklist nos. 29–31.

have taken well over fifty hours to produce a single copper axe. Given the relatively small number of copper axes as compared to flint bifacial tools (ca. 1:250) at Shiqmim, it seems that even the objects archaeologists define as "utilitarian" axes and adzes were probably embedded with high social value (fig. 2-17). This supports the idea that even Chalcolithic axes and adzes defined as "utilitarian" were in fact part of the wealth finance system. While some utilitarian tools were made during this period (for example, pins and awls), the metals industry (for pure copper, alloyed copper, and gold) was primarily aimed at producing symbolic and high-value objects that supported the growth and maintenance of newly emergent rank societies in the Southern Levant. Thus, the Chalcolithic period saw the amplification of craft production, agro-pastoralism strategies, ritual centers, regional polities, and social change that had their beginnings in earlier periods and now marked the consolidation of the Mediterranean economy and social structure that remains in place today in the region. This was not a monolithic process that happened in every geographic zone of the Southern Levant. Some regions, such as the Be'er Sheva Valley and the southern Jordan Valley, became the locus of chiefly centers that utilized principles of social debt and economic principles based on staple and wealth finance to make the transition to social inequality. Once this transition was put in place, by the early fourth millennium BCE, there was no returning to the kinds of egalitarian social organization that characterized the Neolithic and earlier periods.

There remain many puzzles concerning the Chalcolithic period. With advances in high-precision radiocarbon dating, especially with the application of Bayesian statistics,[114] tighter stratigraphic control of excavations, and micro-archaeological techniques,[115] and the use of cyber-archaeological methods of data recording, analyses, curation, and dissemination,[116] it will be possible to glean more data from the archaeological record and to more precisely test cultural models concerning this formative period.

The collapse of Chalcolithic societies in the Southern Levant cannot be ascribed to a single factor. Instead, a variety of factors, not all happening at the same instant or location, worked together to create a "perfect storm" for social collapse. Burton[117] has dealt with this problem by examining changes in the organization of ceramic production from the Chalcolithic to the beginning of the following Early Bronze Age. In my own work,[118] I have suggested a web of processes that worked together to promote societal collapse. These include:

- Deterioration in climate based on geomorphological studies. Several geomorphological studies have tracked the onset of drier conditions at the end of the Chalcolithic period that would have been deleterious to subsistence systems.[119]
- Attenuation of the sociopolitical organization. Joffe[120] first pointed out that the Negev Chalcolithic sociopolitical system, which was rich in symbols, focused on territoriality, and engaged in the procurement of rare minerals and goods for local elites, was so tightly stretched across the Wadi Arabah and other regions that any systemic disruption in resource procurement or substance production could damage the entire society.
- Commercialization. Increasing links with Predynastic Egypt were expanding, and this may have further contributed to social change and eroded the debt-based Chalcolithic social system.
- Finally, warfare. As the end of the Chalcolithic period approached, the number of weapons, particularly maceheads (fig. 2-18), increased. Mace heads appear in exponential numbers during the Chalcolithic period. This tendency toward violence and warfare is also apparent through evidence of interpersonal violence on human remains, pointing to an increase in hand-to-hand combat.[121]

Recent radiocarbon studies of both the Chalcolithic and succeeding Early Bronze I period show that the

2-17: Chisel. Copper, Shiqmim.
IAA: 1982-1652. Checklist no. 147.

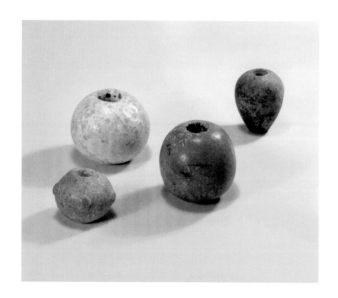

gap between these two periods was much smaller than previously assumed.[122] This means that while the societies we call "Chalcolithic" collapsed, the technological and social achievements of the period were never lost. What exactly the process of transmission was from one period to the next is an intriguing question for future research. However, it is clear that the socioeconomic achievements of the Chalcolithic period helped to lay the foundations for the rise of urbanism in the third millennium BCE.

2-18: Polished mace heads. Stone (1)
and limestone (3), Abu Matar, Bir Ṣafadi,
Peqi'in, and Kibbutz HaZore'a.
IAA: 1991-351, 1994-1199, 1994-1200,
2005-1317. Checklist nos. 99–102.

Notes

Special thanks to Kenneth Garrett for the use of
his photographs in this essay, and to Yorke Rowan
for commenting on an early version of this paper.
I am grateful to Ianir Milevski for his thoughts on
contemporary research concerning the Chalcolithic
period. However, all views expressed here are the
responsibility of the author.

1 Levy 2007.
2 Levy 1986; Rowan and Golden 2009.
3 Golden, Levy, and Hauptmann 2001; Hauptmann
 2007; Hauptmann, Khalil, and Schmitt-Strecker
 2004.
4 Kislev 1987; Rosen 1987.
5 Namdar et al. 2009.
6 Davidovich et al. 2013.
7 Burton and Levy 2001.
8 Levy 1987a; Levy 1995; Levy 2006c; Levy 2007.
9 Gilead 1988; Gilead 1995; Winter-Livneh, Svoray,
 and Gilead 2010.
10 Marcus 2008.
11 Carneiro 1981, 45.
12 Flannery 1999.
13 D'Altroy and Earle 1985.
14 Mallon 1932b; Mallon, Koeppel, and Neuville 1934;
 King 1983.
15 Neuville 1930a; Neuville 1930b.
16 Mallon 1932a.
17 Macdonald, Starkey, and Lankester-Harding 1932.
18 Sukenik 1937.
19 Engberg and Shipton 1934.
20 Fitzgerald 1935.
21 Garstang 1935.
22 Albright 1931; Albright 1932; Levy and Freedman
 2009.
23 Alon 1961.
24 Perrot 1955; Perrot 1968.
25 Perrot 1955, 79–80.
26 Bar-Adon 1962; Bar-Adon 1980.
27 Bar-Adon 1980, 201.
28 Key 1980.
29 Ibid., 240.
30 Kuijt 2000; Twiss 2007; Rollefson 2008.
31 Twiss 2007, 29.
32 Flannery 2002; Banning 2003.

33 Garfinkel and Miller 2002. According to Garfinkel,
 the Sha'ar Hagolan is 20 ha in size, which makes
 it as large as Tuleilat Ghassul. However, the aver-
 age size of Pottery Neolithic sites is probably much
 smaller, as highlighted by the large-scale research
 project at the sites along the Nahal Zehora, such as
 Nahal Zehora I, which is 5 to 8 dunams, or 0.5 to 0.8
 ha; see Gopher 2012, 56.
34 Alon and Levy 1980; Levy 1981; Levy and Alon
 1987.
35 Stekelis 1935; Perrot, Zori, and Reich 1967; Dollfus
 and Kafafi 1986; Gophna and Sadeh 1988/89; Doll-
 fus and Kafafi 1993; Bourke 2001.
36 Tsori 1958.
37 Gophna 1974; Gophna 1979; Gophna 1989.
38 Epstein 1977; Epstein 1998.
39 Levy, Burton, and Rowan 2006.
40 Gilead and Fabian 2001.
41 Perrot 1956; Eldar and Baumgarten 1985; Com-
 menge-Pellerin 1990.
42 Levy and Alon 1985b; Levy 1987a; Witten et al.
 1995.
43 Cohen 1972.
44 Alon 1961.
45 Alon and Levy 1989; Levy, Burton, and Rowan
 2006.
46 Alon 1961.
47 Gilead 1989; Gilead 1995.
48 Levy 1995.
49 Earle 1997.
50 Bourke 2001, 213.
51 Ibid.
52 Perrot 1955; Perrot 1956; Dothan 1959; Levy et al.
 1991.
53 Witten 1995; Witten 2006.
54 Levy 1992.
55 Curry 2008; Flannery and Marcus 2012.
56 Rollefson 2000; Levy 2005; Rollefson 2005; Banning
 2011.
57 Levy 2006b; Levy et al. 2006.
58 Seaton 2008.
59 Ussishkin 1980.
60 Mallon, Koeppel, and Neuville 1934.
61 Cameron 1981.
62 Seaton 2008, 168–74.
63 Levy 1993.
64 Ussishkin 1980.

65 Goren 1995.

66 Ilan and Rowan 2012.

67 Levy and Burton 2006.

68 Commenge et al. 2006.

69 Levy and Burton 2006.

70 Levy et al. 2006.

71 Commenge et al. 2006, 794.

72 Burton and Levy 2006.

73 Smith et al. 2006.

74 Bilu 2006; Marx 2006.

75 Alon and Levy 1989; Levy, Burton, and Rowan 2006; Levy 2006b.

76 Levy 1983.

77 Sherratt 1981.

78 Grigson 1987a; Grigson 1987b; Grigson 1995; Grigson 2006.

79 Evershed et al. 2008; Curry 2013.

80 Levy 1983.

81 Amiran 1970; Garfinkel 1999.

82 Bar-Adon 1980; Schick 1998; Levy et al. 2006.

83 Zohary, Hopf, and Weiss 2012.

84 Stern 2009.

85 Zohary and Spiegel-Roy 1975.

86 Gophna and Kislev 1979.

87 Neef 1990.

88 Zohary and Spiegel-Roy 1975.

89 Levy and Alon 1987.

90 Maher et al. 2011.

91 Stekelis 1935; Levy and Alon 1985b; Gal, Smithline, and Shalem 1997; van den Brink 1998; Goren and Fabian 2002; Gorzalczany 2006; Golani and Naggar 2011; Rowan and Ilan 2013.

92 Perrot 1965.

93 Levy and Alon 1985a.

94 Levy et al. 2006; Smith et al. 2006.

95 Scheftelowitz 2012.

96 ˋMilevski 2002.

97 Avrutis 2012.

98 Gorzalczany 2006.

99 Perrot 1964; Levy and Alon 1992.

100 Rosen 1983; Rosen 1989; Davidzon and Gilead 2009.

101 Philip and Williams-Thorpe 2001; Bar-Yosef Mayer et al. 2004; Rowan et al. 2006; Rowan and Ebeling 2008; Rutter and Philip 2008.

102 Commenge-Pellerin 1990; Roux 2003.

103 Edmonds 1990.

104 Davidzon and Gilead 2009.

105 Hauptmann 2007; Golden 2009.

106 Khalil and Eichmann 2001; Pfeiffer 2009.

107 Gosden 1989.

108 Levy 1995.

109 Key 1980; Levy and Shalev 1989; Shalev 1991.

110 Levy et al. 2008.

111 Namdar et al. 2009.

112 Shugar and Gohm 2011.

113 Levy 2007.

114 Bronk Ramsey 2009.

115 Weiner 2010.

116 Levy 2013.

117 Burton 2004.

118 Levy 1995.

119 Goldberg and Rosen 1987; Cordova 2007; Rosen 2007.

120 Joffe 1993.

121 Bar-Adon 1980; Sebbane 1998; Dawson, Levy, and Smith 2003.

122 Burton and Levy 2001; Regev et al. 2012.

Imagery in the Chalcolithic Period

Dina Shalem
Institute for Galilean Archaeology, Kinneret College

Anthropomorphic stand with horns
and bearded face. Basalt, Rasm Ḥarbush.
IAA: 1987-911, exhibited at IMJ.
Checklist no. 36.

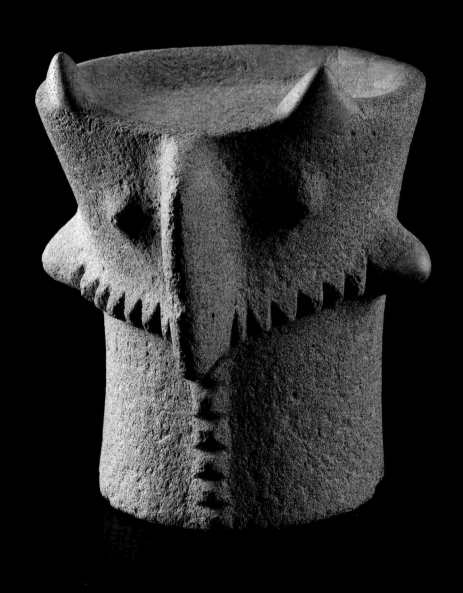

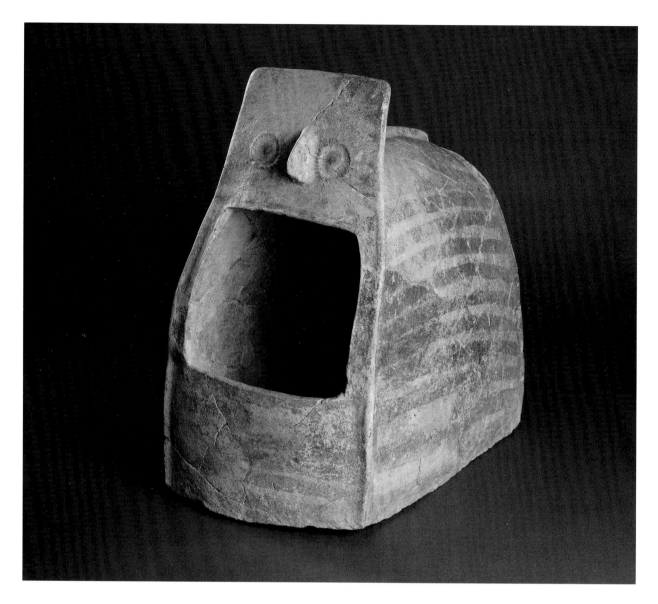

Richly decorated artifacts represent one of the most important characteristics of the Late Chalcolithic period, testifying to the complex spiritual life of the people during this period in the Southern Levant. Motifs include sculpted and/or red-painted anthropomorphic, zoomorphic, geometric, floral, and other symbolic designs.[1] These designs are ubiquitous but reflect certain regional features.

Ossuaries

Imagery from the Chalcolithic period is primarily characterized by facial features consisting of a large and often exaggerated sculpted nose and a pair of large, usually round, open eyes. These features are known, first and foremost, from the facades of ceramic ossuaries on which two distinguishing elements of the Chalcolithic period—secondary burial and anthropomorphic features—meet. The faces of these mysterious images were sculpted and painted on the upper parts of the facades of ossuaries, and less often on burial jars, suggesting that the ossuaries were their bodies. Sometimes the "faces" were represented solely by a nose, but often eyes

3-1: Painted anthropomorphic ossuary with sculpted nose, stamped eyes, and gaping mouth. Clay, Taiyiba. IAA: 1990-1129, exhibited at IMJ. Checklist no. 64.

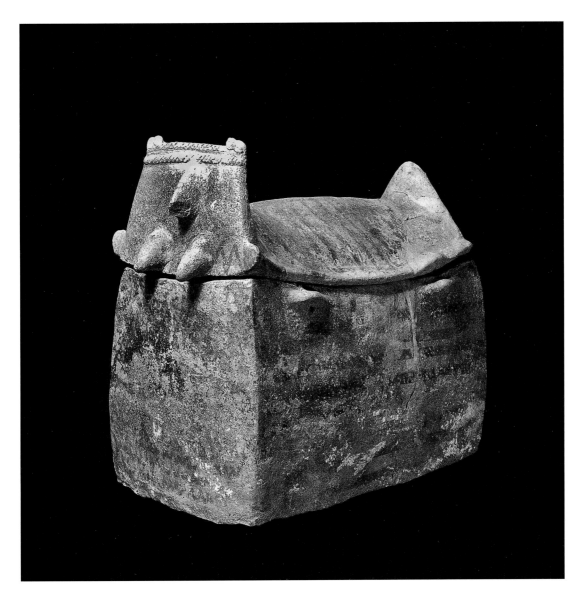

were added (fig. 3-1). Facial features were sometimes accompanied by female breasts, and the body of the ossuary was at times painted with geometric designs representing clothes, body painting, or perhaps tattoos (fig. 3-2). In the most elaborate examples from Peqi'in in the Upper Galilee,[2] sculpted and red-painted anthropomorphic features include female breasts, a pair of eyes, noses with nostrils, mouths with teeth, beards indicating male images, hair, and even arms and hands, as well as tails suggesting zoomorphic images.

Attribution of gender to the images on the ossuaries is not always certain. Ossuaries and jars bearing clear breasts obviously represent female images (fig. 3-3). But a careful examination of the ossuaries within the context of the iconography of other objects (see the discussion of violin-shaped figurines below) hints that the presentation of a female image did not necessarily include explicit breasts. One specific type of female ossuary has a fan-shaped head in which a sculpted nose and a pair of usually small eyes are depicted (fig. 3-4). The examples from Peqi'in also have a wavy upper edge with cut marks that probably represent hair. Below the fan shape are sculpted female breasts. It is interesting to note that this type of ossuary, with its particular characteristics, was used in many of the

3-2: Female ossuary. Peqi'in. IAA.

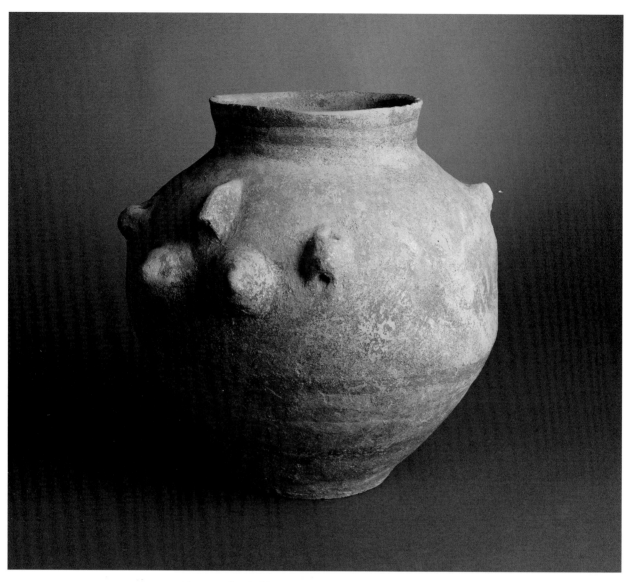

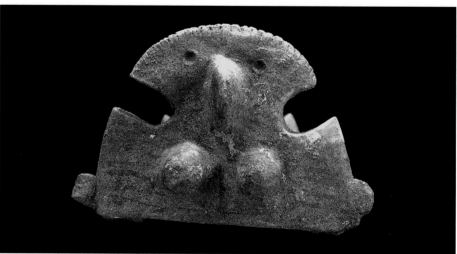

3-3: Burial jar with sculpted nose
and female breasts. Clay, Peqi'in.
IAA: 2007-1692, exhibited at IMJ.
Checklist no. 71.

3-4: Lid of a fan-shaped ossuary.
Clay, Peqi'in. IAA.

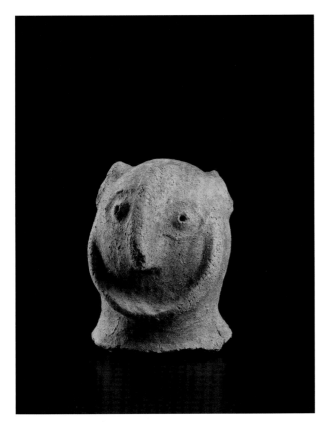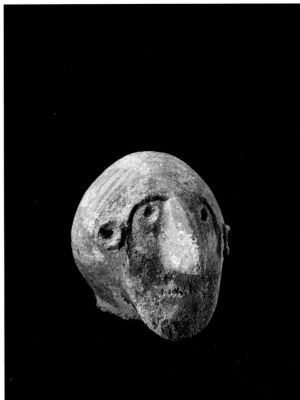

burial caves. Hence it is most likely that this was a widely known image specifically represented in burial cultic contexts.

While ossuaries never bear genitals, male images can nonetheless be recognized by a sculpted and/or painted beard, which may also represent power and/or divinity (fig. 3-5). Two unique three-dimensional sculpted heads were discovered at Peqi'in. One has a huge nose, small eyes, large round ears, and a sculpted beard (see figs. 3-5, 5-5). The rear of the head was painted with a net pattern that probably indicates a headdress. The second head has a flat face, as if it wears a mask, with small eyes, a large nose, a mouth with teeth, and a sculpted painted beard, as well as a pair of ears and painted hair (fig. 3-6). Noteworthy is the fact that some features—mouths, teeth, ears, nostrils—are shown solely on male ossuaries (although nostrils are also depicted on zoomorphic ossuaries). It is possible that the absence of mouths may be explained by the fact that female figurines also lack that feature. A striking ossuary that may present a masked male

image (fig. 3-7) has a sculpted nose and large, round, wide-open, painted eyes with eyelashes, as well as a large, round, open mouth with teeth, a beard, and painted lines surrounding the face.

In some instances identical or very similar ossuaries were purposely placed next to each other in the Galilean Peqi'in Cave. Two of the ossuary pairs from Peqi'in have arms that include hands with fingers. One pair represents males with the arms along the body and the hands on the hips. The second pair represents females with breasts and upraised arms.

Zoomorphic ossuaries were defined in the Peqi'in assemblage based on the presence of a small sculpted tail at the back (fig. 3-8). Further examination also showed that, in these cases, when facial features were fully depicted the mouth was sculpted in the nose, rather than below it, an arrangement that more closely resembles the snout of an animal than the face of a human. As a consequence a unique double-faced ossuary from Peqi'in (fig. 3-9), displaying noses

3-5: Three-dimensional anthropomorphic head from an ossuary. Clay, Peqi'in. IAA: 2007-2247, exhibited at IMJ. Checklist no. 73.

3-6: Three-dimensional sculpted and painted head. Peqi'in. IAA: 2007-2248.

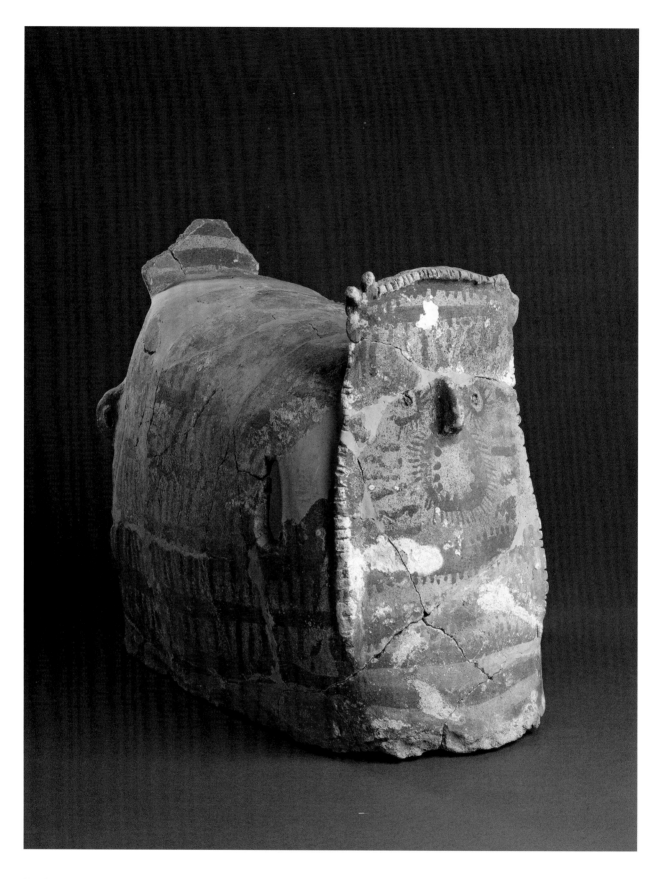

3-7: Ossuary with painted anthropomor-
phic face. Clay, Peqi'in. IAA: 2007-1807,
exhibited at IMJ. Checklist no. 66.

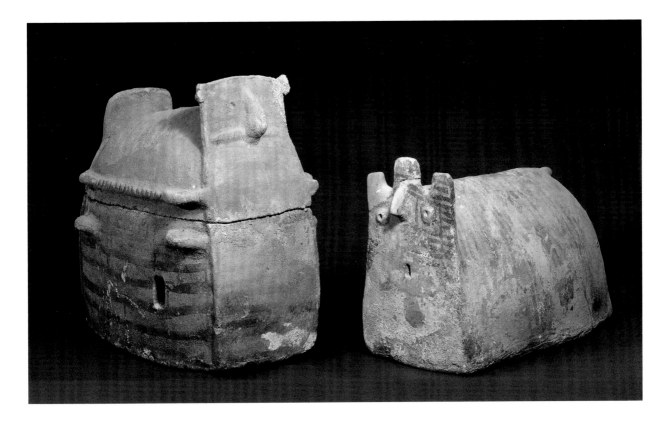

with nostrils and mouths, was identified as representing a pair of zoomorphic images, although the rear of the ossuary, which may have included a tail (or tails), did not survive.

The combination of anthropomorphic and zoomorphic features creates some questions. Several ossuaries include sculpted horns on their facades yet have faces that would otherwise be considered anthropomorphic. Should they be identified as anthropomorphic or zoomorphic images? Could they perhaps represent a mythological hybrid, perhaps a man dressed as a (horned) animal? The horns are depicted in one, two, or three pairs, and in possibly two cases from a burial cave in Qula[3] on the Coastal Plain, the same ossuary has three horned faces.

Other ossuary designs are also difficult to categorize. Painted geometric motifs include a variety of line, triangle-and-net, and herringbone patterns. Further, some of the ossuaries bear nail-like knobs, and one ossuary from Azor has a pair of scepter-like motifs on each side of its opening (see fig. 5-4).[4]

These same motifs appear in other ceramic forms, particularly jars and chalices, while knobs as well as herringbone and line patterns are also represented on copper objects, including so-called "crowns" and scepters.

Basalt Stands and Chalices

Similar motifs that are present on ossuaries also appear on some chalices and basalt stands. A regional hallmark of the Chalcolithic culture is the assemblage of basalt cultic stands found in houses on the Golan Heights (fig. 3-10).[5] These stands are shaped similarly to the ceramic chalices, and are usually biconical in shape, culminating at the top in a shallow bowl. They bear features that include eyes, a large nose, small horns, ears, and a (goat) beard. These stands were found in houses and are explained as domestic cultic stands associated with the fertility of flocks and agriculture.[6] The Peqi'in Cave revealed a large number of ceramic chalices in different sizes, some bearing anthropomorphic facial features, and one with sculpted fingers indicating that this image originally included

3-8: Anthropomorphic ossuary with tail and door-shaped lid. Clay, Peqi'in. IAA: 2007-1812. Checklist no. 61. Lidded anthropomorphic ossuary. Clay, Peqi'in. IAA: 1996-2634. Checklist no. 65.

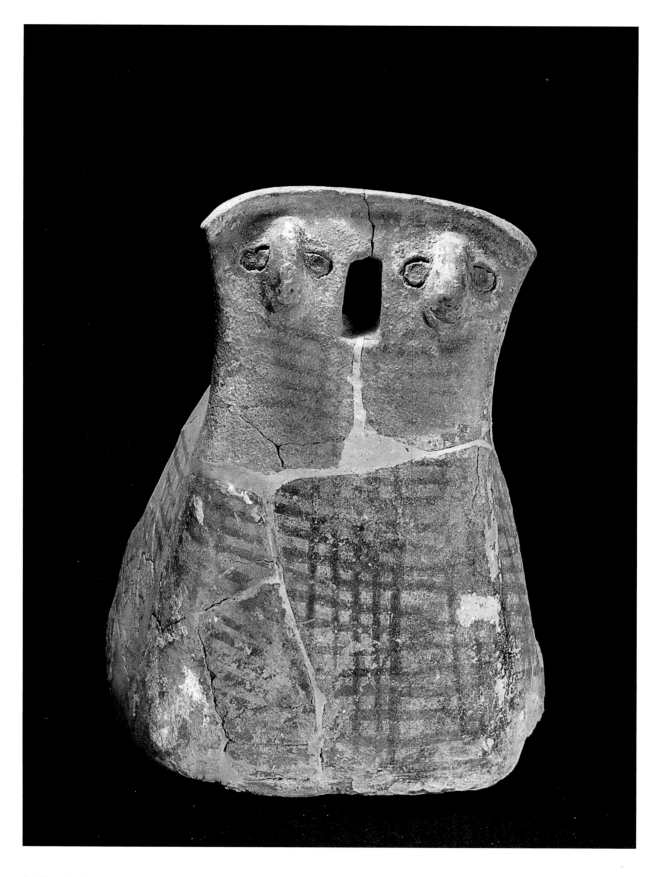

3-9: Double-faced zoomorphic ossuary.
Peqi'in. IAA.

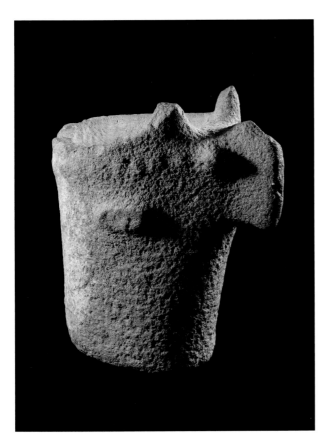

One ivory figurine-head of this type was found in the Peqi'in Cave (fig. 3-12), suggesting that it was imported from the south. A similarly shaped full-body figurine of a male was found at Qula (figs. 3-13a–b). The latter example is odd for several reasons.[7] It is made of clay, includes a mouth, and has an extended torso; its surviving arm was placed along the body, and the hand(s) were possibly grasping the genitals. This type of full-body figurine in the Southern Levant was probably influenced by similarly shaped Egyptian figurines with the same stylized position of the body and the hands.[8]

The unique full-body figurine known as the Gilat Lady[9] is a ceramic three-dimensional image of a nude woman, seated on a pedestaled vessel while carrying a churn on her head and a chalice in her left arm. Her body is rounded, with small breasts and a button-shaped navel but exaggerated genitals (see page 79, fig. 4-6). The limbs are emaciated, and the fingers and toes are only incised. Like other Chalcolithic images, she has a pronounced nose and no mouth, but sculpted ears. Her hair is long and wavy, her body is covered by horizontal lines, and long painted lines extending from her eyes may suggest that she is crying.

A three-dimensional sculpted ceramic ram (see figs. 1-1, 4-6),[10] was found in the same context as the Gilat Lady. On its back is a painted design composed of triangles, which has been explained as a blanket.[11] The ram carries three large cornets. The head has sculpted and painted horns, sculpted ears, round painted eyes, a mouth, and a pair of nostrils. The tail is broken, but genitals are obvious. The center of the body is painted with horizontal lines while the legs and cornets are fully painted.

As the Gilat Lady and the Gilat Ram were discovered together in the same room, this has led to discussions concerning their reciprocal functions. Although the role of this space is debated, a general cultic meaning is agreed upon with regard to the functions of both the room and the figurines. The two figurines are also vessels and were most probably used for libations during ceremonies or other cultic contexts. The careful composition of

arms. The most extraordinary ritual chalice (see page 101) is one meter high and has three bowls. Below each of the bowls are facial features that comprise a sculpted nose with nostrils and a pair of sculpted and painted eyes.

Figurines

Figurines represent another context rich with Chalcolithic motifs. The figurines themselves can be divided into two main types: full-body examples and those that are violin shaped. The full-body figurines, usually made of worked ivory, are mainly known from the area of Be'er Sheva in the Negev Desert. They are generally quite flat, with arms along the body and hands on the hips, and all lack mouths. Some of the figurines have holes around the top of the head and/or the lower part of the face, indicating that hair was inserted. Female figurines bear breasts and often include exaggerated genitals (fig. 3-11), and in one case a swollen belly indicating pregnancy.

3-10: Anthropomorphic stand with horns and crown motif. Basalt, Seluqiyye. IAA, Katzrin Museum: 1987-6935. Checklist no. 35.

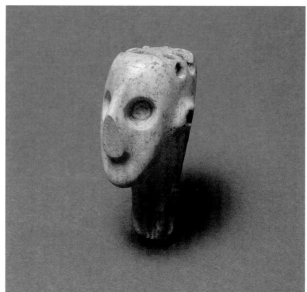

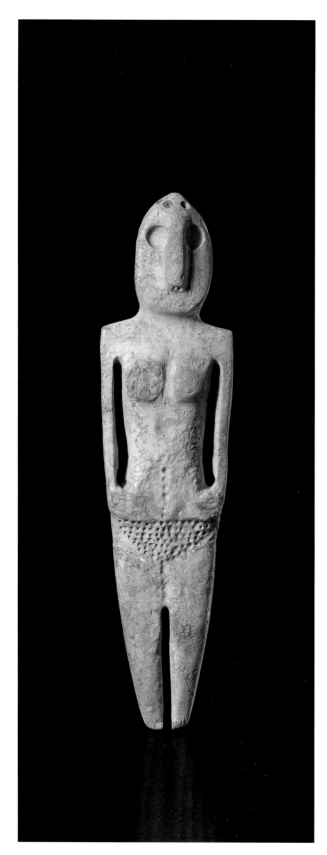

each of these vessel-figurines, the emphasized genitals of the woman (which may indicate fertility), the churn, the ram (related to fertility of the flocks), and the cornets (a vessel associated with cult) are unique in the diverse repertoire of Southern Levantine artifacts. Thus, it is conceivable that the Gilat Lady and the Gilat Ram are a pair, perhaps of gods. The female represented as a woman and the male represented by a male horned animal probably reflect the continuation of a Neolithic tradition.[12]

The violin-shaped figurines are flat and lack faces and limbs. More than fifty figurines of this type were found at Gilat,[13] and small numbers at several other sites. These figurines are usually made of stone, but occasionally bone (see figs. 3-14, 2-6, 2-7). The long neck sits on broad shoulders, above a narrow waist and wide hips. Although just two of the Chalcolithic figurines, one from Gilat (see fig. 4-3) and one from Peqi'in, have applied breasts, it is commonly accepted that they all represent female images, perhaps a specific known image.

A set of plaques, also typical of the south, are trapezoidal pendants, with a pair of holes on the top of each. Given the penchant for abstraction in the violin-shaped figurines, these simple shapes may cautiously be explained as schematic anthropomorphic depictions with two "eyes" (fig. 3-15).[14]

3-11: Female figurine. Ivory, Be'er Sheva. IMJ: 81.1.43. Checklist no. 10.

3-12: Male (?) Head. Ivory, Peqi'in. IAA: 1997-3572. Checklist no. 7.

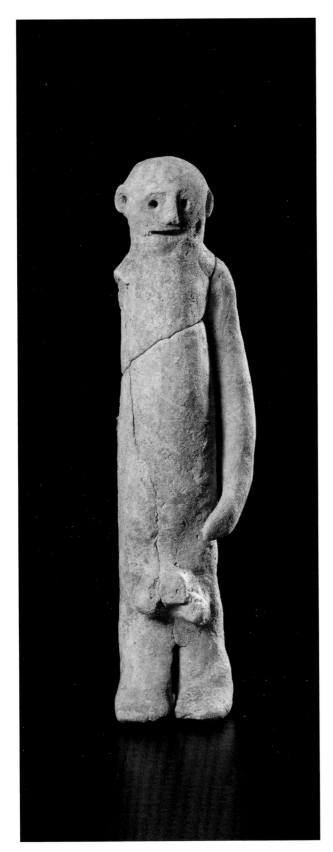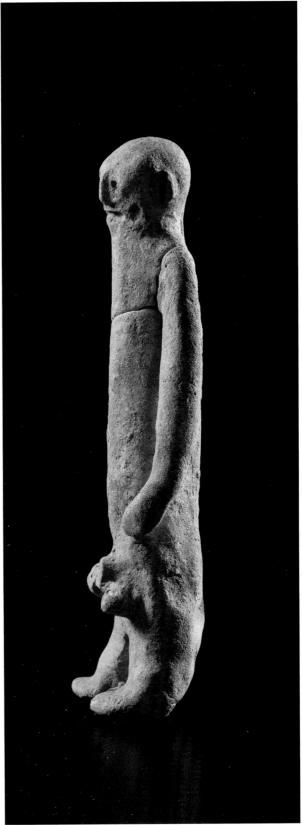

3-13a–b: Male figurine. Clay, Qula.
IAA: 2003-733, exhibited at IMJ.
Checklist no. 9.

The Ghassul Painting

The unique wall paintings exposed at Tuleilat Ghassul[15] illustrate a wide variety of extraordinary, enigmatic motifs (see fig. 4-13). One of the two main paintings is of a large stylized star measuring 1.84 m in diameter. It consists of three concentric eight-ray stars, the external and largest star with four black and four red rays. It has been suggested that the star is the symbol of Ishtar (in earlier periods known as Inanna).[16] The star is surrounded by different motifs, some in fragmentary condition. To the right is what may be the facade of a building or perhaps of an ossuary.[17] To its left are, among other images, large round eyes with black irises encircled by white. These images are depicted in most of the frescoes, and are explained as masks (see fig. 4-15) similar to those described above, perhaps with beaks and feathers; according to some scholars, the images may symbolize death.[18] To the left of the star, other distinguishable designs include two animals, one probably with wings. An additional interesting painting depicts persons wearing what seem to be long robes and masks. They are walking one behind the other, possibly illustrating a ceremonial procession, and the leading individual holds a sickle, rod, or scepter.

Discussion

Chalcolithic images and other motifs, whether depicted on ossuaries, in wall paintings, or on pottery, copper, ivory, or basalt artifacts, testify to a rich visual life that was expressed in sculpted and painted designs and in a variety of materials and objects. Many of these motifs can be traced back to the Neolithic period and to northern Mesopotamia. The tendency to emphasize the importance of the head or torso in imagery reached its peak in Neolithic cult objects, such as the monumental figures, statues, busts, and torsos from Nevali Çori[19] and Göbekli Tepe[20] in southeastern Turkey, as well as those from 'Ain Ghazal[21] in Jordan. The persistence of Neolithic traditions appears to be present in the geometric designs and the herringbone pattern, but also in specific motifs, including masks painted on the walls of Ghassul, the mask-like ossuary facade and the painted net headdress on the sculpted head from Peqi'in, and the position of arms on the Peqi'in ossuaries. Moreover, violin-shaped figurines, birds of prey, snakes (rare in the Chalcolithic period), and horned animals (bulls in the Northern Levant and probably goats in the Southern Levant) can be added to the list of elements that reflect the continuation of Neolithic designs. These observations may be strengthened by references to burial traditions. The primary burials common to the Neolithic period continued in the Chalcolithic in the Southern Levant, while certain areas (in modern Israel) such as the coastal plain exchanged that method for secondary burial. Moreover, in both periods skulls of chosen individuals were in certain cases specially treated—in the

3-14: Violin-shaped figurine. Bone, Peqi'in. IAA: 2005-1314. Checklist no. 32.

3-15: Pendant. Limestone, Bir Ṣafadi. IAA: 2007-1628. Checklist no. 33.

Neolithic by sculpting and reburying them[22] and in the Chalcolithic by placing them in bowls[23] or chalices.[24] The motifs themselves are similar across the spheres of life, as depicted on objects found in the home as well as objects found in public ritual contexts or burial caves.

The motifs frequently demarcate male (beard) and female (breasts) across a range of object and material types. The idea of the female is further depicted through the stylized bodies of the violin-shaped figurines. Among male motifs, there is some combination of anthropomorphic and zoomorphic motifs through the addition of the horns of a goat or possibly an ibex. Drawing a line, however, between anthropomorphic and zoomorphic figurines can be difficult.

The linkage between secondary burial and anthropomorphic imagery is an appropriate place to start when searching for an explanation of the images. Beliefs concerning afterlife, burial traditions, and ancestor worship are united in these artifacts and symbols, which may to a certain extent be explained as attributes of divine powers, perhaps gods. A specific female image—the fan-shaped ossuary facade—supports this hypothesis.

The motifs of the Chalcolithic period also include axes and horns on crowns and scepters. It has been suggested that the ossuaries and a certain type of burial jar represent silos,[25] and some were painted with patterns similar to heads of grain. Through the motifs of the Chalcolithic, the images of an agrarian society permeate the symbolic repertoire. This overlap is nowhere clearer than in the two figurines from Gilat, the painted woman with a churn on her head and the ram with cultic cornets placed along his back. Chalcolithic figurines, especially those that bear exaggerated genitals, are often considered as private domestic objects related to fertility cult. The most interesting figurines are the Gilat Lady and the Gilat Ram, which have been explained as a pair of gods, the female presented as a woman and the male as a ram.[26] Whatever their status, they are linked to agriculture by the churn, to pastoralism by the ram, and to fertility.

While a specific interpretation of these prehistoric products escapes the modern viewer, it is conceivable to propose that their motifs, especially the anthropomorphic images, had the same symbolic meaning whether placed on an ossuary, a jar, or a scepter. Furthermore, the assemblage of motifs—anthropomorphic, agricultural, architectural, and those related to power and death—should be studied while bearing in mind that societies in the Chalcolithic period already had mythological stories and deeply rooted traditions. Although there are no written texts as early as the Chalcolithic, later texts surely contain mythological stories that were created much earlier. Considering the artifacts bearing this variety of symbols in light of these later texts has led some scholars to identify certain of the Chalcolithic images and symbols with the gods Inanna and Dumuzi.[27]

Whether or not the association with gods is correct, the corpus of motifs points to links to ancestors, stories, myths, and rituals. Further research may explain the meaning of these figures and motifs, but whoever these images represent, they are witnesses to the people of the Southern Levant and to their extraordinary culture and spiritual life at the dawn of prehistory.

Notes

1 Several scholars have addressed the relations between iconography and culture in the Chalcolithic period. See, e.g., Beck 1989; Epstein 1978; Epstein 1982.
2 Shalem, Gal, and Smithline 2013.
3 Milevski 2002, 138.
4 They have also been suggested as an early depiction of the "pillars of Inanna" that are represented on later artifacts as a pair of pillars, one on each side of the entrance to Inanna's temple. Merhav 1993.
5 Epstein 1998, 230–33.
6 Ibid.
7 Milevski 2002.
8 E.g., Midant-Reynes 2000 (fig. 4A).
9 Commenge et al. 2006 (and see there further bibliography).
10 Ibid.
11 Tadmor 1986b.
12 Commenge et al. 2006.
13 Levy 2006a.
14 North 1961.
15 Cameron 1981.
16 Mallon, Koeppel, and Neuville 1934, 140.
17 Bar-Adon 1980, 133.
18 Cameron 1981, 18.
19 E.g., Hauptmann 1993.
20 E.g., Schmidt 1999.
21 E.g., Schmandt-Besserat 1998.
22 E.g., Kenyon 1956; Akkermans and Schwartz 2003, 85, 91.
23 Goren and Fabian 2002.
24 Shalem, Gal, and Smithline 2013.
25 Bar-Yosef and Ayalon 2001.
26 Sacher 1995.
27 E.g., Bar-Adon 1962.

Spiritual Life in the Southern Levant during the Late Chalcolithic Period, 4500–3600 BCE

Osnat Misch-Brandl
The Israel Museum, Jerusalem

"Gilat Lady" libation vessel in the shape of a woman carrying a churn. Clay, Gilat. IAA: 1976-54, exhibited at IMJ. Checklist no. 12.

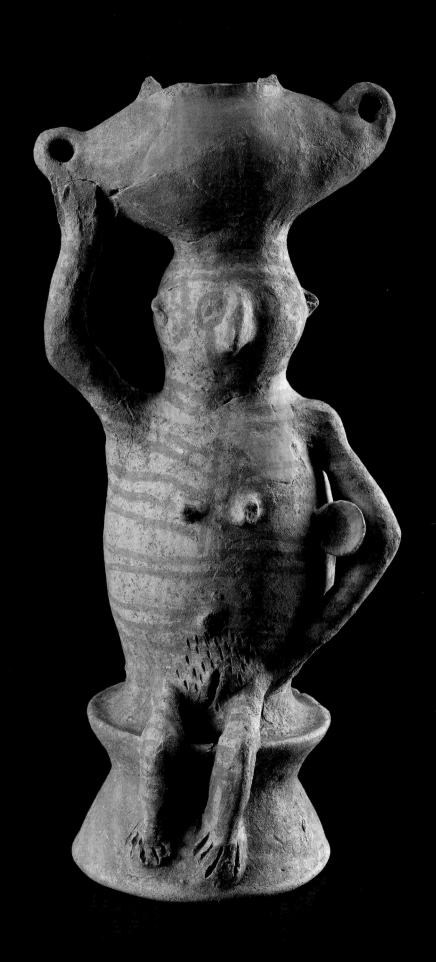

The patterns of social behavior in the prehistoric Chalcolithic period, for which there are no written records, are reconstructed on the basis of archaeological finds and ethnographic analogies. This was an age of prosperity, largely the result of two revolutions: First, the secondary-products revolution saw the introduction of new types of vegetation, such as fruit trees, and the expanded use of domesticated animals, particularly cattle, sheep, and goats, now exploited for their milk and utilized as beasts of burden. Second, this was the time of the metal revolution, when knowledge of the means of transforming ore into metal and metal into objects was acquired. These revolutions not only led to increased economic wealth but also played a crucial role in changing the nature of society. A ruling class emerged that consisted of a religious elite and a governing power. The latter drew its authority from the new economic well-being.[1] It has been argued that an elite class ensured the constant supply of raw materials, including metal and basalt, as well as the distribution of final products, which in turn guaranteed the society's continuing material comfort.[2] This was also a period of peace. Permanent settlements of herdsmen and farmers were formed that contained a greater number of inhabitants than had previous settlements. They may have been organized as chiefdoms, societies comprised of individuals of different social statuses.[3] All these changes made it possible for people to devote most of their resources to the creation of many new types of objects that served the spiritual life of the community.

In many Chalcolithic settlements, objects have been found that suggest a strong connection with spirituality. The connection with supernatural forces, abstract beings, spirits, and anthropomorphic and zoomorphic gods was clearly of great importance. Cultic activities were related to the seasonal cycle and the cycle of human life, with a special emphasis on rites related to the ancestor cult, the spirits of ancestors in general and of leaders in particular.

Peace, prosperity, and increased material resources led to the rise of organized religion—expressed for the first time by the construction of temples, which were large, elaborate houses for the god—and to the emergence of a class of priests, who bridged the gap between gods and believers, placating the deities, on the one hand, and the believers, on the other. The gods were appeased by votive offerings, animal sacrifices, and incense and by the creation of their visual representations. In addition to the rites performed for the gods in their temples, there were other religious activities that were already carried out in earlier periods: magical rites that connected people with primordial forces, celestial bodies, forces of the underworld, and spirits—the work of shamans and magic healers.[4]

Temple Complexes

In this period the house of the god—the temple—was a complex consisting of a structure or structures, and a courtyard or courtyards, surrounded by *temenos* walls. These structures were broadhouses, buildings with entrances in one of the long sides, and consciously made in imitation of private dwellings. One of the buildings served as the sanctuary, in which one or more divine statuettes were placed. Priests and the ruling elite entered this space, while the courtyard or courtyards adjacent to the sanctuary were used by the rest of the population, who came from near and far to take part in the rites.[5] To date, three Chalcolithic temples have been unearthed in the Southern Levant.

The Temple Complex at Tuleilat Ghassul

The settlement established at Tuleilat Ghassul was large, occupying an area of some 20 ha (fig. 4-1).[6] The site is situated 292 m below sea level, 5 km northeast of the Dead Sea. Stratum III corresponds to the Middle Chalcolithic period, Wadi Raba culture. Stratum IVA–B corresponds to the Late Chalcolithic period, which ended around 3800 BCE. After a time during which "house sanctuaries" (see below) were used for public rites in the area called Tell 2–3, a temple complex was built in a new area, Area E-Tell 5, some 100 m from the center of the settlement.[7] The new area afforded an unobscured view of the Dead Sea and En-Gedi. The large temple complex was in use for around a thousand years, with three construction phases identified. In what is called the

Classical Courtyard Phase, the temple seems to have comprised two buildings and a courtyard that were enclosed within a wall.[8] Near the complex were an industrial area and agricultural and grazing areas. The buildings of the temple complex were constructed on stone foundations and had stone pavements and mud-brick walls that were plastered and painted on the interior. The roof was made with unworked timber beams 10 cm in diameter, including the bark. Building A had interior dimensions of 7.90 by 2.60 m, and its walls were painted orange. The entrance had a stone door socket and was flanked by a pair of windows. Inside the building a stone altar was unearthed as were fragments of the limbs of a female figurine. In the courtyard an altar was discovered that was connected to Building A by means of a paved path. Building B had interior dimensions of 4.60 by 2.56 m. Its entrance had a stone door socket, and its walls were painted with up to eight layers of paint, based on the section that has survived. There were benches along the southern wall as well as a platform. A zoomorphic statue was unearthed inside.

The finds from the two buildings differ from the usual household assemblages and include zoomorphic vessels, incense stands, V-shaped bowls, cornets, and a double-cornet vessel (*kernos*). According to Seaton, this was the temple of a sacred pair.[9] This assumption is based on the discovery of fragments of the female figurine in Building A and the zoomorphic figurine in Building B. The representation of both a human and an animal in two cult rooms suggests that the cult focus was duotheistic, consisting of a female deity and a male deity—a human female and a domestic (bovine?) animal comprising the sacred pair. The limb fragments from the female statue exhibit a similarity to the goddess statue from Gilat and may even be part of the statue of a deity that was imported to Ghassul from Gilat along with other sacred objects from the Negev.[10] The female statue appears to have been intentionally shattered and buried in a cultic favissa (pit). The temple courtyard was a closed precinct where ceremonies focusing on the sacred pair were held. All the industrial activities and crafts carried out nearby were performed in an area physically separated from the courtyard.

4-1: Reconstruction of the temple complex at Tuleilat Ghassul.

The Temple Complex at Gilat

The settlement at Gilat in the Negev, on the banks of Wadi Patish, occupied an area of some 12 ha (fig. 4-2). Its monumental temple complex, which stood out prominently in the Negev, was situated at the top of the tell in an area isolated from the rest of the settlement. Stratum IV corresponds to the Middle Chalcolithic period, Wadi Raba culture. Stratum III corresponds to the Late Chalcolithic period and is the largest construction stage of the settlement.[11]

The temple complex, with an interior measurement of 14.85 by 16.25 m, had two buildings in the north (A and B), one in the west (C), and one in the south (E); the latter had benches and probably served as the gatehouse. The buildings were constructed from mud brick on a foundation of stones and had tamped mud floors. The complex had two courtyards—Courtyard D in the east and Courtyard A in the center of the complex—where basins, favissas, stelae, bamot, and portable objects came to light. West of the above-mentioned buildings and courtyards, in Areas J–T, a 360-m² plaza was discovered, where rites were held and which led to the eastern area. In this plaza favissas were unearthed that contained fragments of incense stands and violin-shaped figurines; a row of stones with a stela in the center, a hoard of ostrich eggshells, and other items were found as well. This plaza could accommodate a large congregation of pilgrims.

The interior dimensions of Building A were 2.2 by 3.2 m. It had mud-brick benches, 30–40 cm wide, along its walls. There was also a brick bamah for incense and libations. This building was the main cult room, the sanctuary, and accessible only to priests. In this room some seventy cultic objects were found: two sculpted vessels, one in the shape of a ram, symbolizing a god, and another in the shape of a woman, representing a goddess; five violin-shaped figurines; six stone plaques; five torpedo vessels; nine incense stands of pottery and two of stone; two alabaster pendants; two stelae; and thirty-six cornet fragments. The sculpted vessels presumably functioned as cult statuettes and represented a sacred pair (see below).

4-2: Reconstruction of the temple complex at Gilat.

Scholars argue that worshipers assembled in the courtyards; they did not enter the sanctuary and thus did not see the statues of the gods. However, it is possible that the statues were brought out on special occasions. In the courtyards incense and libations were offered.[12] Some of these liquid or powdered offerings may have been carried to the sanctuary in the torpedo vessels. Unlike the courtyard of the temple complex at Ghassul, the courtyards at Gilat were also used for public activities, such as cooking, heating, noncultic events, industry, and craft.

In addition to the numerous cult objects discovered in the sanctuary, the temple assemblage included the following items, mainly of local manufacture but some imported as complete objects from a great distance:

- About seventy violin-shaped figurines made primarily of stone, though some were made of bone or pottery (fig. 4-3). A wide variety of stones were used, the origins of which were in the vicinity of Gilat or farther away. There is no evidence of the production of these figurines at the site, and thus the assumption is that they were brought to the site by pilgrims.
- More than twenty incense stands made of basalt or pottery. Those of basalt originated in the area east of the Jordan, the Golan, and the Upper Galilee and were brought to Gilat as completed objects.
- About forty stone palettes, most of which were completed objects imported from outside the area (fig. 4-4).
- Twenty-five mace heads made of a variety of stones. Among these, some were made of Egyptian diorite and granite, and faceted.
- Seven stelae made of limestone or chalk.
- One hundred pottery torpedo jars that were imported from far away, some possibly from Ghassul.[13]
- Fifty-seven amulets made of stone, shell, pottery, or bone (fig. 4-5).
- More than seventy miniature churns.
- More than eighteen painted cornets.

The fact that the temple had a wide variety of objects, some of which were imported from other areas, points to the fact that it served as a regional religious center for worshipers from the area as well as those who traveled a great distance. Its well-organized economic activities, evidently including trade relations, were handled by a social elite associated with the religious elite in charge of the temple complex.

A Pair of Fertility Gods

The statues representing a divine pair that were found in Building A were produced by the same artist, from clay that originated in the Shephelah (Judean foothills), some 50 km from Gilat (fig. 4-6). They are painted red, which symbolized life, and as they were meant to be looked at, not touched, the paint has been well preserved.[14]

The goddess is represented in human female shape, with an emphasis on her fertility. She is seated on a birthing stool, her navel is prominent, her genitalia are swollen, her abdomen is extended—in short, she is ready to give birth. She supports an incense stand with one hand and holds a churn on her head with the other.

The god is depicted in the shape of a ram carrying cornets (cultic vessels characteristic of Chalcolithic culture alone) on its back. The ram, the head of the herd, served as a beast of burden only in the Chalcolithic period.[15] It thus became an important symbol of strength, virility, and abundance (figs. 4.7, 4.8). For this reason the male god was represented by the image of a powerful ram.

As mentioned above, the statues are actually vessels and may have been filled with a liquid, perhaps milk, in the context of a rite performed by the priest in the temple. From this iconographic reading it seems that the god and goddess may have been the center of a fertility cult that revolved around the herd's fertility and reproduction, so crucial to this pastoral society, which was the first to engage in the production of dairy products. The divine pair ensured the continuity of the life cycle: birth, death, and rebirth.[16]

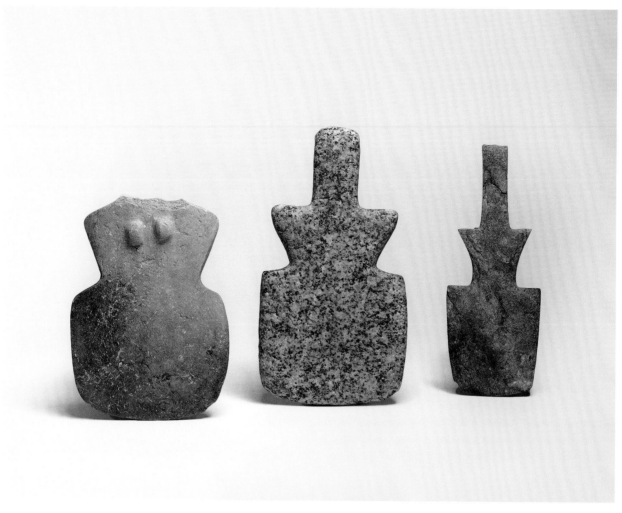

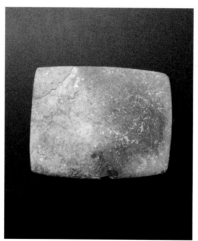

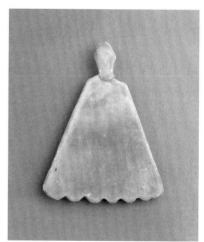

4-3: Violin-shaped figurines. Sandstone, Gilat. IAA: 1975-1033, exhibited at IMJ. Checklist no. 15.

4-4: Rectangular palette. Stone, Gilat. IAA: 1975-1044. Checklist no. 18.

4-5: Pendant. Shell (mother-of-pearl), Patish (Gilat). IAA: 1975-1050. Checklist no. 20.

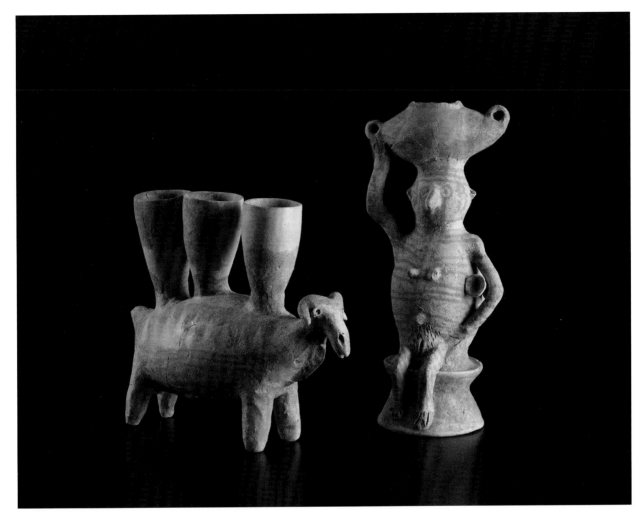

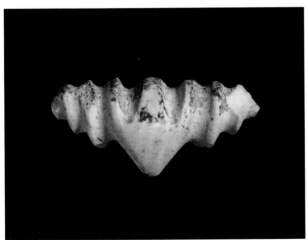

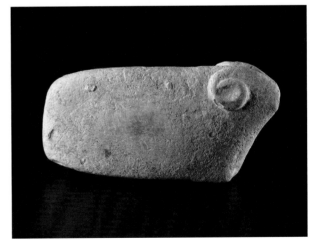

4-6: Libation vessels (2) in the shape
of a ram carrying cornets and a
woman carrying a churn. Clay, Gilat.
IAA: 1976-53, 1976-54, exhibited at IMJ.
Checklist nos. 11, 12.

4-7: Stylized head of a ram. Limestone,
Kabri. IAA: 1994-2656, exhibited at IMJ.
Checklist no. 5.

4-8: Figurine of a ram. Stone,
Azor region, chance find, n.d.
IAA: 1939-722, exhibited at IMJ.
Checklist no. 3.

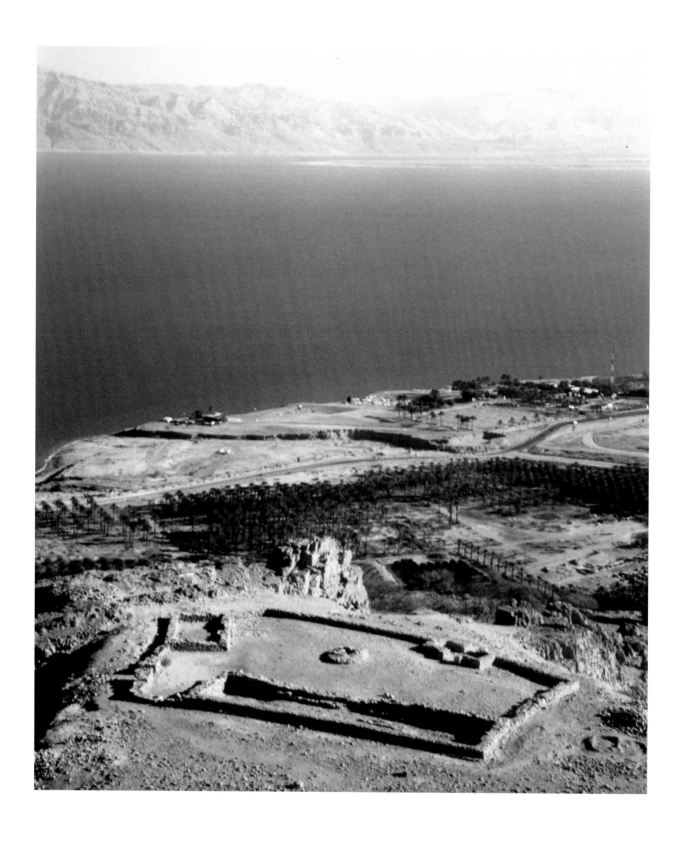

4-9: Temple complex at En-Gedi.

The Temple Complex at En-Gedi

This isolated temple complex, on the eastern border of the Judean Desert and situated between two springs, occupies an area of 4 ha and overlooks the Dead Sea from a height of 218 m above sea level (fig. 4-9).[17] It consists of four separate buildings—a main gatehouse, a secondary gate (postern), a sanctuary, and a service building—as well as a courtyard with a circular structure, all of which were surrounded by a wall (fig. 4-10).

The buildings had foundations of local stone, and their walls were constructed from mud bricks. A single fragment of painted plaster decorated with pink and blue stripes against a white background is all that is left of the wall paintings that probably covered the interior walls. The floors of the structures were made of crushed chalk. Except for the postern, all the buildings had door sockets, indicating that the structures were closed with doors. The roofs were constructed from reeds, branches, and date palms, which covered wooden beams placed widthwise across the structure, above the walls.

The interior dimensions of the sanctuary were 19.7 by 5.5 m. Opposite the entrance was a horseshoe-shaped altar built of brick and surrounded by a row of stones. A statue of a ram bearing churns was found on the altar in the remains of ash.[18] To the right of the altar, a stone base was discovered that probably supported a statue or symbol of the god. Along the long walls and in the center of the sanctuary were benches for votive offerings. Some of the votive offerings had been intentionally shattered and thrown into the favissas at the edge of the room. A round structure that was used for liquids or as the base of a sacred tree was unearthed in the center of the courtyard.[19]

The finds from the temple complex were of a clearly cultic nature and include dozens of goblets, 195 cornet bases, approximately ten V-shaped bowls, and nine incense stands. It is possible that some of the rites performed there were related to water, since the complex was built between two springs and the gatehouse is only 150 m from the spring.

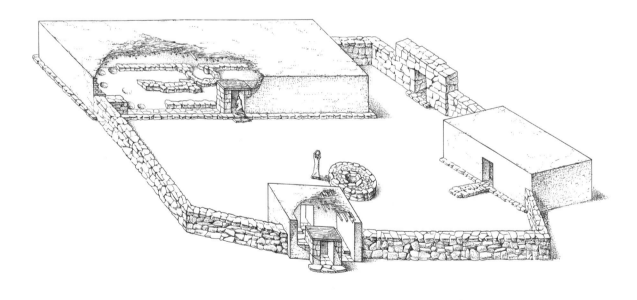

4-10: Reconstruction of the temple complex at En-Gedi.

The temple complex was evidently abandoned in an orderly manner. It seems that the priest carried away the representation of the god and additional cultic equipment. No contemporary settlements have as yet come to light in the vicinity, except for the Moringa Cave, which served for habitation. The isolated temple complex served as a pilgrimage site for worshipers from the vicinity and from a distance.

The Cave of the Treasure

The Cave of the Treasure was discovered in 1961 some 10 km south of En-Gedi, about 250 m above the bed of Naḥal Mishmar.[20] It contained a hoard of 426 ritual objects[21] from the Chalcolithic period: 5 of hippopotamus ivory, 1 of elephant ivory, 6 of hematite, 1 of limestone, and the rest of copper, in most cases an alloy of copper, antimony, and arsenic but some of pure copper. Some of the objects showed signs of repair and restoration, indicating that they had been in use for a long time (fig. 4-11).

The most prevalent interpretation is that the majority of the objects in the hoard served as ritual standards. The discovery of parts of wooden poles, cloth, and threads inside the mace heads and scepters indicates that these objects were mounted on poles and held aloft, presumably in ceremonies. Objects that could have served as standards have come to light in houses—at Giv'at Ha-Oranim, for instance—and in burial sites—at the Peqi'in burial cave, for example—suggesting that ceremonies involving the use of standards were held in these contexts. Interestingly, no objects of this type have come to light in temple complexes. However, the large number of standards located in the Cave of the Treasure suggests that this assemblage was used in rites held in a large public place (fig. 4-12). Considering the fact that the temple complex at En-Gedi was abandoned in an orderly fashion, and cultic equipment suiting a large temple of this kind was not found at the site, it is reasonable to assume that the source of the hoard in the cave was the nearest temple, the temple complex at En-Gedi.[22]

The symbols appearing on the objects in the hoard are taken from everyday life: geometric patterns,

floral patterns, fruit, celestial bodies, and images of birds and horned animals, all of which represented the forces of nature that were venerated. As the Ghassulian wall paintings reveal, during religious rites priests walked in processions while carrying scepters whose designs represented power and virility. Presumably, the priests were hoping to procure prosperity, fertility, and power for the communities they represented.[23]

Domestic Shrines

In every inhabited site spiritual life found expression, even if no temple complex was located there. Magical rites that connected worshipers with primordial powers (celestial bodies, powers of the underworld, spirits) were performed long before the emergence of temple complexes and continued to be performed by shamans and healers alongside temple cults even after temples appeared. These rites were conducted in "domestic shrines." Such structures were not different in their appearance from large private houses (hence the term

4-11: Pierced crescents (2) and tusk.
Ivory (hippopotamus), Naḥal Mishmar.
IAA: 1961-161, exhibited at IMJ.
Checklist no. 104.

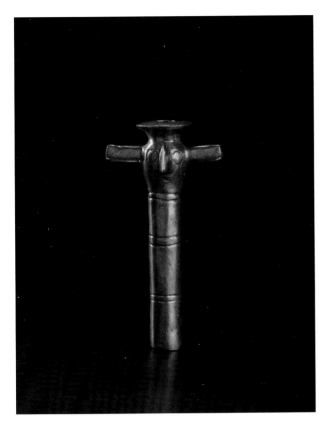

"domestic"). They were unique, however, in the wall paintings that decorated their walls and in the special objects and furnishings discovered in them.[24] Buildings of this type have come to light mainly at Ghassul. They were broadhouses with courtyards and included cultic installations and wall paintings. The buildings were constructed next to houses and constituted part of the settlement layout in the Late Chalcolithic period.

Two important examples were found at Tell 3 at Ghassul. One is Building 10 from Stratum IVB, and the other is Building 78 from Stratum IVA (which is later than IVB). The distance between the two buildings is roughly 50 m. In Building 10[25] a "star" wall painting was discovered, measuring 1.84 m in diameter (fig. 4-13). According to the excavator, the painting was located in an elaborate house that contained fine objects, a brick silo, and an oven. The excavator related the painting to a religious ceremony, while another scholar tied it to a solar cult.[26] The "star" was found along with other wall decorations, for which many explanations have

been proposed. Most if not all the motifs belong to earlier stages of the wall painting, and thus it is reasonable to assume that they are not necessarily related to the "star."

The second domestic shrine is Building 78,[27] which is well preserved. It consists of a broadhouse (15.0 by 5.8 m) with an intentional internal partition, an adjacent building that served as a storeroom, and a courtyard with several installations. It is larger than an ordinary house and is decorated with wall paintings. A high bamah was discovered in the building, as well as an altar and favissas, ten intact cornets, and about thirty cornet fragments. The most important painting in this building was the "Dignitaries Frieze," which is 5 m long. In the lower part figures can be seen sitting or standing in front of a celestial body—a sun painted with red and yellow rays. The excavator had no doubt that there was a connection between this celestial body and the "star" from Building 10.

Another domestic shrine was discovered in Area A-Tell 2-AIII, in a building similar to Building 78. It had a wall painting depicting a procession of three dressed figures wearing masks and carrying scepters (fig. 4-14).[28] Presumably, the rites performed in this building also involved cornets, since such objects were found in the building. North of the "procession" painting, a wall-painting fragment, measuring roughly 0.5 m² and depicting a garlanded sickle, was found in 1995.[29] The sickle is red and decorated with white flowers inserted in round holes. The object itself resembles the ivory scepters in the Cave of the Treasure hoard. It is possible that both the "garlanded sickle" painting and the ivory scepters from the Cave of the Treasure were objects carried in ceremonial processions, such as the one depicted in the building in Tell 2-AIII.

Another domestic shrine was found in 1961 in Tell 3-Trench A2,[30] some 30 m distant from Building 10, where a wall painting depicting a "tiger," or more precisely a figure wearing a mask, was found (fig. 4-15). In one of the layers of this painting, seven masks were revealed, as well as the painting of a star with rays in black and white.

4-12: Scepter with grooved shaft, decorated with a human head and three elongated bosses. Copper, Naḥal Mishmar. IAA: 1961-84, exhibited at IMJ. Checklist no. 94.

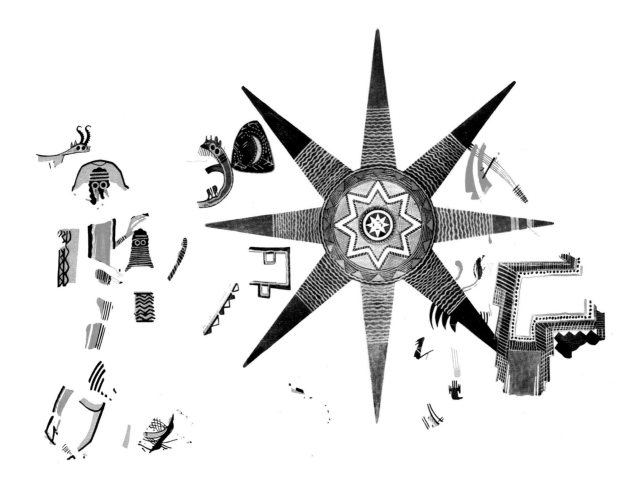

Another possible example of a domestic shrine was discovered at Abu Ḥamid, where excavators unearthed a building containing a wall painting in yellow and red. The building was unearthed in a complex of closely built structures, similar in construction to those at Ghassul. Violin-shaped figurines and the figurine of an animal similar to the statue of a ram from Gilat were found at the site.

The domestic shrines mentioned above had wall paintings depicting images of celestial bodies, including the sun, masked figures, and masks.[31] On the basis of these paintings, it appears that when shamans or magic healers performed these kinds of magical rites, they wore special attire and masks and carried cultic scepters.

Masks play an important role in the everyday life of contemporary tribal societies in the Volta River basin in northwest Africa.[32] When individuals put on masks, they become the embodiment of deities,

tribal ancestors, and protective spirits. The masks are used in a wide variety of ceremonies: those related to the continuity of the life of the tribe; purification ceremonies, which are meant to drive away evil spirits from the villages; new-year ceremonies; ceremonies meant to ensure the health and fertility of people, livestock, and crops; initiation ceremonies for men; and burial rites. Such ceremonies are executed in different tribes in various ways. These contemporary ceremonies may shed light on the types of rites that were held in domestic shrines, both before the construction of the first temple complexes and after their emergence.

In summary, based upon the above evidence one could argue that the domestic shrines were used for magic activities connecting humans and primordial forces—including the celestial bodies, among which, judging from the finds, the sun figured prominently—and honoring the forces of nature (figs. 4-13, 4-14). With the construction of the first

4-13: Drawing of "star" wall painting, from the domestic shrines at Ghassul.

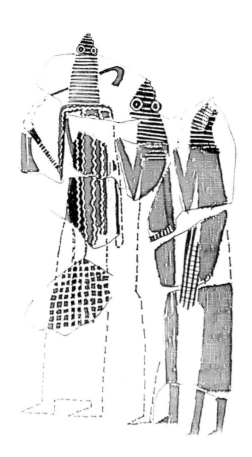

temple complexes, these activities were joined by ceremonies held in the temples, where anthropomorphic and zoomorphic deities were venerated.[33]

Household Cult

Evidence of the practice of a household cult has come to light in the large village of Be'er Sheva, a center for ivory and metalworking. At the site, ivory statues depicting both males and females were found in household contexts. The statues are elegant and well made, which suggests that they were communal property rather than private possessions, and thus it is surprising that they came to light in houses, a fact that is difficult to explain.[34] One such statue—a male figurine with a phallic sheath that emphasizes his virility and power—was located in a ritual pit along with a ceremonial ivory sickle, suggesting a connection between human fertility and the fertility of the fields (fig. 4-16).[35] Moreover, the Be'er Sheva ivories—the nude male figures with prominent phalli

and the pregnant female figures—indicate that the cult included both a god and a goddess, perhaps alluding to a rite that involved the sexual act as a means of ensuring human fertility, and fertility in general (see figs. 4-17, 3-11).

In the settlements of the Golan, by contrast, one or more incense stands were found in practically every house (fig. 4-18). These stands were carved from basalt in the image of humans or animals. They are round or biconical in shape and terminate in a shallow bowl, in which the incense offering was placed. Most have ear knobs, and all but one or two have a nose. They are divided into two groups: those with horns and those without. The horned specimens may have been related to the herds, while those without horns may have been associated with humans. Presumably, all were intended to ensure fertility and abundance.[36]

4-14: Drawing of a wall painting with figures wearing masks and carrying scepters, from the domestic shrines at Ghassul.

4-15: Drawing of a wall painting depicting a masked face, from the domestic shrines at Ghassul.

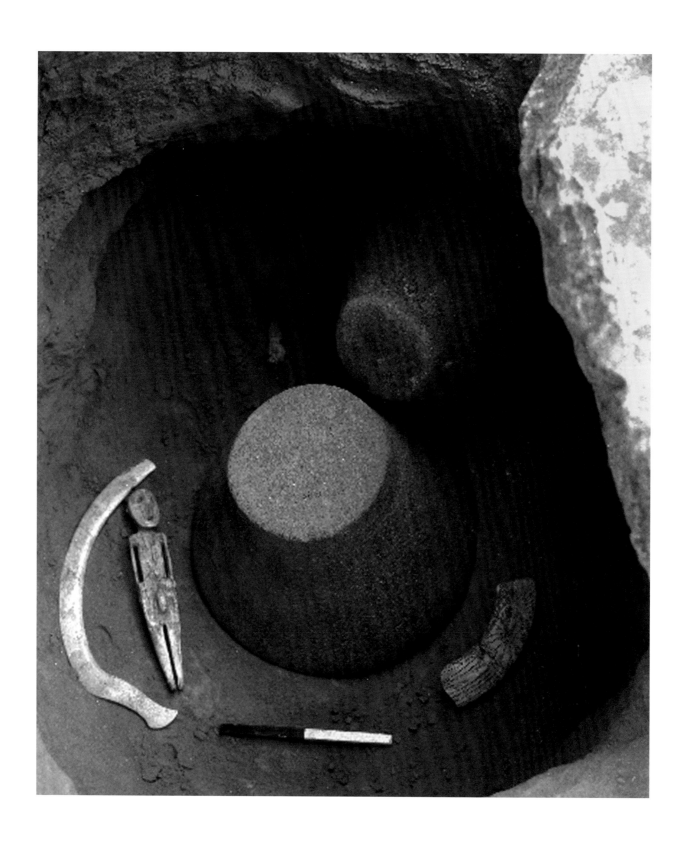

4-16: Male figurine in its original
archaeological context, Be'er Sheva.

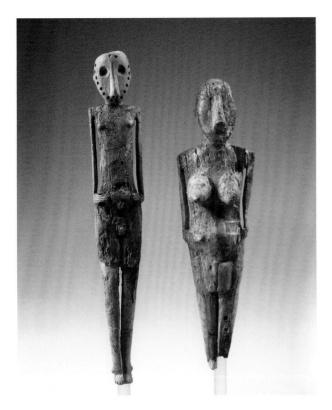
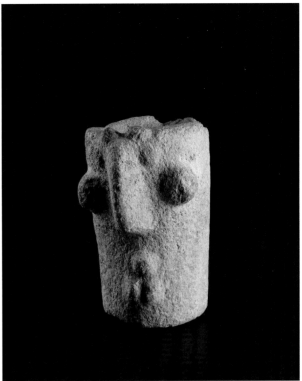

Life after Death

The evidence presented above leads to the conclusion that the people of this period invested tremendous effort in religious rites and ceremonies related to daily life. This was also the case regarding the afterlife: the finds from burial contexts, particularly those from the Peqi'in Cave, suggest that death and the dead were an integral part of life. The relationship between the living and the dead was reciprocal—the dead were perceived to be dependent on the prayers and food of the living, while the living were believed to be dependent on the protection of the dead. Thus, ceremonies related to the funerary cult, beliefs concerning the afterlife, and devotion to the ancestors also played a central role in everyday life.[37]

The connection between life and death was also expressed through the practice of secondary burial, which is itself based on a belief in an afterlife.[38] At death the bodies of the deceased were exposed to the elements, including birds of prey (primary burial). After the flesh had been picked clean, the bones were collected and placed in chests called ossuaries, which were often deposited in burial caves (secondary burial). The ossuaries were richly decorated, with the human image as the main decoration.

A variety of objects, some of which have been mentioned above, seem to have been used for burial rites. The so-called crowns from the Cave of the Treasure, for instance, apparently represent the round structures used for primary burial and may have had a role in the rites (see page 19, figs. 1-10, 6-18).[39] The eagle scepter (and possibly other scepters) from the hoard may also have been a funerary object, with this powerful bird of prey perhaps symbolizing the god of the dead.[40] A male figurine with a prominent phallus was found along with the bones of the deceased in an ossuary that was discovered in a burial cave at Qula, some 15 km south of Tel Aviv (see figs. 3-13a–b).[41] This is an exceptional find, since usually only bones are found inside an ossuary. Perhaps the purpose of the figurine was to ensure the fertility of the deceased in the world of the dead. Finally, it is believed that masks were used in funerary ceremonies as well, the mask

4-17: Male and female Be'er Sheva figurines (2). Male: Ivory, Bir Ṣafadi, IAA. Female: Ivory, find location unknown. IAA, IMJ.

4-18: Anthropomorphic stand with horns and pronounced eyes. Basalt, Seluqiyye. IAA: 1981-3017, exhibited at IMJ. Checklist no. 34.

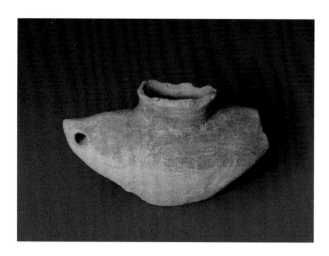

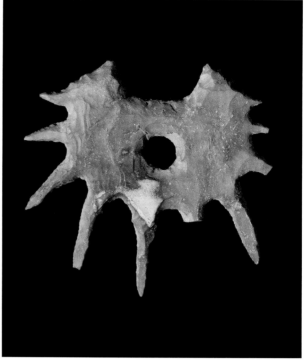

serving as a means of preserving the deceased's memory through the re-enaction of his deeds. Masked figures accompanied the bodies of the deceased, watched over their graves as ancestral spirits, and released the spirit of the deceased for life beyond the grave.[42] As mentioned above, miniature churns have also been discovered in burial caves, and also evidently played a role in the rites (fig. 4-19).

Assorted Prestigious Cult Objects Used in Contexts Related to Both the Living and the Dead

Violin-Shaped Figurines
The violin-shaped figurines depict the female form in an abstract, schematic manner. They are not only the most widespread figurines of the Chalcolithic period, but they are also exclusive to this time. These figurines are made mainly of various types of stone, but examples have also come to light in bone, ivory, and pottery. The majority were found in the temple complex at Gilat, where they were brought as votive offerings to the mother or fertility goddess (see fig. 4-3). Others have come from the domestic shrines at Ghassul and Abu Ḥamid, from cultic areas in small sites, such as Pella, and from burial caves, such as the large cave at Peqi'in.

Palettes
The palettes[43] are mainly rectangular, occasionally with rounded corners. They were discovered in Chalcolithic sites primarily situated in the south. Most came from the temple complex at Gilat. They are made of the same material from which the violin-shaped figurines are made—a wide range of stones originating in local and distant areas. The palettes were used for grinding, but they probably also had magical and symbolic roles in ceremonies held in the temple. However, in view of the fact that only two examples out of the entire assemblage bear signs of having been used for grinding and none bears traces of pigment, the excavator David Alon called them human body–shaped plaques, believing that they were cultic figurines even more abstract than the violin-shaped figurines (see fig. 4-4).[44]

Cultic Stands
Cultic stands, mainly of basalt but also of pottery and in a variety of forms, are among the most prestigious symbols of Chalcolithic culture.[45] A tremendous amount of work was required to produce objects from basalt, beginning with selection of the heavy raw material and its transportation from distant sources, and continuing through the time-consuming task of carving the objects. Incense stands played a key role in the rites held in temple

4-19: Miniature churn. Clay, Gerar.
IAA: 2004-2453. Checklist no. 39.

4-20: Tool with chipped spikes.
Flint, find location unknown.
IMJ: 82.13.849. Checklist no. 111.

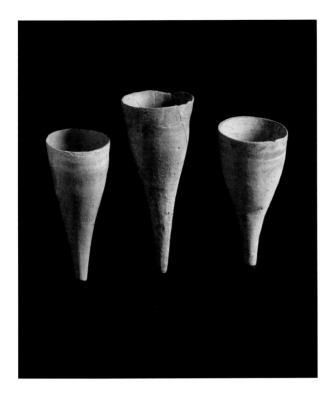

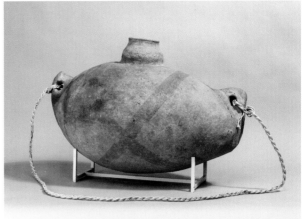

the cultic assemblages of small settlements and cemeteries suggests that these were the most significant objects used in the rites held at these sites. It is worth noting that cornets are also widely found in domestic shrines, making it the most common cult vessel of the Chacolithic period (fig. 4-21).

Churns

Pottery churns may be a later imitation of leather churns used for making butter, as it would have been much easier to produce the leather version than the pottery one. They represent one of the developments of the secondary-products revolution, namely, the manufacture of dairy products. The importance of the churn is reflected in the discovery of full-sized churns for making butter, as well as miniature model churns used in funerary rites. These miniature models came to light in burial caves, and an especially large number of such models were found in the temple complex at Gilat. Considering the churn on the head of the goddess from Gilat—who, like her male counterpart, was responsible for fertility—it is probable that churns in general had also come to symbolize fertility and abundance (fig. 4-22).[48]

Torpedo Jars

Torpedo jars are tall, heavy pottery vessels with thick walls and four large lug handles, one pair on each side. Some ten examples were found in the temple complex at Gilat. Most were discovered broken (apparently intentionally) in ritual pits. Based on petrographic examination, it appears that the jars

complexes and cemeteries. An important part of the ceremony involved the intentional breaking of the stands and their burial in ritual pits (see fig. 4-18).

Flint Luxury Items

The rounded, high-quality flint plaques in the shape of stars or disks, each with a single hole in the center, have come to light at sites ranging from Ghassul in the south to the Golan in the north, thus pointing to the existence of trade relations among these sites.[46] The plaques were apparently mace heads from standards that were carried on poles inserted into the central holes (fig. 4-20).[47]

Cornets

More than any other object, the cornet, made of painted pottery, symbolizes the Chalcolithic period. Such objects were undoubtedly associated with rites performed in the temple complexes. It is unknown, however, whether they served as drinking vessels or as libation vessels, and what liquid they contained— possibly milk, although this cannot be determined. The discovery of dozens of cornets in the temple complex at En Gedi, in the domestic shrines at Ghassul, in the temple complex at Gilat, and among

4-21: Cornets (3). Clay, Tuleilat Ghassul. PBI, Jerusalem. Checklist nos. 45–47.

4-22: Churn. Be'er Sheva. IAA: 1992-1193, exhibited at IMJ.

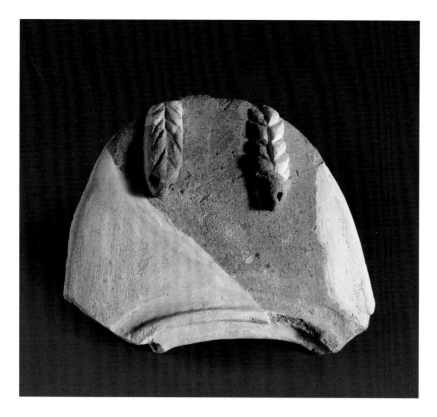

were made outside Gilat in at least five different locations and brought to Gilat as completed items. Chemical examinations have revealed that they contained olive oil.[49]

The Snake

The snake was not a widespread motif in the world of the Chalcolithic people, but a number of examples have come to light. Snakes form part of the decoration on vessels of different shapes from Ghassul, on which the creature is shown crawling toward the vessel's rim. On a model ossuary from the cemetery at Ben Shemen,[50] a snake undulates across the body (figs. 4-23a, 4-23b). Finally, on a fragmentary ossuary from Tel Aviv, a pair of snakes creeps toward the opening in the front.[51] The snake is a universal symbol of fertility, rebirth, and eternity. It could also symbolize the underworld, and for this reason it was associated with the ancestral realm. The snake protects and safeguards the deceased in their abodes within the earth. The underworld that the snake inhabits is also the fruitful earth, out of which new life grows. This very

notion is captured in the Bible: "Moses made a copper serpent and mounted it on a standard; and when anyone was bitten by a serpent, he would look at the copper serpent and recover" (Num. 21:9) (fig. 4-24).

Epilogue

The inhabitants of the Late Chalcolithic Levant—from Peqi'in in the north to Naḥal Be'er Sheva in the south—spoke a single "spiritual language" for a thousand years, but their settlements and cemeteries were not in use during the entire period. Some were built after others had already been established, but some were built earlier. Nevertheless, the fact remains that throughout the entire period, in all the areas where Chalcolithic people lived, similar symbols were depicted on different types of objects made of different materials: ossuaries, figurines and statues, scepters and standards, containers, and jewelry. From this we may infer that the inhabitants of the region during this period shared the same set of beliefs. This underlying unity is readily apparent, despite minor differences among the

4-23a: Fragment from an ossuary decorated with two snake heads. Clay, Tel Aviv. IAA: 2001-6153. Checklist no. 8.

4-23b: Drawing of reconstructed ossuary with two snake heads. IMJ: 2001-6153.

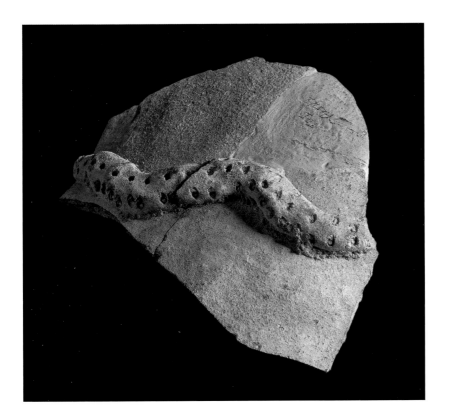

different parts of the region. It points to a common origin for all the inhabitants of the region, who shared similar customs regarding the rites of life and death. The temples of the period and the local rites conducted at every site were all drawn from the same iconographic and architectural world, local variations notwithstanding. The interconnections among the different parts of the "Late Chalcolithic land" were facilitated through the establishment of an economy and a system of rule that was responsible for supplying workshops with the raw materials they needed to manufacture their products, and for distributing finished products to consumers. Intensive trade in ritual objects is attested between the different parts of the region, with these close relations reaching a peak at the end of the Chalcolithic period.

Translated by Nancy Benovitz

4-24: Pottery sherd with snake decoration. Clay, Tuleilat Ghassul. PBI, Jerusalem. Checklist no. 1.

Notes

I am especially grateful to Nancy Benovitz for translating this article and for all her insightful comments.

1 Eliade 1978: "The powers attributed to those who were in charge of the metalworking process have made them the most important sector in their society: economically, socially and religiously. They became the chiefs or priests of their communities."

2 Alon and Levy 1989, 211: "The quantity and variety of traded items found at Gilat indicate that an elite, probably connected to the sanctuary, was responsible for organizing exchange systems at the site."

3 Levy 1995, 226.

4 This assumption is based on the fact that at Ghassul domestic shrines were used before the appearance of the temple; this was also probably the case in the rest of the Chalcolithic world.

5 This assumption is based on ethnographic analogy with contemporary Hindu temples in India, in which the Holy of Holies is too small to accommodate worshipers, and only priests are allowed in. For this reason the cult statue is carried out of the temple and into the courtyard by the priests for veneration by the worshipers. See note 12, below.

6 Hennessy 1982, 55: "Ghassul was not a group of small, closely tied settlements but one big settlement."

7 Seaton 2008, pls. 7–12, 32–47, and reconstruction of temple on cover.

8 Ibid., 19.

9 Ibid., 128: "On the evidence of the Ghassul 'Gilat-type Hand' fragment the cult focus of the Area E Sanctuary was duotheistic; a human female plus domestic (possibly bovine) animal partnership in a sacred pair. The lack of a full cult vessel to which the hand (and indeed the other five limb entities) attaches is explained by the deliberate breaking of cult materials and re-deposition in the cult disposal pits." Ibid., 135: "At En Gedi, the 'Bull With Churns' provides the equivalent animal form, and En Gedi figurine fragments may yet evidence a female partner. . . . The association between an animal and a human representation in special cult rooms is an identifiable phenomenon, and one which strongly links Gilat, Ghassul and probably En Gedi despite other evidence of differences in ritual expression between the sites."

10 Ibid., 121: "The strong presence of imports (significantly probably from Gilat's cult catchment and probably Gilat itself) in the Area E Sanctuary precinct strengthens Ghassul's cultic claim."

11 Alon and Levy 1991b, 167–68.

12 Alon and Levy 1989, 208: "The fact that Room A is small suggests that only a small number of individuals were allowed to view the statuettes at any one time. Activities carried out here were outside of public view. . . . The courtyards adjacent to Room A and the cult objects found there suggest areas where larger numbers of people could congregate."

13 Seaton 2008, 169: "There are strong indications of a direct relationship between Gilat and Ghassul in the Area E Sanctuary. A torpedo vessel at Gilat was possibly made at Ghassul."

14 Alon and Levy 1989, 194: "The fact that both the Gilat Woman and the Ram were found with excellent paint and small feature preservation . . . may be another indication that they were singularly made to be looked at and worshipped but not touched."

15 Milevski 2009, 162: "It is clear from the zooarchaeological data of the southern Levant that in our area donkeys were domesticated in the beginning of the EBA [Early Bronze Age] and not before." Thus, the statuettes of donkeys carrying containers all belong to the Early Bronze Age I and not to earlier periods. The fact that the only animal depicted carrying containers in the Chalcolithic period is the ram suggests that it was the beast of burden of this period.

16 Commenge et al. 2006, 751: "Two preeminent symbolic figures emerge from the symbolical shift marking the initiation of Neolithic subsistence strategies in the Near East. One is 'the Goddess' who rules creation. The other is the Bull, generated by the Goddess herself. The Lady of Gilat and her ram acolyte could be reminiscent of this 'primary myth,' illustrated at Catal Huyuk, where the Goddess gives birth to bulls or, exceptionally, to rams. The Lady carries on her head a spindle-shaped vessel (the so-called 'churn') that, according to analysis proposed *supra*, symbolically stands for the Ram itself."

17 Ussishkin 1980.

18 Epstein 1985, 55.

19 Ussishkin 2012, 72. The basin in the center of the installation was plastered and meant for water—clearly water that was brought from the spring at En-Gedi and used in the cult. Mazar 2000, 33: "It can be suggested that a sacred tree with a stone platform built around it stood at the centre of the sanctuary."

20 Bar-Adon 1980.

21 In August 2013 the objects from the hoard were carefully recounted. Today the official count is 426.

22 Sebbane 2009, 251–52: "The hoard from Naḥal Mishmar accumulated in the temple, since assemblages of this size and quality could only have been collected in temples. The varied assemblage may allow us to conclude that some of the mace heads served as the community's weapons cache, some accumulated as votives . . . and some were used in the cult itself" (all translations from Hebrew sources are by N. B.).

23 On the basis of written sources from later periods, many scholars have tried to give divine names to the shapes found in the standards' decoration; see, e.g., Merhav 1993. In my opinion, these assumptions are somewhat problematic.

24 Bourke 2001, 120.

25 Mallon, Koeppel, and Neuville 1934.

26 Elliott 1977, 11: "An eight-rayed star, 1.84 m. in diameter, is the central feature and probably represents the sun."

27 Mallon, Koeppel, and Neuville 1934.

28 Cameron 1981, 13: "The horns on the masks are new. It could be possible that at the time of the reconstruction of the painting the bumps on the top of the masks could have been mistaken for horns."

29 Bourke 2001, 147.

30 North 1961, 32–36.

31 Seaton 2008, 125: "It is possible that the solar iconography of Chalcolithic Ghassul was an early indication of the adoption of sunrise and moonrise deities."

32 Roy and Chaffin 1987.

33 Seaton 2008, 127–38. According to Seaton, the domestic shrines and the temple overlap one another in time, or were roughly contemporary. The excavators connected the ceremonies that were held in the domestic shrines in Tell 2–3 and in the temple—thereby proposing the existence of two types of cult in a single site. The cult that was conducted in the temple was a new type related to growth in agriculture and in the economy, the first hint at the centralization of administration—an example of a direct relationship between cult and the development of a political model in the hands of an elite society.

34 No public buildings have come to light in the large settlement at Be'er Sheva. The assumption is therefore that the precious ivory statues represented deities and were used by the community and not for private use.

35 Elliott 1977, 3.

36 Epstein 1998.

37 The concept of death in Chalcolithic society may have been similar to that of inhabitants of Japan today, where there is not a clear distinction between the world of the living and the world of the dead. The roots of this belief lie in the ancestor cult and are not directly related to Buddhism. The Japanese believe in life after death and that the dead continue to be a part of our lives. Death is just one of many acts in the life cycle. See Hadad 2012, 91.

38 Bar-Yosef and Ayalon 2001, 43: "The very fact of secondary burial of the dead symbolizes the continued existence of souls that might return to life, just as seed collected can be replanted and will regenerate in the spring."

39 Moorey 1988, 179.

40 Merhav 1993, 38: "In our case the scepter may thus be the emblem of the divinity as patron of the dead."

41 Milevski 2010, 425.

42 Roy and Chaffin 1987, 143–48.

43 Rowan et al. 2006, 595–97.

44 Alon and Levy 1991a, 28–30.

45 van den Brink, Rowan, and Braun 1999, 163, 180. The stands are among the most important symbols in the spiritual world of these people, and include the example found under the arm of the goddess from Gilat as well as hundreds of stand fragments found in tombs, e.g., at Naḥal Qanah and Giv'at Ha-Oranim.

46 SInce most of these objects were discovered in the Golan and in the vicinity of the Sea of Galilee, it is possible that the workshop that produced the objects was located there. From this region the objects were distributed to other sites.

47 Perrot et al. 1967, 210.

48 Rosen 2002, 5.

49 Commenge 2006, 445; Golden 2010, 19.

50 de Miroschedji 1993, 215.

51 Kaplan 1959, 30–31.

The Mortuary Process in the Chalcolithic Period

Yorke M. Rowan
University of Chicago

Fenestrated stand with three bowls
and sculpted motifs. Clay, Peqi'in.
IAA: 2005-811, exhibited at IMJ.
Checklist no. 70.

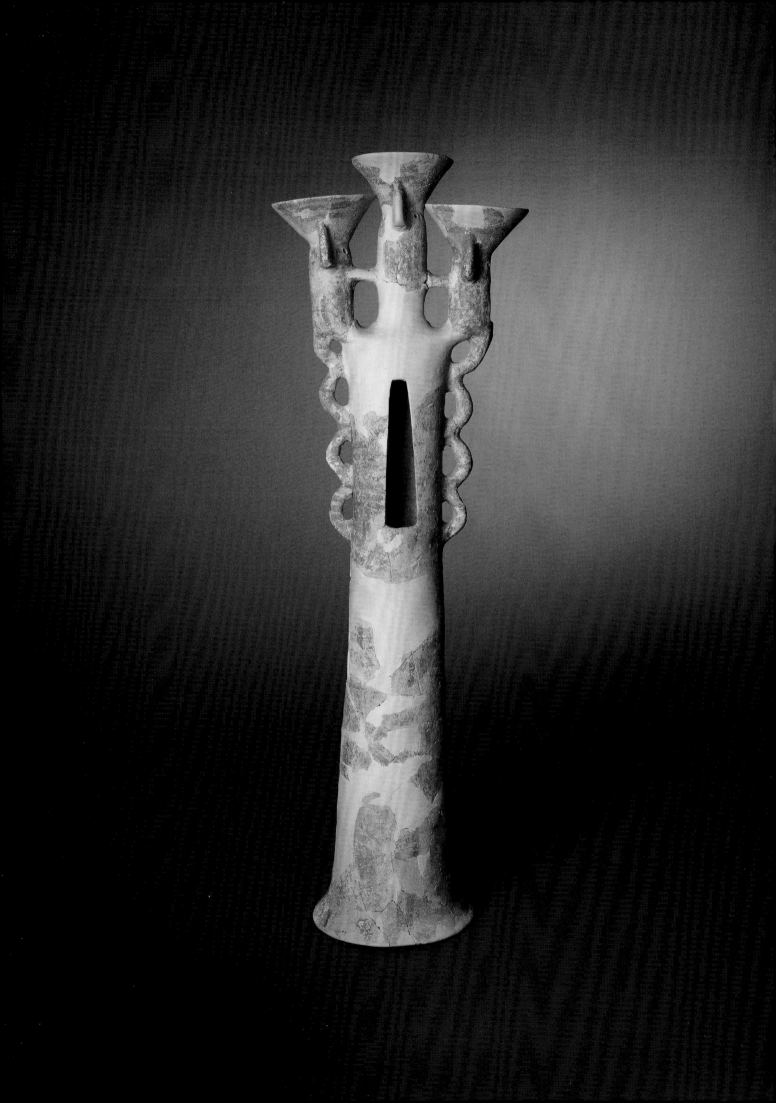

Human reactions to death are certainly not universal, although they are frequently expressive, possessing meaning. As Tarlow notes,[1] death is typically associated with intense emotion; the practices and paraphernalia associated with these sentiments surrounding the dead are culturally mediated.[2] As a result, the universality of death's impact on individuals and communities often produces rich practices and evocative material culture associated with mortuary activities. The burial process also implies intentionality, such that archaeologists are drawn to ancient funerary rituals, attempting to decipher and understand the complexity attached to the subject.

A number of publications[3] review the many approaches to the archaeology of death, highlighting some of the more salient aspects for analysis. Burial, or inhumation, is just one of the ways the living remove the dead. Burial practices, and the associated objects, may reflect a wide variety of choices based on gender, age, cosmological beliefs, or social status in life; these choices are made based on cultural preferences of the living. The resulting patterns from these choices may also reflect local traditions, timing of death, or temporal variations. Finally, deviation from well-established patterns may represent individual agency or reflect unusual circumstances of death.[4]

Significant changes in burial practices occurred during the Chalcolithic period, hinting at profound changes in beliefs about death. Relative to earlier periods, burial customs during the Chalcolithic were creative, diverse, and innovative. While most interments during the preceding Late Neolithic period were single, intramural (within living areas), primary burials, by the Chalcolithic, secondary burial became common in a variety of regions. And although separate burial areas are known by the Epipaleolithic in the Southern Levant,[5] the Chalcolithic witnessed construction of structures and hewn subterranean chambers for interment in formal cemeteries. This major change, manifest in a variety of different forms, corresponds with significant changes in the treatment of the human body, specifically secondary burial, typically for reburial in cemeteries (see below).

Primary vs. Secondary Burial of the Dead
Primary Burial
Primary burial is the initial interment of the body after death. Intramural, articulated burials, of all ages and both sexes, are not uncommon at Chalcolithic villages (among them, Gerar, Shiqmim, Tel Te'o, and Tuleilat Ghassul). As in the Neolithic, the absence of burial goods with most primary burials is notable (but for an exception see the Cave of the Warrior, below). Where articulated, skeletons are often flexed and interred in pits, under floors, or along walls. Storage jars were used as receptacles for primary infant burials, an additional continuity with the previous Late Neolithic. At Tuleilat Ghassul ceramic-vessel sherds were sometimes used to hold or cover the body. Five complete adult skeletons were excavated at Bir Ṣafadi, three of them placed in pits. Perrot[6] noted two in particular; one was flexed and found at the bottom of a bell-shaped pit, while the other, found near a wall inside a subterranean chamber, was situated on its side with hands covering the face, sherds placed on points of articulation, and a flint tool in the mouth.

Extramural primary burials are less common but are also known, typically found in caves. An exceptional example was found in Wadi Makukh, near Jericho. Preserved in a dry cave, the primary burial of the Cave of the Warrior included exceptional preservation of organic materials, such as a wooden bowl (fig. 5-1), a wooden bow and arrow shafts (fig. 5-2), a basket (fig. 5-3), sandals, and extensive textiles.[7] The skeleton, with preserved cartilage, ligaments, and skin tissue, was an articulated, flexed male placed on a mat (see fig. 1-11) and wrapped in flax linen, all liberally sprinkled with ochre. The organics provided AMS dates in the late Chalcolithic (ca. 3912–3777 BCE cal), although the mat dates

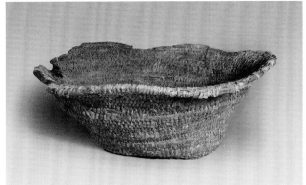

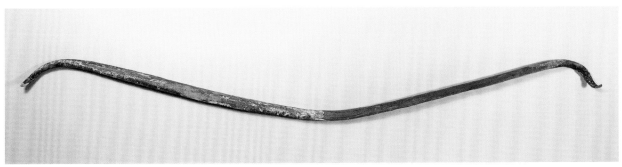

substantially earlier (ca. 4515–4456 BCE cal).[8] The wrapping sheet, a large rectangular woven cloth with fringe at either end, was almost 7 m in length and manufactured as one complete piece.[9] Additional textile fragments were also included with the burial. Schick points out that these were exceptional textiles, requiring substantial time and labor, perhaps indicating a person of some importance (albeit more likely a hunter rather than a "warrior").[10]

At the site of Gilat, which Levy[11] suggests functioned as a sanctuary site, an estimated ninety-one individuals were buried,[12] constituting the most substantial concentration of intramural burials dated to the Chalcolithic in the Southern Levant. In one large burial structure, possibly a re-used silo, nine primary burials were interred within a large, well-made circular mud-brick structure, without apparent burial goods.[13] Many of the burials at Gilat, however, are bone clusters apparently in shallow pits; others are no more than a few stray bones or teeth. These may represent skeletal elements left behind during

collection of skeletal remains for the secondary burial process, but no connected cemetery is known.

Secondary Burial

In many cultures death is not a brief, final event but a process of transition from one state to another. Secondary burial is recognized as a manifestation of this extended transitional process, concluding a liminal period of decay after the initial phase of inhumation or defleshing. In the archaeological literature, primary and secondary burial are often treated as separate practices, rather than as a multistaged process.

Although intramural articulated primary burials continue earlier Neolithic traditions,[14] the secondary treatment of human remains becomes an established phenomenon during the Chalcolithic. Secondary treatment (or secondary burial) refers to the manipulation of human remains following the initial, primary burial of the dead body. Archaeologically, this is typically recognized by the disarticulated state of the skeletal elements and missing bones. Often, long

5-1 (top left): Asymmetrical bowl. Tabor oak (*Quercus ithaburensis*), Cave of the Warrior, Wadi Makukh. IAA: 1961-1181. Checklist no. 120.

5-2 (bottom): Bow. Olive wood, Cave of the Warrior, Wadi Makukh. IAA. Checklist no. 112.

5-3 (top right): Basket. Straw, cow leather, linen thread, Cave of the Warrior, Wadi Makukh. IAA: 607/48. Checklist no. 125.

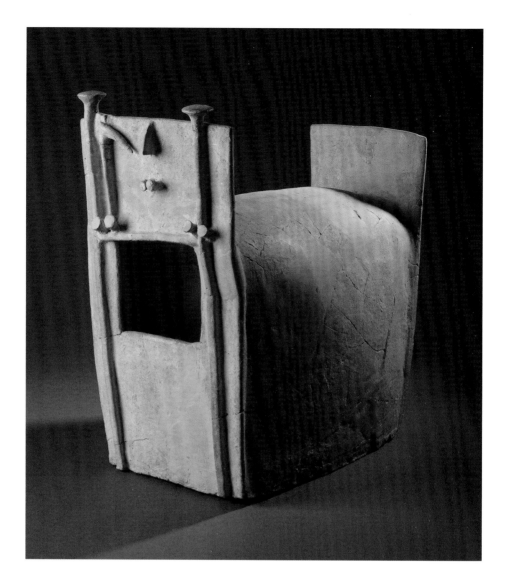

bones and skulls are removed for reburial after decay, away from the initial interment. Removal and modification of crania was common during the Natufian and Pre-Pottery Neolithic, emphasizing that the focus was primarily on the head; by the Chalcolithic this shifted dramatically to include removal of many skeletal elements for reburial elsewhere, often in stone or ceramic containers (ossuaries).

Ossuaries

A hallmark of burial practices during the Chalcolithic is the introduction of ossuaries, or receptacles for bones. These containers were typically buried in natural karstic caves, hewn spaces taking advantage of natural hollows or subterranean spaces dug into sediment.[15] Known cave burials are concentrated along the coastal plain and the hills, from the Northern Galilee to the Judean Desert. A few ossuary fragments were recovered from grave circles at Shiqmim[16] and subterranean features such as Kissufim.[17] These are limited to the more southerly, arid zones where caves are uncommon.

5-4: Ossuary with architectural facade. Clay, Azor. IAA: 1971-341, exhibited at IMJ. Checklist no. 63.

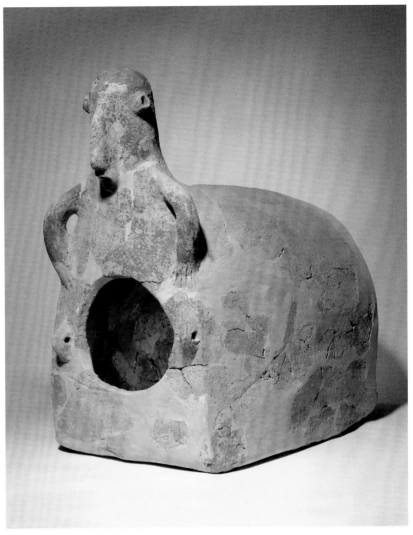

Perrot and Ladiray[18] established a typology for ossuaries, comprising three general forms—the box (including stone examples), the "house," and jars. Box forms (or tubs) are generally open, elongated boxes; the "house" type is roofed and usually painted, and often includes a prominent modeled nose with painted eyes above the opening where skeletal elements would be inserted (fig. 5-4). The peaked roof and other modeled aspects on the exterior of the "house" ossuaries inspired the name, although these more elaborate forms are unlikely to represent dwellings of the period. Jar forms are less common and typically lack modeled features with the exception of a knob at the top. A fourth type—

open ceramic bowls and jars—should be added to the typology (see fig. 1-12).

The "house," or structural ossuary, is most frequently decorated; examples of this type often include pronounced modeled noses and painted eyes, but the discoveries at Peqi'in established a new range of motifs,[19] particularly with the addition of modeled arms, mouths, snouts (deviating from the typical Ghassulian noses), headdresses, and other head adornments (figs. 5-5, 5-6, 5-7). In one case double heads were modeled atop an ossuary from Peqi'in. A rich assortment of vessels, particularly painted fenestrated, pedestaled stands ("chalices"

5-5: Three-dimensional anthropomorphic head from an ossuary. Clay, Peqi'in. IAA: 2007-2247, exhibited at IMJ. Checklist no. 73.

5-6: Anthropomorphic ossuary with modeled arms and torso. Clay, Peqi'in. IAA: 2007-1801, exhibited at IMJ. Checklist no. 60.

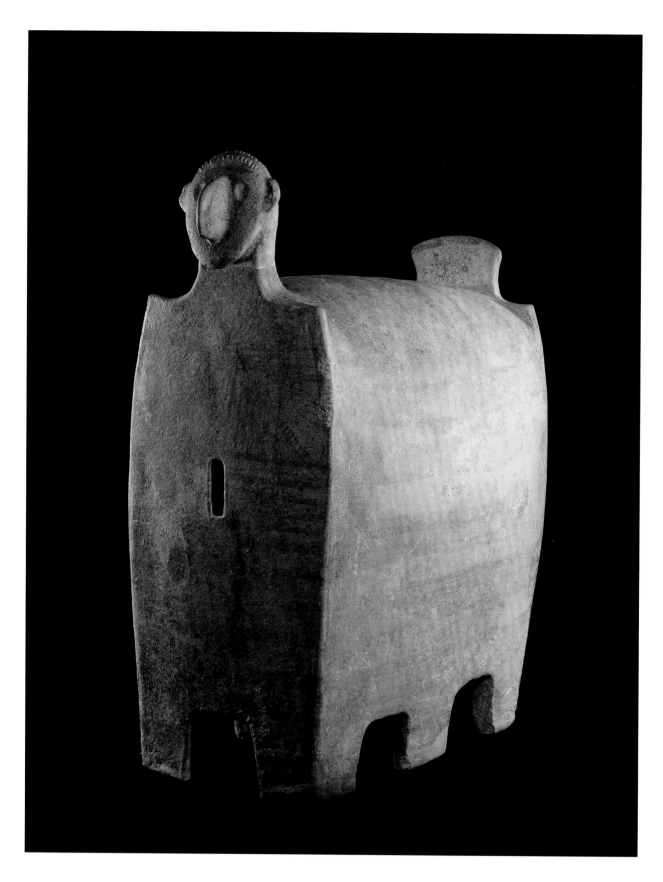

5-7: Anthropomorphic ossuary with
prominent male face. Clay, Peqi'in.
IAA, Eretz Israel Museum: 2002-1038.
Checklist no. 59.

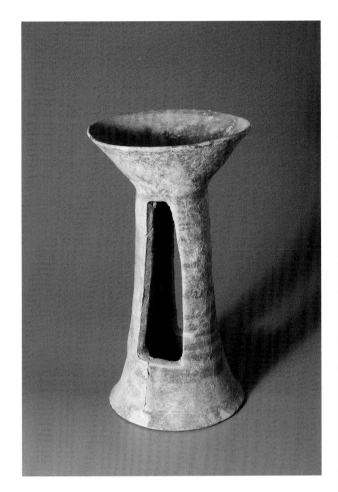

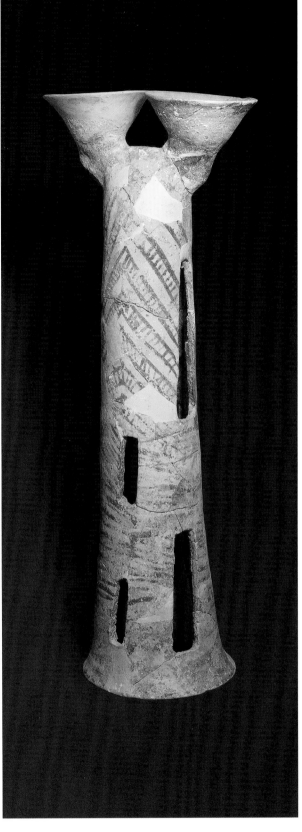

5-8: Fenestrated bowl with painted
motifs. Clay, Peqi'in. IAA: 1997-3567.
Checklist no. 69.

5-9: Fenestrated stand with two
bowls. Clay, Peqi'in. IAA: 1997-3564.
Checklist no. 68.

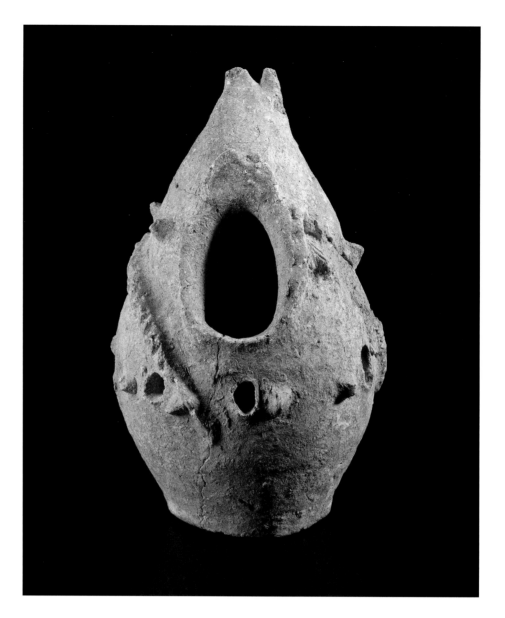

or "incense burners"), formed part of the mortuary assemblage at Peqi'in (page 101, figs. 5-8, 5-9). Jar ossuaries (fig. 5-10) have been posited to represent grain silos[20] or a chrysalis;[21] the latter interpretation is supported by lines painted in red that may represent the veins of a cocoon (or, alternatively, a floral motif).

The diverse ossuary forms and decoration preclude a simple analogue to a single concept. Some forms of historic silos are similar, but only to selected ossuaries. Likewise, some jar ossuaries bear similarities to biological forms such as a chrysalis or bud, but those biological structures are unlike other ossuary types. Ultimately, though, ossuaries seem intended to ensure or expedite regeneration or rebirth.[22]

The distribution of ossuaries is limited. An apparent concentration along the central coastal plain and piedmont zone reflects, at least in part, the higher density of modern building and development around Tel Aviv driving salvage archaeology excavations. Nonetheless, the concentration of ossuaries diminishes from west to east, with the most easterly discoveries near Tell Balatah in the highlands,

5-10: Miniature ossuary decorated with a snake. Clay, Ben Shemen. IAA: 1963-443, exhibited at IMJ. Checklist no. 38.

and Umm Qaṭafa on the western edge of the Judean Desert.[23] Recent cave surveys in north and central Jordan produced little evidence of Chalcolithic mortuary remains or ossuaries.[24] To the north no ossuary fragments are known beyond Peqi'in in the Upper Galilee, and none to the south beyond the cemeteries at Shiqmim (where only five grave circles included ossuary fragments) and Kissufim. This suggests that despite other similarities in material culture, secondary burial in ossuaries was an uncommon practice for those living in areas such as the Golan Heights, the arid southern zones, or east of the Jordan Valley.

Regional Patterns

Regional aspects of mortuary practices are difficult to discern. Dolmens may have started during the Chalcolithic, but datable material is rarely found with the dolmens. While the uncommon cist burials apparently concentrate to the east of the Jordan Valley, well-dated examples of these are rare, although examples such as the Adeimeh cemetery near Tuleilat Ghassul[25] are more convincingly dated to the Chalcolithic than are dolmens. Grave-circle cemeteries may concentrate in the southerly arid zones, but they are not well documented beyond Shiqmim (although they are known from Palmaḥim).

In the north, Chalcolithic settlements in the Golan are well-known, but burials remain unknown. Here too dolmens may have served as burials for some segment of the population, but no skeletal material is dated to the Chalcolithic. Were the cadavers left out to be devoured by scavengers? Or were the bodies removed to more distant places such as Peqi'in, where Golan-style pottery found in the cave attests to connections among these regions?

The use of deep karstic caves and hewn caverns is discussed above, but caves in the Judean Desert also included human interments. Many of these are poorly documented, but primary burial appears typical in this region. The extraordinary cache of copper and other exotic items at Naḥal Mishmar included primary burials, some almost certainly associated with the Cave of the Treasure.[26] Whether this is a mortuary assemblage or not,[27] the motifs of the deposit underscore the primary concern with death and the regeneration of life.[28]

Other cemeteries such as Kissufim are without parallel and thus cannot be considered representative of a region or culture. A few cave examples such as Peqi'in are extraordinary for the wealth of iconographic and decorative representation on the ossuaries, but include artifacts typically found in other regions. For example, before their discovery in Peqi'in, copper and ivory (see fig. 3-12) were limited to southern sites, particularly in the northern Negev and southern Jordan Valley. Likewise, although the pottery and flint assemblages are similar to those of Tuleilat Ghassul, Gilat has an atypically dense burial population without parallel in other regions or sites.

These comparisons suggest that although the practice of secondary burial became common during the Chalcolithic, this was not a homogenous, standard phenomenon across the Southern Levant. Ethnographic studies demonstrate that such great variability across a diverse landscape is also typical in other societies, including those practicing secondary burial treatment. Metcalf and Huntington[29] note that among the Berawan of Borneo (who also practiced secondary burial), diversity in actual practice was evident; secondary burial was considered ideal, but attendant rituals varied from village to village and from family to family, and many of the dead were not given secondary treatment. Leaders, or those aspiring to lead, would also use the death of relatives as an occasion to demonstrate their own prestige and power by motivating followers for the construction of mausoleums.[30] The social status of the dead could be manipulated or misrepresented, expressing the political machinations of the living much more than the status of the deceased.

The Human Remains

Our knowledge of the skeletal remains from Chalcolithic burials is sadly incomplete. Environmental conditions and site-formation processes create poor preservation of secondary remains in caves. Political pressure from the Haredi Jewish community requesting human remains for reburial has prevented, at times, all but the most rudimentary anthropological analysis. Some information, however, allows a few basic observations. Skeletal and dental pathologies are generally severe, with enamel hypoplasia indicative of environmental stress, possibly the result of an increasing reliance on cereal crops and endemic infectious diseases.[31] At Peqi'in examination of 100 mandibles identified hypoplasia, caries, and wear rates on molars, indicating that the young endured significant stress.[32] Likewise, the Gilat population exhibited similar poor health, with enamel hypoplasia more pronounced than that of Peqi'in.[33] At the nearby site of Kissufim, similar attributes of poor health were observed.[34]

Infants and neonates are usually not included in secondary-burial cemeteries; this absence does not indicate a lack of concern but simply a different status and burial treatment. At Peqi'in all individuals were over three to four years old, and approximately 80 percent of the sample was fifteen or over.[35] At another cave site, Ma'abarot, an estimated 90 percent of approximately fifty-eight individuals were identified as male.[36] At Kissufim infants and young children were recovered but were buried outside of the subterranean, mud-brick structure.[37]

Mortuary Goods and Interpretation

The pattern of symbolically loaded, prestige-items inclusion with parts of the mortuary process during the Chalcolithic dramatically increases in contrast to Late Neolithic burials, which have virtually no burial goods. Chalcolithic prestige items are typically found associated with secondary burials, often in caves and other subterranean space, and usually in association with ossuaries. Nevertheless, many Chalcolithic burials have no directly associated finds.

Although there is no standardized burial "kit" in Chalcolithic funerary assemblages, there are recurrent forms, particularly pottery vessels. Vessel types include V-shaped bowls, basins, jars, and pedestaled, fenestrated bowls. Cornets are uncommon in burials, although there are a few examples. Groundstone vessels, specifically basalt bowls, are also found,[38] including particularly elaborate forms of pedestaled, fenestrated stands.[39] Very few items of personal adornment are found, except occasional shell pendants (fig. 5-11). Whether these objects were possessions of the deceased, equipment for the afterlife, or intended to ward off negative spirits is unclear.

Where prestige items occur, they are rarely found in clear association with a single individual. Instead, most mortuary goods are found in secondary burial contexts, where individual skeletal elements are commingled. Vessels and other burial goods were not placed in the ossuaries, but near the center of the chamber/cave holding the ossuary and grave goods. There are virtually no burials dated to the Chalcolithic where prestige objects are directly connected to a single individual (although the extensive linen found in the Cave of the Warrior burial is a notable exception). Collective burial contexts where burial goods and individuals are not clearly associated (or are even intentionally blurred or erased) further complicate interpreting social status based on artifact patterns.

At Naḥal Qanah, where the gold-and-electrum rings were recovered, their original position and contextual associations are unclear due to the karstic conditions and collapse in the cave. Gopher and Tsuk,[40] the excavators, suggest that the rings were associated with Grave X, based on similar use of natural and constructed surfaces for burials in other areas of the cave during the Chalcolithic period. According

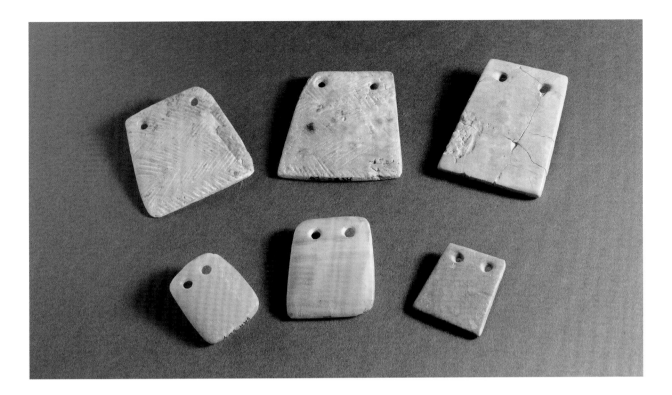

to this reconstruction, four individuals were associated with the contexts attributed to Grave X: one small child, one child, one adolescent, and one adult. An additional adult could also be associated with this group. Assuming these individual burials belong together and the contextual reconstruction is accepted, basalt vessel fragments, hematite mace heads, copper, and ostrich-eggshell fragments originally accompanied the gold-and-electrum rings. This burial group, then, was the richest found at Naḥal Qanah.[41] Ossuaries were not, however, connected with these finds. Summarizing the artifacts and the burials throughout the cave, and confounding efforts to establish direct links of valuable grave goods with individuals, the excavators concluded that group burials have a tendency to be rich in grave goods while single interments (whether of children or adults) have poorer offerings.

Conclusion

The inclusion of valuable objects far more exotic than personal adornment or mundane items emphasizes a dramatic change in beliefs about how to care for the dead. Differential burials are recovered, some with elaborate finds, many with no finds. This hints at a nonegalitarian social structure, yet because the exotic finds are found with commingled secondary bones, it leaves open the question of whether or not inherited status may be inferred based on mortuary information. Ranking of social groups seems likely, but emphasis is placed on the inclusion of evocative, prestige objects with secondary group burials. For these reasons Chalcolithic mortuary practices do not necessarily directly reflect individual status or rank—not all mortuary ritual is political.

Nevertheless, these patterns underscore the ritual disposal of sacred items,[42] emphasizing the significance of this final stage of the mortuary process and reintegration of the dead. The retrieval of bones, inclusion of mortuary finds, and creation of

5-11: Pendants (4). Stone, Bir Ṣafadi and Abu Matar. IAA: 1958-573, 1993-2350, Checklist nos. 13, 23. Shell (mother-of-pearl), Kissufim. IAA: 1993-2934, 1993-2943, Checklist nos. 24, 25. Greenstone, find location unknown. IAA: 1993-5219, Checklist no. 26. Limestone, Bir Ṣafadi. IAA: 2007-1628, Checklist no. 33.

decorated, specialized containers indicate that death was an extended, ceremonial process, probably with some aspect of a social event. Secondary burial suggests that death did not entail the immediate destruction of an individual.

Dramatic changes occurred during the Chalcolithic period, and this is particularly evident in new attitudes to the dead. Specific containers were designed for the secondary burial of bones, and these were often interred in subterranean spaces, separate from the living. Cave burial was not new, but the intentionally hewn and modified caves and other subterranean features carved explicitly for the dead represented a new concept. Although the practice of secondary burial waned soon after the Chalcolithic, the concept of the tomb persisted for millennia, a legacy of the impressive changes wrought during this period.

Notes

1 Tarlow 1999.
2 Piggott 1969; Harke 1997.
3 See, e.g., Morris 1987; Brown 1995; Tarlow 1999;
 Parker Pearson 2000; Rakita and Buikstra 2005;
 Laneri 2007.
4 Giddens 1984; Tarlow 1999; Robb 2007.
5 Maher et al. 2011.
6 Perrot 1984.
7 Schick 1998.
8 Jull et al. 1998, 111 (table 20.1).
9 Schick 1998, 8.
10 Schick et al. 1998, 126.
11 Levy 2006a.
12 Smith et al. 2006.
13 Levy et al. 2006.
14 Gopher and Orelle 1995.
15 van den Brink 1998; van den Brink 2005; Rowan and
 Ilan 2013.
16 Levy and Alon 1982; Levy and Alon 1985a.
17 Goren and Fabian 2002.
18 Perrot and Ladiray 1980.
19 Gal, Smithline, and Shalem 1996; Gal, Smithline,
 and Shalem 1997; Gal, Smithline, and Shalem 1999.
20 Bar-Yosef and Ayalon 2001.
21 Nativ 2008.
22 Rowan and Ilan 2013, 90.
23 Perrot 1992.
24 Lovell 2009.
25 Stekelis 1935.
26 Bar-Adon 1980.
27 Ilan 1994.
28 Ilan and Rowan 2012.
29 Metcalf and Huntington 1991, 85.
30 Ibid., 150.
31 Lev-Tov, Gopher, and Smith 2003.
32 Ibid.
33 Smith et al. 2006.
34 Zagerson and Smith 2002.
35 Nagar and Eshed 2001, 29 (table 1).
36 Agelarikis et al. 1998, 439.
37 Ibid.
38 Rowan 2005.
39 van den Brink, Rowan, and Braun 1999.
40 Gopher and Tsuk 1996, 223–24.
41 Ibid., 226.
42 Ilan and Rowan 2012.

The Hoard from Naḥal Mishmar, and the Metal-working Industry in Israel in the Chalcolithic Period

Michael Sebbane
Israel Antiquities Authority

Cave of the Treasure, Naḥal Mishmar.
In 1961 a team of archaeologists led by
Bar-Adon (shown here) discovered the
copper hoard. (Photo by Werner Braun)

Metal hoards are not common in the archaeological record of Israel, and hoards that can be attributed to the fifth and fourth millennia BCE, when copper tools, weapons, and ceremonial artifacts were first manufactured, are particularly rare. Among these, the hoard from Naḥal Mishmar is outstanding in its scale and the impact it had on scholarship (see page 115).[1] More than fifty years after its astounding discovery, the significance of the hoard from Naḥal Mishmar in reconstructing the metal industry of the Chalcolithic period in Israel is still unsurpassed. Naḥal Mishmar provides unique insight into raw-material procurement, manufacturing techniques, and craft specialization; it allows the researcher to reconstruct assemblages and their function, whether as weapons, working tools, or ritual artifacts; and it even provides insight into regional and inter-regional contacts and social stratification. A comprehensive discussion of this range of subjects is beyond the scope of this article. My intention is to examine briefly the typological and chronological aspects of the hoard and to investigate through it the character and scale of the metalworking industry in Israel in the Chalcolithic period.

Metalworking in Israel in the Chalcolithic Period

The Chalcolithic-period metallurgic finds in Israel—artifacts and industrial remains—indicate the existence of two distinct specialized industries:

- Casting tools using an open mold. This industry produced axes, adzes, chisels, and awls in open molds (fig. 6-1), exploiting primarily local ores from the areas of Timna in Arava and Feinan in Transjordan, which contain almost pure copper.[2]
- Casting utensils and prestige items using the lost-wax technique.[3] This complex technique involves the following stages (fig. 6-2): (1) Preparing a stone or clay core that was roughly fashioned in the shape of the mace head, but in a smaller size. The aim of this stage, which is optional, is to save metal. (2) Preparing a wax model (tree resin and bitumen could be used as substitutes). The model is constructed around the core, to which it is attached by metal, wood, or bone pins. It is made in the exact size and shape as the desired end product, down to the last detail of surface finish and decoration. If the object is made entirely of metal, this is the first stage. (3) Preparing the clay mold. The wax model is coated with clay, which takes the imprint of its surface when the object is fired. In the course of firing, the wax melts and runs out through a prepared channel that will act in the casting stage as a conduit to relieve air pressure. The resulting hollow mold is the exact negative of the wax model. (4) The molten copper is poured through a funnel into the mold, and the air escapes through the channel, thereby preventing the formation of bubbles in the cast. Once the metal has cooled and hardened, the mold is broken. (5) In the final stage the surface is polished to a smooth, lustrous finish. Ethnographic evidence makes it clear that the actual casting (stage 4) is a relatively simple part of the production. Labor and expertise are mostly necessary for carving the wax model and preparing the clay mold (stages 1–3).

6-1: Axes and adzes. Copper, Meser and Givat Ha-Oranim. IAA: 1956-958, 1956-960, 1997-3463. Checklist nos. 132, 133, 152.

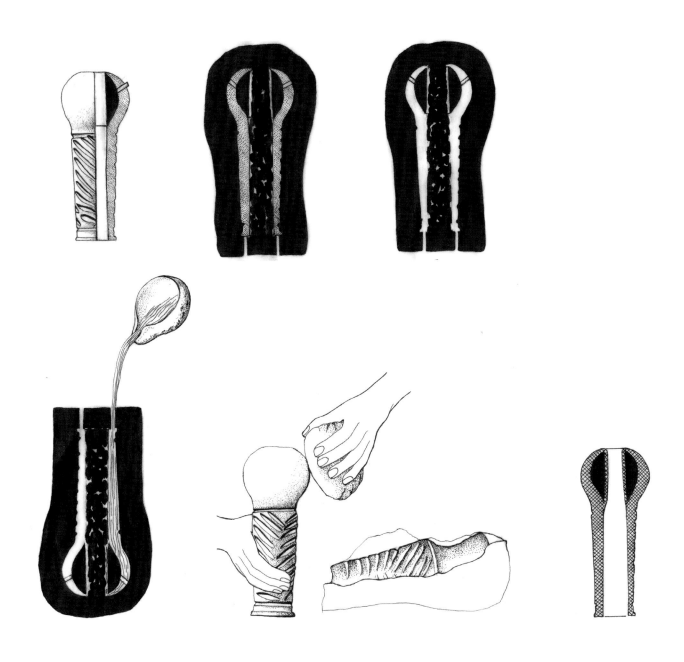

6-2: Casting in the lost-wax technique.

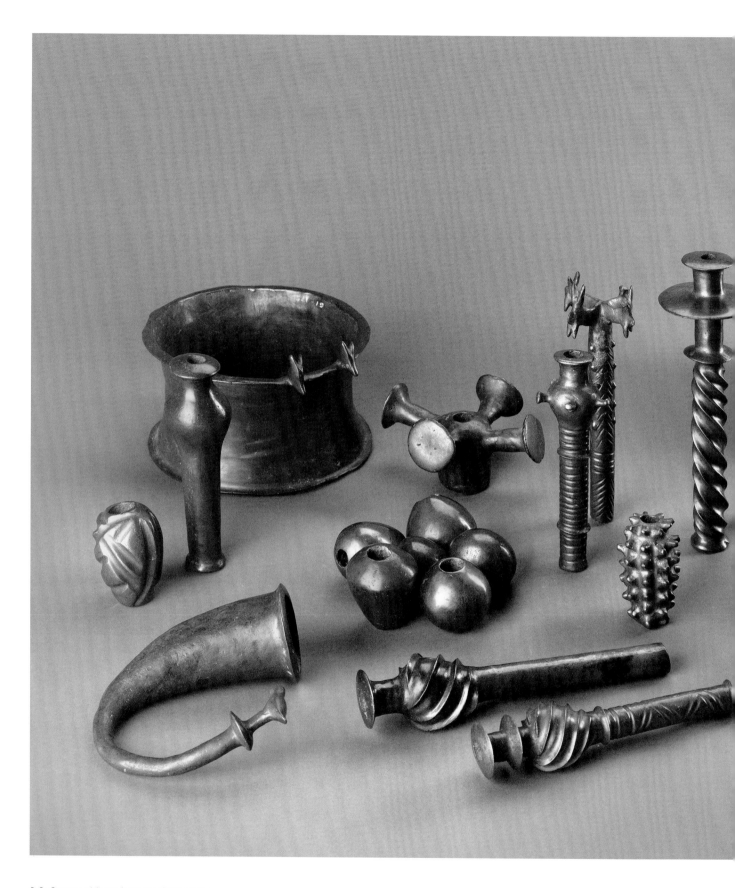

6-3: Copper objects from the Cave of the
Treasure hoard, Naḥal Mishmar, made with
the lost-wax technique. Exhibited at IMJ.

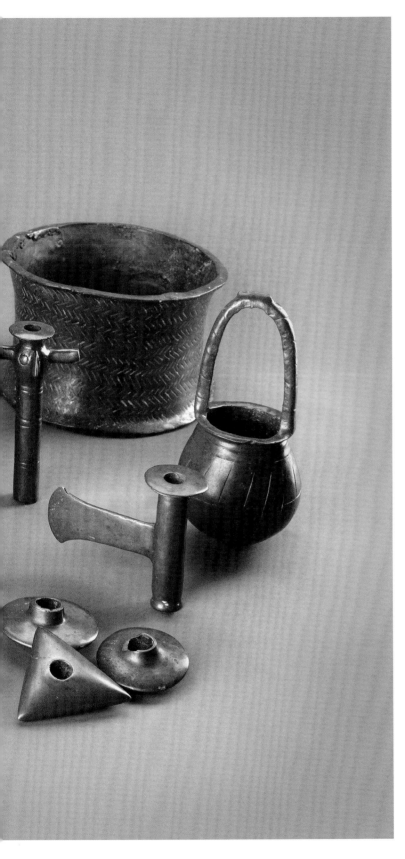

This industry produced mace heads, maces, scepters/standards, "crowns," shaft axes, and containers (fig. 6-3), using primarily ores or alloys containing arsenical copper, antimony-arsenical copper, and nickel-arsenical copper.[4] The lost-wax technique is the most advanced manufacturing technique of ancient metallurgy,[5] and is unknown in most of the Ancient Near East before the second half of the fourth millennium.[6] Its occurrence in Canaan as early as the second half of the fifth millennium raises questions about the origin of the craftsmen and the source of their knowledge, as well as the circumstances of their sudden disappearance at the end of the Chalcolithic period.

The source of raw materials so far remains an open question. Extensive geological surveys that were undertaken in the areas of the mines of Timna and Feinan found no evidence of the existence of lodes of arsenical copper, antimony-arsenical copper, or nickel-arsenical copper. These results reinforce the opinion expressed by geologists since the hoard was found that there is no reason to look for the source of the copper in these mines.

The options that have been suggested so far include eastern Anatolia;[7] Azarbaijan—the Small Caucasus and the Trans-Caucasus;[8] Georgia, on the southern slopes of the Great Caucasus; Anarak in Talmessi; and the Meskani region in central Iran.[9] Additional possibilities are southern Sinai, Hejaz, and the Idumean Mountains.[10]

Another unresolved issue is whether there was a genuine process of copper alloying, or instead the fortuitous use of naturally occurring antimony-arsenic and nickel-rich copper. The latter possibility seems more plausible, but in either case the high frequency of these elements in the copper indicates that the Chalcolithic metalsmiths recognized their efficacy in lowering the melting point of the metal and increasing its fluidity, thereby improving the quality of the cast, in particular increasing the

hardness of the product.[11] Regarding the area of production, petrographic analyses that were conducted on remnants of cores and clay plugs from scores of artifacts show that they were cast in Israel.[12] The actual place of manufacture is, however, yet one more open question, as is the mode of production: whether at a specialized production center operating outside settlement boundaries, or by specialized itinerate craftsmen-artists who traveled between the Chalcolithic settlements and cast vessels according to local demand.[13]

The Hoard: Archaeological Context, Typology, Technology, Function, and Regional and Inter-regional Contacts

The hoard from Naḥal Mishmar was discovered wrapped in a reed mat under a sloping stone in a natural niche in Hall B of Cave 1 (see page 115). It is difficult to identify the location of the niche within the hall from the published description, or to relate the hoard to the other Chalcolithic remains that were uncovered in the cave. These include pottery, bone artifacts, mortars, hearths, and five burials in Hall B.[14] The hoard comprises predominantly artifacts that were manufactured in the lost-wax technique, with a small number of tools that were cast in open molds (see Table 1 for a detailed list).[15]

Table 1. Composition of the Naḥal Mishmar Treasure

Cast with the lost-wax method

Plain rounded mace heads	240
Decorated rounded mace heads	18
Carinated mace heads	16
Cylindrical mace heads	4
Maces	87
Scepters/standards	11
"Crowns"	10
Containers	8
Shaft axes	3
Hammer	1

Cast in open molds

Axes	11
Adzes	4

Nonmetal artifacts

Hippopotamus- and elephant-ivory objects	6
Rounded hematite mace heads	6
Rounded limestone mace head	1

The metallurgical quality of the artifacts is not homogenous. In addition to outstanding objects, there are those with casting defects, bubbles, repairs, or lacking surface finish and polishing.[16] This diversity supports the assumption that the assemblage was the work of a number of groups of craftsmen-artists, and that some objects were used extensively before they were stowed away.

No two artifacts among the hundreds that were cast in the lost-wax technique are identical, indicating that each item was individually fashioned, and that no use was made of two-part stone master molds, a method that would have undoubtedly streamlined and shortened the production process.

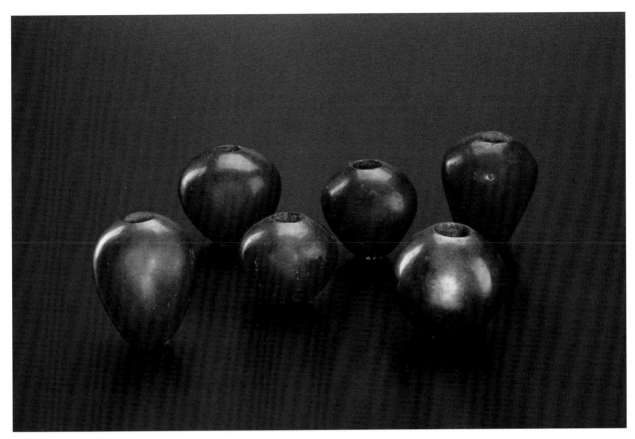

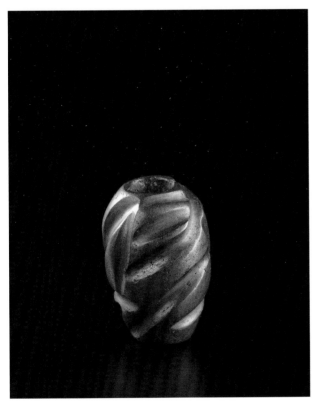

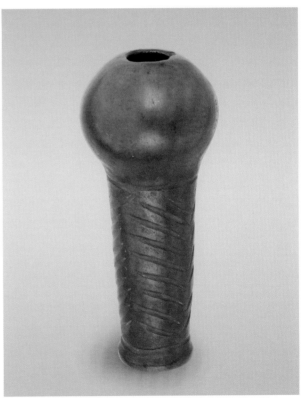

6-4: Plain round mace heads.
Copper, Naḥal Mishmar.
IAA: 1961-297, 1961-313,
1961-316, 1961-330, 1961-336,
1961-344, exhibited at IMJ.
Checklist nos. 86–91.

6-5: Incised mace head.
Copper, Naḥal Mishmar. IAA:
1961-114, exhibited at IMJ.
Checklist no. 77.

6-6: Decorated mace head with
long neck. IAA: 1961-90.

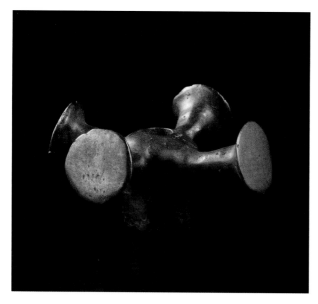
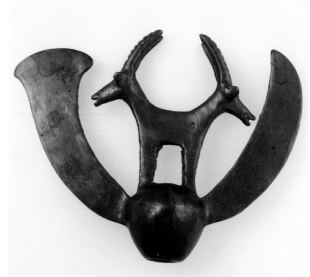

Plain rounded mace heads. This category includes 240 items—spheroid and piriform metal mace heads in a wide range of types, without relief or plastic decoration (fig. 6-4).[17] Other Chalcolithic sites yielded in total seventeen plain rounded mace heads: three at Abu Matar,[18] one at Bir Ṣafadi,[19] one at Gan HaShlosha, one in a cave in Naḥal Lahat, three in a cave in Naḥal Ẕe'elim,[20] three at Ḥorvat 'Ashan, one at Shiqmim,[21] and four at Giv'at Ha-Oranim.[22] The size and weight of the rounded mace heads place the vast majority within the parameters of those that can be used as weapons— weight 150–650 gr, height 4–6.5 cm, and internal diameter of the shaft 1.1–2.2 cm.[23] These data lead to the assumption that at least some may have been manufactured as weapons and became votive objects at a later stage (see below). Rounded metal mace heads are not known in assemblages of the period elsewhere in the Ancient Near East, and may be considered an innovation of the local Chalcolithic metalsmiths who mastered the lost-wax technique. To the best of my knowledge, there is only one exception that corresponds chronologically, typologically, and technologically to the Chalcolithic copper mace heads from Israel.[24] It was found in the large Chalcolithic cemetery that was exposed at Parchina, in Pushti-Kuh, Luristan, where tens of

mace heads, in a wide range of types and raw materials, were uncovered in tombs that date between the second half of the fifth millennium and the first half of the fourth. Among them was a single rounded copper mace head that was manufactured in the lost-wax technique.[25] The circumstance of the find, within a large and varied assemblage of stone mace heads, makes it plausible that similar items will be discovered in the future.

Decorated mace heads. This category includes eighteen decorated items with long or short necks. The decoration comprises designs in relief—grooves, herringbone patterns and round protuberances (figs. 6-5, 6-6), and plastic decoration—mushroom-shaped protuberances, spikes, blades, and ibex figures (figs. 6-7, 6-8).[26] Conspicuous among them is a rounded mace head with outstanding technological and artistic qualities. It incorporates applied images portraying a pair of ibexes, the blade of an axe/adze, and a knife blade.[27] The components were carefully chosen to convey power, and their integration has a synergistic effect. The mace head is the central element of the object and from it emerge all other symbols and artifacts. The same principle applies to the scepters and the other ceremonial mace heads, and it clearly expresses the central

6-7: Mace head with four protruding cylindrical bosses. Copper, Naḥal Mishmar. IAA: 1961-117, exhibited at IMJ. Checklist no. 78.

6-8: Rounded mace head with a pair of ibexes. IAA: 1961-119.

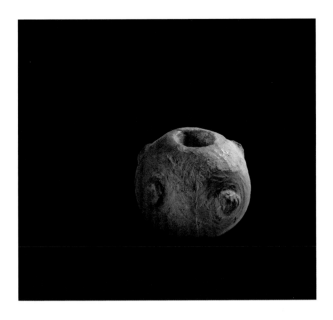

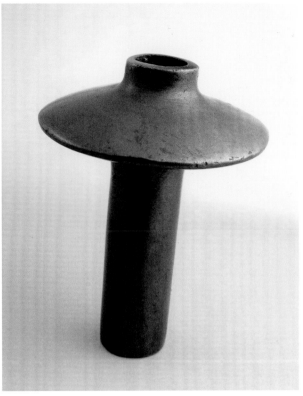

status of the mace in the assemblage of weapons and ritual objects of the period (see below). Ibexes typically decorate objects with religious meaning during the fifth and fourth millennium, and they seem to have been considered a symbol of might and potency. The central position of axes and adzes in the assemblage of everyday tools during the Chalcolithic period, when they were first manufactured in metal, renders them an obvious symbol of power. The knife blade is so far unique in the Chalcolithic assemblage, and seems to be inspired by the Egyptian flint blades of the Predynastic period. The importance of these last is best demonstrated by knives with ivory handles that are lavishly ornamented in relief images of animals, mythological motifs, and battle scenes.[28] This ornate composite object is undoubtedly ceremonial, and may have been carried as a symbol of authority and power in ritual ceremonies. It may have reached the temple as a votive, or it may have functioned as a cultic focal point (see below).

Three rounded mace heads with necks were found in other Chalcolithic sites, but unlike the items from Naḥal Mishmar, they have no relief or plastic decoration: a mace head from burial cave no. 9 at Palmaḥim,[29] a mace head from Neveh Noy,[30] and a mace head from a burial cave at Peqi'in (fig. 6-8).[31] No decorated metal mace heads were found in contemporary assemblages in the Ancient Near East, and they seem to be unique to the local industry. It seems, however, that there was contemporary use of decorated stone mace heads that were produced by specialized stone masons, as for example the mace head from HaZore'a, which is decorated with four round protuberances (fig. 6-9), and two rounded limestone mace heads decorated with four round protuberances that were discovered in Naḥal Besor Site A.[32] The eight limestone mace heads decorated with round protuberances and spikes that were discovered in the large Chalcolithic cemetery at Parchinah further support my assumption.[33]

Scores of stone mace heads that were produced by such specialized masons were found in fourth- and third-millennia temple complexes in Mesopotamia and Egypt, decorated with relief patterns and plastic images, some of them carrying dedicatory inscriptions to gods and kings (see Discussion below).

6-9: Mace head decorated with four protruding knobs. Stone, Kibbutz HaZore'a. IAA: 1991-351. Checklist no. 99.

6-10: Carinated mace head with long neck. IAA: 1961-98.

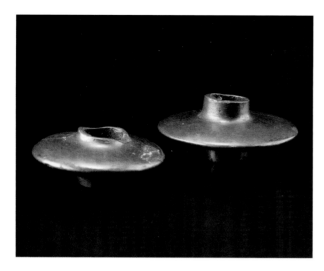

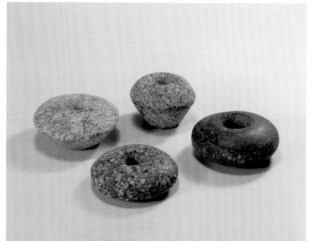

Two examples will suffice: a piriform mace head decorated with two crouching lions and a dedicatory inscription to Inanna that was found in the oval temple of the early dynastic period at Khafajah,[34] and a rounded mace head decorated with four lion heads, one of forty mace heads discovered in the large brick altar at Tell Aqrab.[35]

The elaborate decorations—particularly the plastic ones—the dedicatory inscriptions, and the fact that the most common archaeological contexts for these mace heads are temples clearly indicate that the decorated mace heads had a ceremonial function. There is no doubt that they were produced expressly to be used on ritual and ceremonial occasions, whether as symbols of rule and authority, as votive offerings, as symbols of deities that were carried in ritual ceremonies, or as cultic focal points (see Discussion below).

Carinated mace heads. Sixteen items that were described by Bar-Adon as disks, or short hollow standards with disk-shaped projections, are included in this category (figs. 6-10, 6-11).[36] Two objects were eventually added to this group—a carinated mace head with a long neck that was uncovered in a burial cave in Naḥal Qanah,[37] and a carinated mace head that was uncovered in burial cave VII/28 at Ketef Jericho.[38] Carinated mace heads are

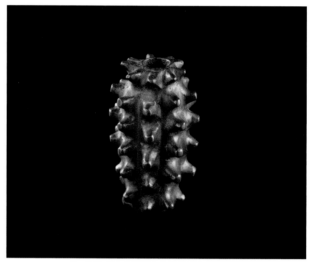

characteristic of the Predynastic culture in Nubia and Egypt,[39] and it is noteworthy that they are not known in other assemblages outside the Nile Valley. The thirty-eight angular mace heads that were discovered in Chalcolithic sites constitute an assemblage of unusual size, surprising particularly because eighteen of them are made of copper and have no parallels in the Nile Valley. The angular mace heads from Israel are a product of two distinct specialized industries:

- an Egyptian stone industry specializing in the manufacture of carinated mace heads from magmatic rocks, to which the artifacts from Bir Ṣafadi, Gilat, Naḥal Gerar, Ghassul, and

6-11: Disk-shaped mace heads (2). Copper, Naḥal Mishmar. IAA: 1961-131, 1961-180, exhibited at IMJ. Checklist nos. 81, 82.

6-12: Mace heads (2). Diorite and granite, Gilat and Gerar. IAA: 1975-1116, 1975-1117. Checklist nos. 96, 97.

6-13: Mace head with vertical rows of protruding knobs. Copper, Naḥal Mishmar. IAA: 1961-108, exhibited at IMJ. Checklist no. 76.

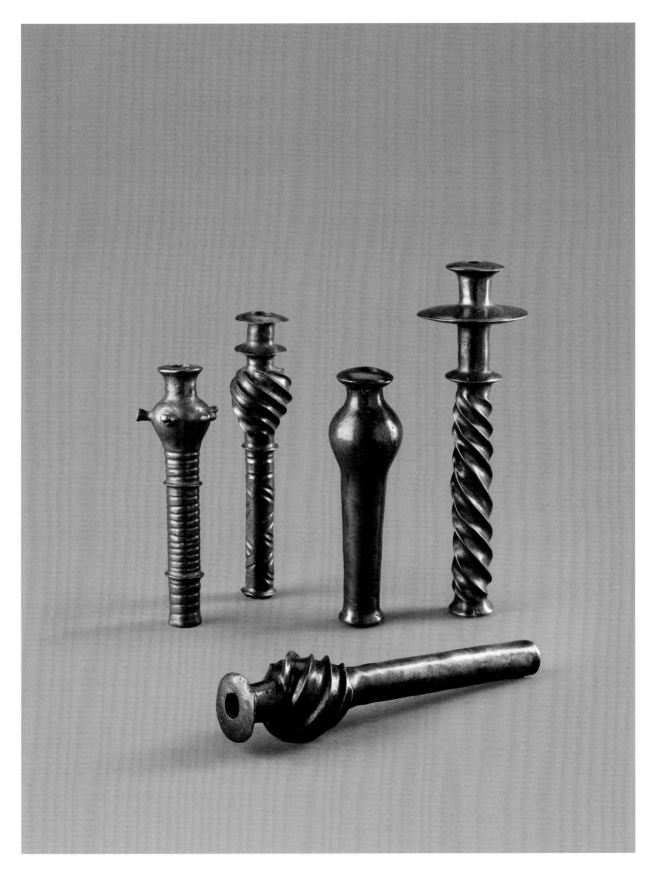

6-14: Scepters (5). Copper, Naḥal Mishmar.
IAA: 1961-2, 1961-13, 1961-27, 1961-69,
1961-90, exhibited at IMJ. Checklist nos.
80, 83–85, 92.

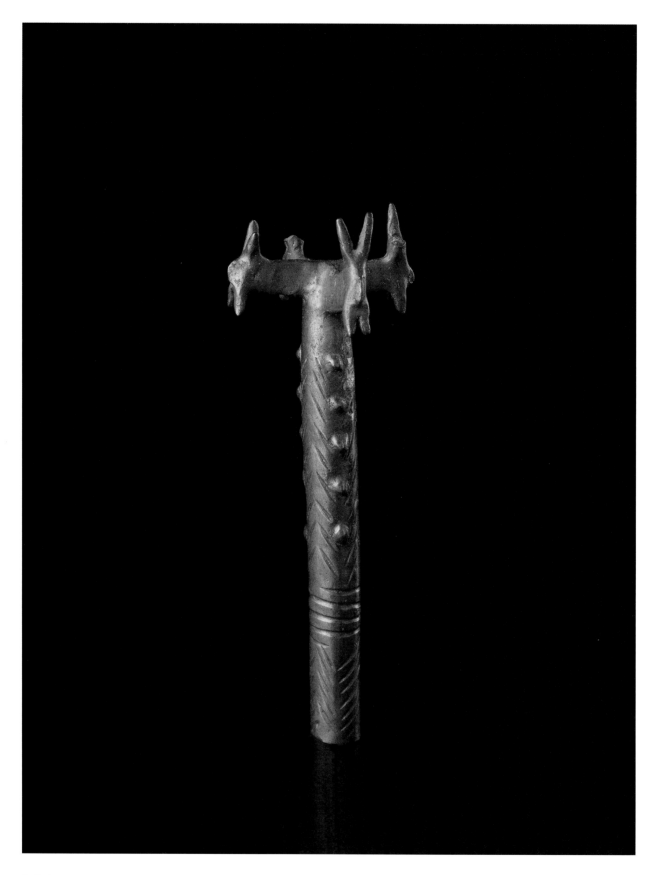

6-15: Scepter with grooved shaft and
four horned animal-head finials. Copper,
Naḥal Mishmar. IAA: 1961-86, exhibited
at IMJ. Checklist no. 95.

Gath-Govrin can be attributed, most securely those made of diorite or porphyry, which apparently arrived as finished artifacts (fig. 6-12);

- a local copper industry that specialized in the lost-wax technique, and which included angular mace heads in its repertoire. Apart from the obvious Egyptian inspiration, the copper mace heads are distinct from the stone ones in their outline and their dimensions, and should be viewed as a product specific to the local Chalcolithic culture.

The range of sizes and weights of the carinated mace heads—weight 150–320 gr, diameter 5.4–8 cm, and internal diameter of the shaft 1.1–2.0 cm—implies that they may have been used as weapons.[40] It is therefore not impossible that some of the carinated metal mace heads from Naḥal Mishmar, like the rounded metal ones, were originally intended as weapons.

Cylindrical mace heads. This category includes four copper artifacts from Naḥal Mishmar that were described by Bar-Adon as having a "truncated cone-shape" or "elongated barrel-shape," decorated with "vertical rows of small knobs" or "vertical rows of tooth-like knobs" (fig. 6-13).[41] With the exception of Merhav,[42] who described one of these artifacts as a copper scepter decorated with floral motifs, and Tadmor and his coauthors,[43] who presented two of them as "mace heads with bosses," these artifacts were not mentioned in any of the articles about the hoard from Naḥal Mishmar, and therefore there has been no discussion relating to their chronology, typology, or function. This neglect may be due to the fact that no parallels have been found so far in Chalcolithic sites in Israel, or in other contemporary sites in the Ancient Near East. I consider these four artifacts to be mace heads because of their similarity to a small number of later metal artifacts that were interpreted as such. These were found in various sites in the Ancient Near East: in Mesopotamia at Ur;[44] in Iran at Marlik,[45] and in

western Iran at Hasanlu.[46] The so-called spikes/knobs that are a feature of both the Naḥal Mishmar mace heads and their later parallels would add an element of slashing and crushing to the action of striking and smashing. Centuries, if not more, separate the mace heads from Naḥal Mishmar and those from Ur. An even larger gap separates these two sites from Marlik, which dates from the end of the second to the early first millennium, and Hasanlu, which dates from the end of the ninth to the eighth century BCE. These chronological gaps negate any cultural tie between the artifacts; the value of the typological comparisons is in the insight they provide into their function.

Maces. The hoard contains eighty-seven maces.[47] Six more were recovered from other Chalcolithic sites: two from Giv'at Ha-Oranim,[48] and one each from

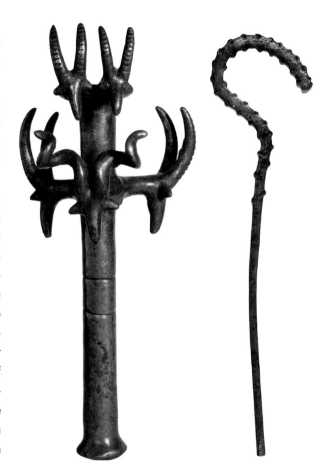

6-16: Scepter/standard decorated with ibex heads. IAA: 1961-88.

6-17: Scepter. IAA: 1961-152.

127

Abu Matar,[49] Neve Noy,[50] Shiqmim,[51] and Peqi'in.[52] It is my belief that these objects, usually called standards, are in fact maces that could function as weapons or ceremonial objects, and whose head and handle could be cast as a single piece thanks to control over the lost-wax technique (fig. 6-14). They can be divided into three typological groups according to the type of mace head: maces with a rounded head, maces with a carinated head, and maces with a cylindrical head. The maces are decorated in a wide range of relief designs: round or cylindrical knobs; grooves and ridges forming circles, spirals, diagonal and zigzag lines, or a herringbone pattern; and plastic decoration of projections in the shape of mushrooms, blades, and horns. The variability is manifest in the different combinations of these motifs and their position at different intervals along the handle and on the mace head.[53] The maces with knobs and plastic imagery are quintessentially ceremonial. There is no doubt that they were manufactured specifically for ritual and ceremonial use. As for the other maces, it is not impossible that some of them were intended also for use as weapons. The decorative ridges along the handle and around the mace head of some imitate, in my opinion, the leather thongs and ropes that were wound around the handle and head to provide a better grip and secure the joint between them. Metal maces are not common in the archaeological record of the Ancient Near East. Judging by discoveries in Iran and Mesopotamia, they appear in the second half of the third millennium BCE, and scholars tend to attribute their origin to the metal industry of Luristan.[54] The large group of maces from Chalcolithic sites in Israel is exceptional in this context, particularly given its very early date, in the second half of the fifth or the first half of the fourth millennium.

Scepters/standards. The hoard contains eleven artifacts decorated with relief designs and plastic imagery of blades, floral designs, ibex heads, a human head, an eagle, and more.[55] Discussion of the iconography of these artifacts is outside the scope of

this article; suffice it to say for our purpose that their ceremonial and ritual function, whether as symbols of might and potency (see figs. 6-15, 6-16), symbols of rule and authority (fig. 6-17), or as representations of divinity (see fig. 4-12), is not in doubt.[56] So far no parallels to this group have been found in contemporary sites in the Ancient Near East.

"Crowns." The hoard contains ten items that Bar-Adon defined as "crowns."[57] The only other finds that may belong to this category in Chalcolithic sites in Israel are a small fragment from Neveh Noy,[58] a small fragment from Naḥal Qanah,[59] and two fragments from Giv'at Ha-Oranim.[60] None were found in other sites in the Ancient Near East, contemporary or otherwise. The "crowns," which have a cylindrical outline, are distinct from each other in their decoration. Some have geometric relief designs (fig. 6-18), others plastic imagery—projections in the shape of mushrooms, horns, birds, heads of horned animals, and building facades (see page 19). Soldering repairs and casting flaws indicate

6-18: Crown with two bands of herringbone motifs and horizontal grooves. Copper, Naḥal Mishmar. IAA: 1961-173, exhibited at IMJ. Checklist no. 107.

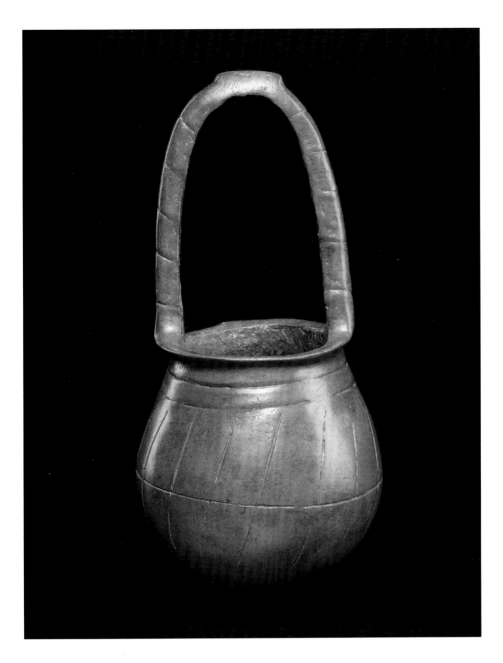

that some enjoyed a long period of use before being stowed in the cave in Naḥal Mishmar. Bar-Adon[61] and Epstein[62] suggested that they were temple models. This interpretation seems to be accepted also by Beck.[63] Amiran[64] placed the "crowns" on top of each other, and suggested that they formed a ritual stand or a horned altar. Moorey[65] considered them models of round houses that represent temple enclosure, or structures for primary burial prior to transfer to ossuaries for secondary burial.

Tadmor,[66] basing her interpretation on "crown" no. 7, suggested that they should be seen as architectural models. An iconographic analysis of the same crown led Ziffer[67] to suggest that it represents a model of a palace or the house of a ruler—*bâtiments de prestige*.

Containers. The hoard includes three that Bar-Adon described as "horn-shaped" vessels, a juglet, three small bowls with a high basket handle (fig. 6-19),

6-19: Basket-shaped jar with looped handle and decorative grooves. Copper, Naḥal Mishmar. IAA: 1961-164, exhibited at IMJ. Checklist no. 105.

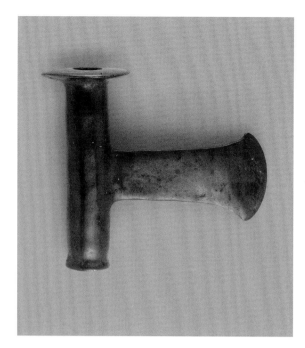 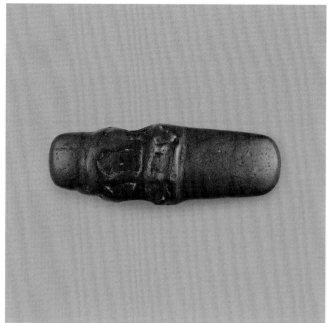

and a larger bowl with no handle.[68] So far these vessels have no metal parallels, but the shapes—cornets, bowls with high basket handles, and juglets—are known in the pottery assemblage of the period.[69] Their unexpected presence in the hoard reinforces the association of metal production in the lost-wax technique with craftsmen-artists who participated in the local Chalcolithic culture.

Shaft axes. There are two axes with a tubular shaft and one with a hole shaft in the hoard (fig. 6-20).[70] Tubular shaft axes developed from the copper socket axes that were in common use in this period as tools and as weapons. The shaft was an innovation that resolved the inherent weakness of the joint between blade and handle, thus turning the common axe into the typical battle-axe. It should be emphasized that the quality of the shaft axes from Naḥal Mishmar is superior to that of the Sumerian shaft axes of the first half of the third millennium, which had previously been considered as the apex of Near Eastern metal-casting technology of the period.[71] It is therefore surprising that these axes—ahead of their time by 1,500 years and more—received no attention in studies of the hoard nor in

studies following weapons development in Canaan and the Ancient Near East, whether general or specifically related to axes. The possibility that these two particular axes from Naḥal Mishmar were manufactured purely as ceremonial scepter heads and were not intended to be used as weapons cannot, however, be entirely ruled out.

The metal hole-shaft axe developed from the stone axes that were common in the Ancient Near East since the ninth millennium BCE, and were to remain in use until the third millennium. The relief decoration, which imitates the leather thongs that secured the stone axe head to its handle, may support the assumption that the Chalcolithic craftsmen intended the metal axes for ceremonial function (fig. 6-21). From the very first appearance of axes in Pre-Pottery Neolithic A assemblages, scholars tended to distinguish between flint axes that were intended for everyday use and polished stone axes that were carefully fashioned in specialized workshops for ceremonial use.[72] Judging from the two polished stone axes with a hole shaft that were discovered in the Early Bronze Age Acropolis Temple, this distinction is characteristic of axes.[73]

6-20: Scepter with axe head. Copper, Naḥal Mishmar. IAA: 1961-123, exhibited at IMJ. Checklist no. 103.

6-21: Hole-shaft axe. IAA: 161-134.

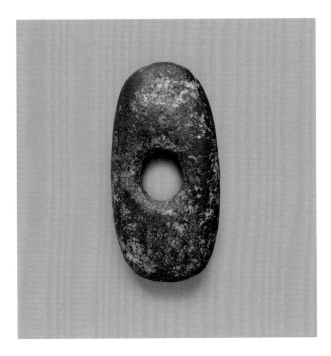

Hammer. This singular object (fig. 6-22),[74] which was cast in the lost-wax technique, imitates the stone hammers that were apparently used, among other things, for grinding copper ores.[75] No similar metal hammers were found in sites of the period in Israel or elsewhere. Considering the importance of the metal industry and its central position in the Chalcolithic period, it is reasonable to assume that the hammer was manufactured specifically for ceremonial use.

Axes, Chisels, and Adzes Cast in Open Molds. Fifteen tools in the hoard were identified by Bar-Adon as chisels, but are here considered to be adzes,[76] or axes/chisels.[77] Twenty-five axes, chisels, and adzes were found in other Chalcolithic sites: two axes at Ghassul;[78] one axe in the dwelling cave at Naḥal Ẓe'elim;[79] two axes at Neveh Noy;[80] one adze at Abu Matar;[81] one adze and two axes at Bir Ṣafadi;[82] one chisel and one axe at Shiqmim;[83] five axes at Meser;[84] two axes in the burial cave at Peqi'in; one axe and one adze in burial cave VII/28 at Ketef Jericho;[85] and three axes, one axe/chisel, and one adze at Giv'at Ha-Oranim.[86] Above we concluded that the work tools were the product of a specialized industry that made use primarily of local ores from the areas of Timna and Feinan. We should add here that a number of axes containing significant concentrations of arsenic and nickel were identified together with the tools of nearly pure copper in the assemblages from Naḥal Mishmar,[87] Giv'at Ha-Oranim, and the cave at Peqi'in.[88] It seems plausible that these axes were produced by the same groups of metalsmiths who cast the utensils and prestige objects in the lost-wax technique.

Discussion

The Copper Industry in Israel in the Chalcolithic Period: The Lost-Wax Technique. The diverse assemblage of the hoard from Naḥal Mishmar provides the main body of evidence for the scale and quality of metal manufacturing using the lost-wax technique during the Chalcolithic period in Israel. The sum total of comparable finds from other sites is twenty rounded mace heads, two carinated mace heads, and six metal maces, which were discovered in a relatively small number of sites. No objects manufactured with this technique were found in other sites of the period, neither settlements nor burials. As the claim that the hoard is an integral part of the local Chalcolithic culture gains credence, the absence of comparable discoveries for some types—shaft axes, cylindrical mace heads, crowns, and most of the scepters/standards—whether made of metal or other materials, or even depicted in art, becomes ever more noticeable. Had these metal artifacts been part of an isolated hoard, unaccompanied by known finds, it would have been difficult to determine their period and cultural affiliation. It is unlikely that under such circumstances the shaft axes and the cylindrical mace heads with knobs would have been dated prior to the third millennium, and Mesopotamia would have been considered their place of origin. Some of the scepters/standards would have been attributed to the Egyptian culture, their date left an open question. As for the rest of the scepters/standards and the "crowns,"

6-22: Hammer. IAA: 1961-150.

both date and source would have remained doubtful, with Mesopotamia and Iran as possible places of origin. Only the association in the same cache with types known from other sites made it possible to identify them as local Chalcolithic. The unexpected presence of types previously known only in pottery, such as bowls with basket handles, juglets, and cornets, gives us an inkling of the rich world of metal manufacture in the lost-wax technique, and the wide array of vessels that were cast using it.

The Copper Industry in Israel in the Chalcolithic Period: Casting in Open Molds. The hoard from Naḥal Mishmar is also a true reflection of the common metal industry of the Chalcolithic period. The fifteen axes/chisels and adzes from the hoard constitute about 40 percent of the total assemblage of these types in the period. The twenty-five examples that were found in various other sites indicate that copper axes and adzes were a regular component of the everyday tool kit.

The Frequency of Rounded Mace Heads and Metal Maces. Rounded metal mace heads and maces were common in the daily-life and ceremonial assemblages of Chalcolithic settlements. This conclusion can be drawn independently of the hoard; it may, in fact, have been more obvious had not the hundreds of specimens of these types from the hoard overshadowed the twenty rounded metal mace heads and six metal maces that were found elsewhere over the years. An often overlooked fact is that copper mace heads were found in Chalcolithic sites in equal numbers to copper axes and adzes, and it is therefore to be expected that more of them, as well as more metal maces, will be discovered as excavations continue in Israel and Transjordan.

The Nature of the Hoard from Naḥal Mishmar and the Process of Its Accumulation. Concealment of the hoard in a far-off cave in Naḥal Mishmar brought to an end the "active life" of the artifacts, but disclosed no details of the processes of collection and accumulation, or of their original function and subsequent use. Indeed, ever since the surprising discovery of the hoard, its meaning has been a subject of debate and speculation. Ussishkin associated the hoard with the Chalcolithic temple at En-Gedi, suggesting that when the temple was abandoned, the priests carefully collected all the ritual artifacts and concealed them in the cave in Naḥal Mishmar, intending to reclaim them at a later date and return to the temple, but failing to do so.[89] Bar-Adon was more cautious when he said: "It seems probable that they came from a temple in the vicinity. However, none of the finds so far confirm the theory that they were brought from the sacred enclosure at En-Gedi."[90] Moorey[91] proposed that the hoard should be considered as a community-owned treasure of weapons and ceremonial artifacts that had been stored in a public building. Tadmor,[92] however, put forward the hypothesis that the hoard and the assemblage from Naḥal Ze'elim are merchandise that belonged to groups of craftsmen-merchants. Garfinkel[93] suggested that the hoard was a Geniza—a dedicated repository of ritual artifacts that could no longer be used. Ilan[94] interprets the hoard and the other Chalcolithic finds from the Judean Desert caves as burial gifts. The impressive assemblages from the Cave of the Treasure indicate, in his opinion, the high status of the person who was buried there.

I believe that the key to understanding the hoard is the 372 maces and mace heads that account for about 87 percent of the assemblage. It is noteworthy that the hoard from Naḥal Mishmar is centuries earlier than similar hoards discovered in Egypt and Mesopotomia, such as the main deposit from the temple at Hierakonopolis, which dates to the end of the fourth millennium and contains about 150 mace heads,[95] and the assemblage from the Shara Temple at Tell Aqrab, which dates to the first half of the third millennium and contains 437 mace heads.[96] While these deposits are all considerably later, they point to a common pattern.

Maces and mace heads are a fundamental component in votive deposits of temples in the Ancient Near East. The assemblages vary in magnitude and significance from a single mace head to deposits or hoards containing hundreds of artifacts. The variation extends also to their style and quality, and they contain conventional mace heads that can only be identified as votives by their context, alongside highly ornate maces and mace heads—decorated with reliefs and plastic imagery, bearing dedicatory inscriptions, of particularly large size, or manufactured from precious materials such as gold, silver, and ivory—whose very sumptuousness identifies them as ceremonial. In other words, the hoard from Naḥal Mishmar probably accumulated in a temple.

The questions that present themselves are, Why do hoards and caches contain so many maces and mace heads? Why is there such an array of types? To answer these questions it is necessary to comprehend the central position and significance of the mace in the Ancient Near East between the fifth and third millennia, both as a weapon and as a ceremonial object.

Briefly, we can say that mace heads are the only type of weapon known between the ninth millennium and the first half of the fourth millennium that is clearly designed for hand-to-hand combat. The only motive behind their development and manufacture seems to be to design an effective weapon. During the fifth and fourth millennia, the mace reached the zenith of its frequency and distribution, and became the most important weapon for hand-to-hand combat in the Ancient Near East. The metal maces and mace heads that were discovered in Israel make it possible to identify the mace as the first dedicated weapon cast in metal.

By virtue of being a superior weapon, the mace assumed a central place as a ritual object and symbol in the Ancient Near East from its very first appearance. Four central ceremonial functions may be attributed to it, as:

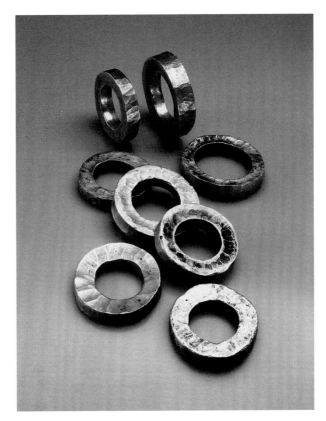

6-23: Ring ingots. Gold and electrum.
SAOJS.

- a symbol of authority and victory of mortals (as part of the material-culture assemblage and in pictorial depictions);
- a votive (as part of the material-culture assemblage);
- a ritual object or a divine symbol (as part of the material-culture assemblage and in pictorial depictions);
- a weapon of the gods (apparently only in pictorial depictions).

The following points are relevant for our purpose, and should be considered in order to appreciate the status of maces and mace heads in temples.

The votives may have been offered to the god in order to receive his protection and grace and ensure the lasting presence of the dedicator in the temple; as an offering of gratitude; or to commemorate a significant event such as a coronation, a victory in battle, or the completion of a monumental construction project.

Unless votives carry dedicatory inscriptions, it is not always possible to distinguish them from objects that were purchased by or manufactured for those who served in the temple, for the purpose of ceremony and ritual or for daily use.

Maces and mace heads are part of a group of objects and artifacts of which it is possible to say with a considerable level of certainty that they were brought to the temples as votives, since it is difficult to assign them a functional role within the temple. Maces with dedicatory inscriptions that were found in a large number of temples in Mesopotamia support this assertion. The custom survived in Mesopotamia even after the mace had gone out of use. In the course of the second half of the third millennium, the mace gradually disappeared from the arsenal of weapons in Israel and in the Ancient Near East in general, and its use in the battlefield ceased.[97] However, the part that the mace played in the ritual process, and its status—whether as a symbol of deity or as a cultic focal point—has yet to be determined. It seems to me that the evidence of the assemblages recovered from temples that date to the fourth millennium and to the first half of the third millennium makes it credible to assume that the mace had a concrete role in the ritual processes of the period.[98]

Conclusions

Hoards, by their very nature, contain a large number of artifacts that went out of use, including at times artifacts not preserved elsewhere, such as metal objects that were continuously recycled. Hoards may represent a single-deposition episode, or they may have accumulated over a long period, definitely so if we accept the possibility of their accumulation being associated with a temple. A case in point is represented by the large assemblages that accumulated in the temples of the Ancient Near East in the fourth and third millennia BCE. We should be careful to distinguish between, on the one hand, the single act of concealing the hoard in the cave at Naḥal Mishmar and, on the other, the possibly lengthy process of its accumulation, as well as the use that the individual objects previously had in the temple. In spite of their rarity, therefore, hoards do reflect their original surroundings. Consequently, the hoard from Naḥal Mishmar, which contains hundreds of artifacts, bears witness to the frequent occurrence of metal objects, in particular maces and mace heads, in the Chalcolithic-period tool kit, and is, moreover, the only source of information available for the wide array of types that were in use at the time.[99] In light of these observations, we should consider whether there are still new types to be found and discoveries to be made in the metallurgy of the Chalcolithic period. The eight gold-and-electrum ring ingots from the burial cave at Naḥal Qanah, the earliest gold finds in the Ancient Near East (fig. 6-23),[100] together with recent discoveries in the burial cave at Peqi'in[101]—which extend considerably the known geographic distribution of artifacts that were cast in the lost-wax technique and tools that were cast in open molds—hint at a positive answer.

Notes

1 Bar-Adon 1980.
2 Ilan and Sebbane 1989, 140–43; Shalev 1991; Hauptmann et al. 1992; Namdar et al. 2004, 77–83; Goren 2008, 375.
3 The process described here refers not only to the maces and mace heads, but to all objects that were manufactured using the lost-wax technique in Canaan during the Chalcolithic period.
4 Ilan and Sebbane 1989, 140–43; Levy and Shalev 1989, 364–67; Shalev 1991; Shalev and Northover 1993; Ilan and Rosenfeld 1994; Tadmor et al. 1995; Namdar et al. 2004, 80–83.
5 Renfrew and Bahn 1991, 296; Moorey 1994, 271–72.
6 Moorey 1985, 42; Moorey 1994, 271–72.
7 Shalev and Northover 1993; Namdar et al. 2004.
8 Key 1980, 243; Moorey 1994, 242–44; Tadmor et al. 1995, 140–45.
9 Pigott 1999.
10 Ilan and Rosenfeld 1994.
11 Muhly 1988, 10.
12 Goren 1995; Shalev et al. 1992; Goren 2008.
13 Gates 1992, 136–37; Kerner 2001, 145, 149–50; Goren 2008.
14 Bar-Adon 1980, 2–5, 135–52, 198.
15 The ivory objects, the hematite rounded mace heads, and the limestone rounded mace head (ibid., 16–23 [nos. 1–6], 116 [nos. 184–89], 423) will not be discussed in this article.
16 Tadmor et al. 1995, 101–9, 124–28 (table 2).
17 Bar-Adon 1980, 116–31, 424–29 (nos. 190–422).
18 Perrot 1955, 79 (pl. 15:A).
19 Perrot 1979 (pl. 103).
20 Aharoni 1961, 14 (pl. 8:B).
21 Shalev and Northover 1987, 359 (pl. 14:1).
22 Namdar et al. 2004, pl. 5.1:1–4.
23 Sebbane 2009, 82–85.
24 For radiocarbon dates for a mat found with the Naḥal Mishmar hoard, see Aardsma 2001; for a chronological assessment of the hoard itself in light of other metal finds from the Chalcolithic, see Shugar and Gohm 2011, 140; for the cave of Naḥal Mishmar and the Judean Desert caves of the Late Chalcolithic in general, see Davidovich 2013.
25 Haerinck and Overlaet 1996.
26 Ibid., 53, 56, 60, 72, 81, 86, 88, 98–99, 118 (nos. 26, 33, 42, 60, 76–77, 103, 114, 115, 120, 122, 150–53, 180–82),
27 Bar-Adon 1980, 100–101 (no. 153); Beck 1989, 42–43; Merhav 1993, 24–31; Schroer and Keel 2005, 118:51 (no. 189; pl. 33:1).
28 Cialowicz 1992; Vertesalji 1992; Pittman 1996; Dreyer 1999.
29 Gophna and Lifshitz 1980, 81 (pl. 1:5).
30 Eldar and Baumgarten 1985, 135.
31 Gal, Smithline, and Shalem 1997, 151.
32 Macdonald, Starkey, and Lankester-Harding 1932, I.27:82.
33 Haerinck and Overlaet 1996, figs. 57:12–14,16,17, 88:9,10.
34 Delougaz 1940, 99 (fig. 91); Delougaz 1942; Braun-Holzinger 1991, 43:K8 (pl. 1:K8).
35 Lloyd 1942, 237–38 (figs. 184, 185).
36 Bar-Adon 1980, 94–97 (nos. 131–33, 135, 137–47).
37 Gopher and Tsuk 1996, 114–15 (figs. 4.19:1, 4.2).
38 Segal and Kamenski 2002, 158 (pl. 3:1).
39 Petrie 1920, 22; Baumgartel 1960, 106–7; Cialowicz 1987; Cialowicz 1989; Gilbert 2004; Cialowicz 2011.
40 Sebbane 2009, 82–85.
41 Bar-Adon 1980, 88–89 (nos. 117–19, 121).
42 Merhav 1993, fig. 4:2.
43 Tadmor et al. 1995, 105.
44 Woolley 1934, 46–53 (pl. 224:U9137).
45 Negahban 1996, 253 (pl. 117:645,646).
46 Muscarella 1988, 57 (nos. 69, 70); Muscarella 1989, 26.
47 Bar-Adon 1980, 40–87 (nos. 18, 22–26, 28–32, 34–41, 43–59, 61–75, 78–102, 104–113, 123, 129).
48 Namdar et al. 2004, 73 (figs. 5.1:17–18, 5.2:1–2).
49 Perrot 1955, pl. 20:24.
50 Eldar and Baumgarten 1985.
51 Shalev and Northover 1987, pl. 14.5:5.
52 Gal, Smithline, and Shalem 1996, 23–24; Gal, Smithline, and Shalem 1997, 151.
53 A limited number of maces have no decoration whatsoever (Bar-Adon 1980, nos. 49–51, 53).
54 Moorey 1971, 90–97; Tallon 1987, 128–34.
55 Bar-Adon 1980, nos. 17, 19–21, 112, 124–26, 154.
56 Elliott 1977; Epstein 1978; Beck 1989.
57 Bar-Adon 1980, 24–39 (nos. 7–16).
58 Eldar and Baumgarten 1985, 132.
59 Gopher and Tsuk 1996, 115 (figs. 19.4:2, 20.4).
60 Namdar et al. 2004, 73 (fig. 5.1:14,16).
61 Bar-Adon 1980, 133.
62 Epstein 1978, 26.
63 Beck 1989, 43–44.
64 Amiran 1985.
65 Moorey 1988, 179.
66 Tadmor 1986a, 75–76; Tadmor 1989, 257.
67 Ziffer 2007.
68 Bar-Adon 1980, 104–11 (nos. 155–62).
69 Cf. Amiran 1986; Goren and Fabian 2002, figs. 4.2:2,4–5, 4.4:1–3; Commenge 2006, fig. 10.4.
70 Bar-Adon 1980, 98 (nos. 148, 149), 112 (no. 163).
71 Yadin 1963, 64.
72 Barkai 2005, 368–71.
73 Marquet-Krause 1949, 39 (no. 68; pl. 37:68,38).
74 Bar-Adon 1980, 114–15 (no. 170).
75 Mallon, Koeppel, and Neuville 1934, 70 (pl. 34).
76 See Bar-Adon 1980, nos. 167–69, 171.
77 Ibid., nos. 172–79.
78 Miron 1992, 8–9:1,2.

79 Ibid., 9:3.
80 Ibid., 9:4,5.
81 Ibid., 9:6.
82 Ibid., 9:7–9.
83 Ibid., 9:10,11.
84 Ibid., 11:29–33.
85 Segal and Kamenski 2002, 158–60 (fig. 1:1,2).
86 Namdar et al. 2004, 70 (fig. 5.1:6–10).
87 Key 1980, table 1:61–147.
88 Namdar et al. 2004, 81 (table 5.3:97–3481).
89 Ussishkin 1971; Ussishkin 1980; Ussishkin 2012.
90 Bar-Adon 1980, 202.
91 Moorey 1988.
92 Tadmor 1989, 252.
93 Garfinkel 1994, 174–76.
94 Unpublished.
95 Quibell 1900; Quibell and Green 1902; Adams
 1974; O'Connor 1992, 84–89; Gilbert 2004, 37–38,
 187–89.
96 Lloyd 1942, 218–88.
97 For a compendium of mace heads with inscrip-
 tions, see Braun-Holzinger 1991, 42–66.
98 For a comprehensive discussion, see Sebbane
 2009, 207–304.
99 The hoard from Kefar Monash (Hestrin and Tadmor
 1963; Sebbane 2003) is another example. The tens
 of tools and weapons it contained, some of them
 not otherwise known, multiply the inventory of
 copper objects from Israel in the Early Bronze Age.
100 Gopher and Tsuk 1996, 165–73.
101 Gal, Smithline, and Shalem 1997.

Textiles, Basketry, and Other Organic Artifacts of the Chalcolithic Period in the Southern Levant

Orit Shamir
Israel Antiquities Authority

Fringed textile fragment. Linen, Cave of
the Sandal, Jordan Valley. IAA: K33645.
Checklist no. 157.

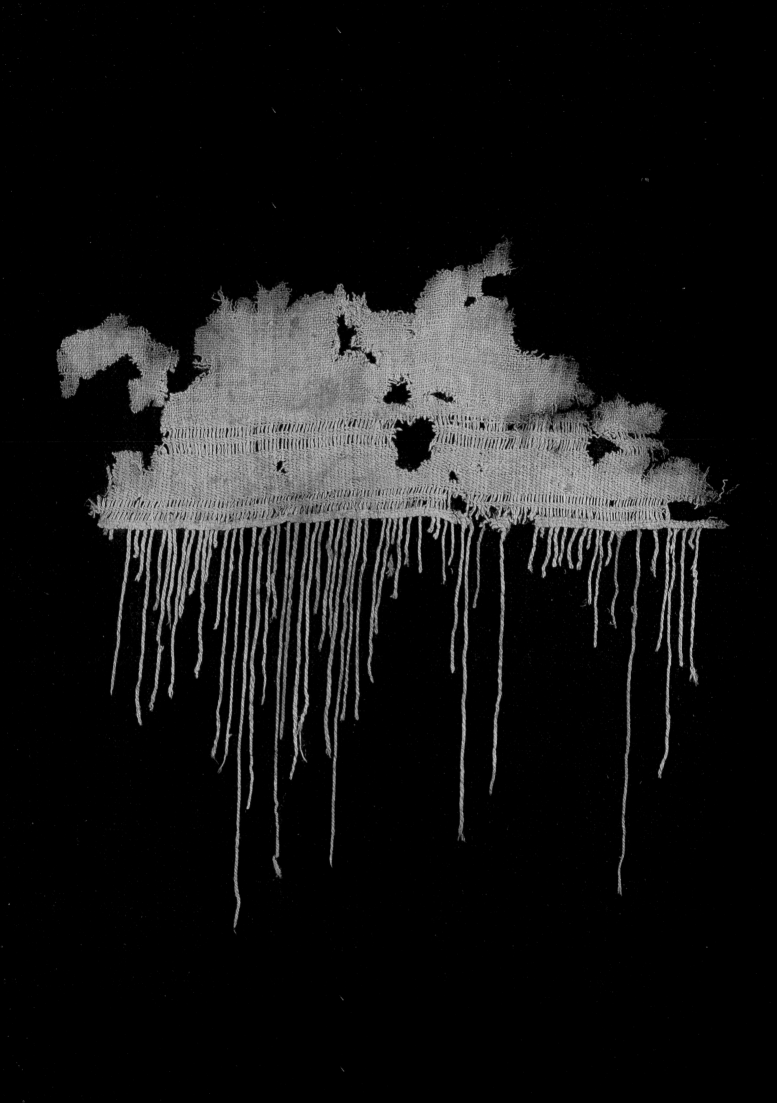

The natural caves located on the margin of the Jordan Valley have been key repositories for organic artifacts for thousands of years. The massive geological fault of the Jordan Valley created high cliffs with caves, while the hills around Jerusalem acted as rain shadow, forming a region with extremely low rainfall and low relative humidity. Such inhospitable conditions meant that the area lacked extensive human occupation in all but a few periods, the Chalcolithic and Roman chief among them. In those rare periods the caves were used mainly for refuge.[1] We know the specific historical circumstances of Jewish refugees in the Roman period, but in the Chalcolithic it is not clear what state of affairs drove people into the wilderness. In both periods, caches of organic objects have added immeasurably to our understanding of the ancient world.

Because of their exquisite preservation, Chalcolithic textiles allow all facets of weaving and basketry to be examined, allowing the modern researcher to pinpoint precisely where the period falls in the history of textile technology. Without the excavations and surveys in Judean Desert caves, our understanding of the use of linen textiles in the region, for instance, would begin some four thousand years later.

The Caves

Naḥal Mishmar: The Cave of the Treasure
Organic materials found at the Cave of the Treasure include textiles, parts of looms (figs. 7-1, 7-2), baskets, ropes, and shuttles. Other artifacts connected with spinning and weaving include stone spindle-whorls and one perforated fragment of a bowl that may have served for spinning.[2]

The initial understanding of the Chalcolithic period through the Cave of the Treasure was hampered because of a second occupation of the cave during the Roman period. In antiquity the artifacts from the two periods were mixed. At first glance linen textiles of the Chalcolithic and Roman periods are

similar: they have the same color, undyed cream, and the same weaving technique, a plain weave.[3] As a result, the publication of textiles from the Cave of the Treasure[4] did not correctly distinguish textiles dating to the Chalcolithic period from those of the Roman period.[5] The research of Schick at the Cave of the Warrior[6] allowed her, and this author, to reliably distinguish the characteristics of the two periods, specifically, the different way in which the thread was made in each period. In the Roman period thread was made by spinning, that is, by taking a collection of processed flax fibers and spinning them together so that the fibers overlap and form one long, continuous twisted thread. The Chalcolithic textiles, however, have threads that indicate splicing (see below), a technique that resulted in better cohesion. These observations allowed the textiles to be sorted, with Chalcolithic linen textiles numbering eighty-seven and Roman-period wool and linen textiles totaling thirty-five.[7]

Because of the richness of the finds, Bar-Adon assumed that some of the textiles found at the Cave of the Treasure were produced in the cave. However, almost no fibers or threads ready for use, and only a few artifacts related to spinning and weaving, were found at the cave. As the cave itself is not conducive to weaving, the textiles probably were not manufactured there.

7-1: Warp beam for horizontal ground loom. Wood, Naḥal Mishmar. IAA: 1961-1172. Checklist no. 134.

7-2: Cylindrical stick for warp-weighted loom. Wood, Naḥal Mishmar. IAA: 1961-1174. Checklist no. 135.

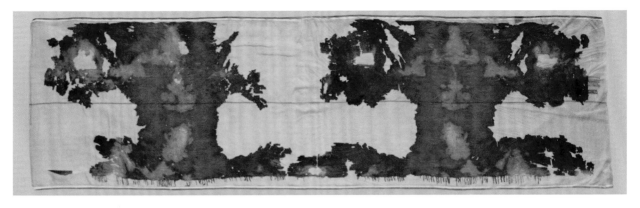

The Cave of the Warrior

A male skeleton (the "Warrior") was found in a flexed position, wrapped in a linen shroud (fig. 7-3a). The shroud is a large rectangular linen cloth, 7 m long and 2 m wide, designed and manufactured as a single sheet, the largest Chalcolithic textile ever discovered. It is decorated with black bands—paint or smeared asphalt—and undyed warp fringes measuring 18 cm in length and secured by knots at their ends (fig. 7-3b). A kilt (fig. 7-4), smaller than the shroud, was found crumpled inside the latter. One edge terminated in a beautifully constructed weft fringe, with the fringes evenly spaced. The sash that was also found is a very long (1.98 cm), narrow cloth. Only the textiles from this cave show selvage[8] elaboration and weft fringes (fig. 7-5).

The deceased was lying on a large plaited-reed mat measuring 1.32 by 1.40 cm (fig. 7-6). The edges were secured on all sides by a cord. He was accompanied by additional objects, including a flint knife (fig. 7-7), a bow (see fig. 5-2), arrows, a wooden bowl (see fig. 5-1), sandals (fig. 7-8), and a walking stick (see Checklist no. 130).[9] This tangled mass of folded, creased fabric in fragile condition (fig. 7-9) was covered—as were the other objects found in the cave—by a layer of red ochre that was possibly sprinkled onto the textile as part of the burial ritual.

7-3a–b (top and middle left): Linen shroud and detail showing black bands and undyed warp fringes secured with knots. Cave of the Warrior, Wadi Makukh. IAA, exhibited at IMJ.

7-4 (middle right): Kilt. Cave of the Warrior, Wadi Makukh. IAA.

7-5: Textile showing selvage elaboration and weft fringes. Cave of the Warrior, Wadi Makukh. IAA.

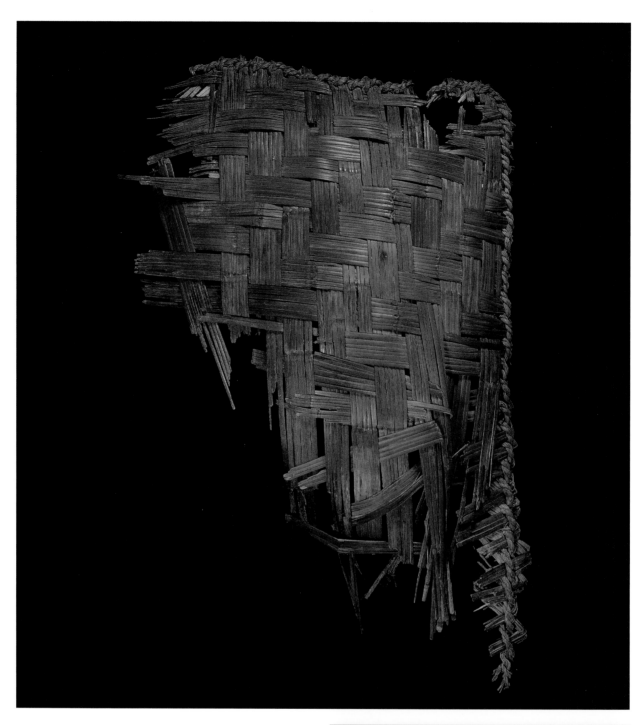

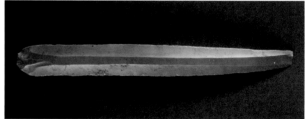

7-6: Fragment of a mat. Reeds and
sorghum, Cave of the Warrior, Wadi
Makukh. IAA: 607/83. Checklist no. 127.

7-7: Blade. Flint, Cave of the Warrior,
Wadi Makukh. IAA: K-23995. Checklist
no. 129.

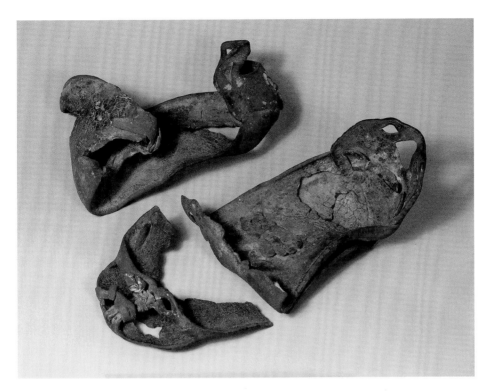

Naḥal Ze'elim

A treasure of about 12,000 white and blue steatite beads[10] and brownish-red carnelian beads, wrapped with two separate and delicate linen textiles, was found at Naḥal Ze'elim in 1960 (figs. 7-10, 7-11, 7-12).[11] The same cave contained a small bag made of white and blue steatite beads in a geometric-diagonal pattern, using linen threads and leather thongs (fig. 7-13). The handles of the bag, decorated with beads, were also preserved.

The Cave of the Sandal

In the Cave of the Sandal, burials of seven adults were discovered, as well as Chalcolithic artifacts such as copper tools and pottery[12] alongside a cut and knotted textile (fig. 7-14).

Textiles

Because of the diversity of fabrics present in the Chalcolithic caves, we can reconstruct almost the entire process of textile production from beginning to end and, in the process, gain insight into the technology of weaving in the Chalcolithic period.

The Raw Material: Flax

Recent reports of 30,000-year-old wild-flax fibers from Upper Paleolithic layers at the Dzudzuana Cave in Georgia[13] suggest that the utilization of wild flax by Old World hunter-gatherer societies predates the Neolithic agricultural revolution. This may help to explain why flax (*Linum usitatissimum*) was the earliest domesticated plant used for textiles.[14] It is

7-8: Sandals. Cow leather, Cave of the Warrior, Wadi Makukh. IAA: 607/74/1,2. Checklist no. 126.

7-9: Tangled mass of cloth consisting of a shroud, kilt, and sash. Cave of the Warrior, Wadi Makukh. IAA.

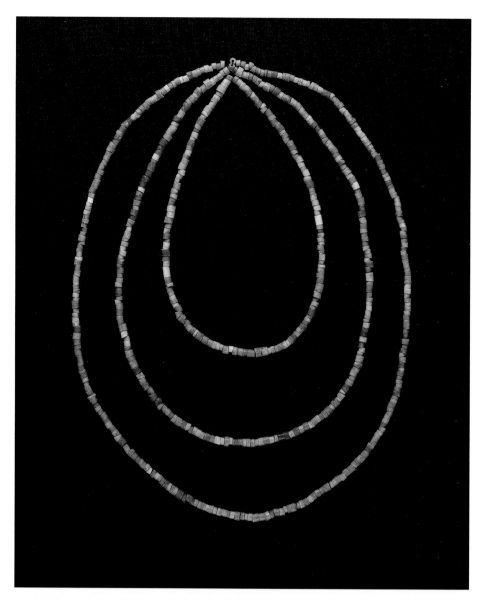

7-10: Beads. Turquoise and other stones,
Ẓe'elim. IAA: 1953-1307. Checklist no. 113.

7-11: Twine. Linen, Ẓe'elim. IAA: 1953-1307.
Checklist no. 114.

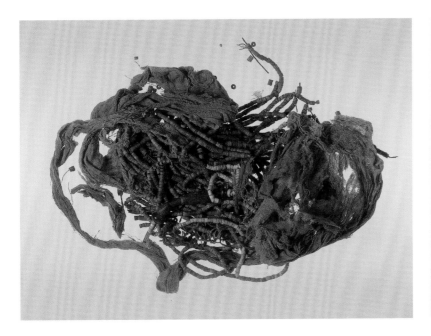

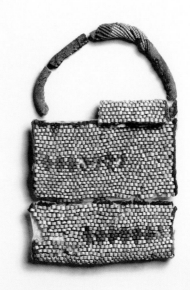

considered to be the first fiber and oil crop of Neolithic Near Eastern agriculture and is often mentioned in the context of Near Eastern Neolithic "founder crops."[15] Flax could be grown in the Jordan Valley at sites such as En-Gedi,[16] Jericho, and the Beth-Shean Valley,[17] which have the most suitable water and climate. While these areas were famous, thousands of years later, for their linen products during the Roman period, examples also date to the Iron Age.[18]

The Neolithic domestication of flax was an essential prerequisite for Chalcolithic textiles, as experimental fiber extraction of wild flax in Israel proved that these plants had surfaces that were too heavily textured to allow the creation of threads suitable for textiles.[19] By the Chalcolithic period flax-fiber processing was based on thousands of years of experience of using tree-bast fibers,[20] and thus the quality of textiles from the Chalcolithic period is quite good.

Flax was the sole material for the manufacture of textiles in the Southern Levant until the Middle Bronze Age.[21] Although sheep were already domesticated by the Chalcolithic, their fleece was kempier and less pliable than wool in future periods. That

appears to explain why wool was not yet a favored fiber.[22] The oldest preserved example of wool is from the North Caucasus, and dated between 3700 and 3200 BCE;[23] but wool with continuous growth, the type ideal for weaving, appears later, not before the second millennium or the end of the Bronze Age.[24]

Making Thread: Spinning and Splicing

The earliest linen threads were identified on a comb from Murabba'at made of sticks of myrtle tied together with cultivated linen threads and coated with asphalt.[25] Already, in this find, it appears that artisans had discovered that linen thread could be strengthened by twisting a single thread (usually referred to as "S-spun" or "Z-spun," depending on the direction of the twist) and then by twisting together several threads ("S-plied" or "Z-plied," depending on the direction of the twist). The Neolithic threads in this instance were Z-spun and S-plied.[26]

The Chalcolithic linen threads from this region are S-spun, coinciding with the natural spin direction of flax fibers. The textiles have the characteristic mixture of S-spun and S-plied threads. Plied threads are considered characteristic of early textiles[27] in

7-12: Beads wrapped with linen textile. Ẓe'elim. (See also figs. 7-10, 7-11.)

7-13: Small bag/pouch. Stone beads and animal tendon, Ẓe'elim. IAA: 1975–247.

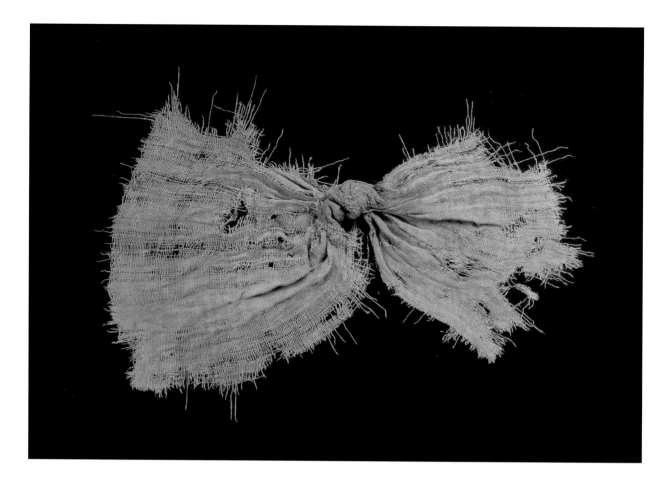

the Southern Levant until the Early Bronze Age and, in this case, were used to aid in the process of splicing, a technique that allowed for better cohesion (figs. 7-15, 7-16). The term "splicing" is used to describe the combination of fiber bundles (strips) to produce a continuous thread. Flax fiber was removed from the stem of the flax plant by stripping. The bundles of flax fibers, between 60 and 90 cm long, were then joined together by rolling the ends between the thumb and index finger.[28]

Splicing is also known in Europe, for example at Neolithic (second half of the fifth millennium BCE) pile-dwelling settlements in eastern Switzerland.[29] It appears to have been one of the earliest yarn-making technologies used by the prehistoric inhabitants of Europe,[30] the Southern Levant, and Egypt. Scenes of splicing are depicted on wall painting in Egypt from the Middle Kingdom.[31] The earliest

Egyptian textile from the Fayum, dated to the early fifth millennium,[32] shows clear evidence of splicing. Barber argues that this crude fabric, which is so different from the later, fine Egyptian linens, may represent new weaving traditions that were arriving from the Southern Levant in the late Neolithic period.[33] As flax is not native in Egypt, it is possible that it was imported into Egypt from the Levant.[34]

After the fibers were spliced, they could be placed in a spinning bowl, a simple bowl with one, two, or three handles on the interior. The spliced thread, wound into the shape of a ball, could be stored here without rolling away. At the same time, water in the bowl could dampen the thread to facilitate the final twisting process. Similar bowls are depicted in Egyptian wall paintings and models, and actual spinning bowls were found in the Chalcolithic period at sites such as Neveh Ur and Bir Ṣafadi.[35]

7-14: Knotted textile fragment. Linen, Cave of the Sandal. IAA: B970/1. Checklist no. 156.

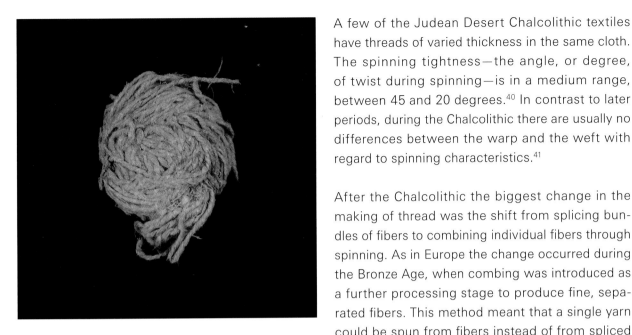

A few of the Judean Desert Chalcolithic textiles have threads of varied thickness in the same cloth. The spinning tightness—the angle, or degree, of twist during spinning—is in a medium range, between 45 and 20 degrees.[40] In contrast to later periods, during the Chalcolithic there are usually no differences between the warp and the weft with regard to spinning characteristics.[41]

After the Chalcolithic the biggest change in the making of thread was the shift from splicing bundles of fibers to combining individual fibers through spinning. As in Europe the change occurred during the Bronze Age, when combing was introduced as a further processing stage to produce fine, separated fibers. This method meant that a single yarn could be spun from fibers instead of from spliced bundles of fibers.[42]

Still, I assume that the use of spinning bowls was very limited in the Southern Levant and that the suspended spindle with spindle-whorls was generally used without a bowl.

Spindle-whorls are small discoid or biconical weights added to the spindle, and examples have been preserved from the Neolithic period and remain in use by Bedouin weavers today.[36] A spindle-whorl adds rotational force to the process of spinning thread and thus allows for a faster, more consistent twist of the thread, which is particularly important for the spinning of flax thread.[37] Four spindle-whorls made of stone (two of chalk, one of basalt, and one of unidentified stone) and four made of reused ceramic were discovered at the Cave of the Treasure[38] and are typical of this period. Hundreds of spindle-whorls were found in other Chalcolithic sites (fig. 7-17).[39]

Weaving: Making a Textile

Linen fabrics from the Pre-Pottery Neolithic period were preserved only at the cave deposits of Naḥal Ḥemar.[43] They were not woven, but were made in other techniques such as looping and knotted netting.[44] The vertical warp-weighted loom had been invented by the Neolithic and was already in use at Çatal Höyük.[45] The first loom in the Southern Levant—the horizontal ground loom—was a somewhat different type, and it first appears in the Chalcolithic period. We can be specific about the type of loom used because the actual wooden beams of a horizontal ground loom (see figs. 7-1, 7-2) were found at the Cave of the Treasure.[46] Bone shuttles were also found there, one of them bearing a thread in the hole.[47]

This equipment was ideal for narrow textile strips such as the bandage that was found at the Cave of the Warrior. The bandage was not just a strip of a larger piece of fabric but a cloth with finished edges on either side.[48] The horizontal ground loom is also known in Egypt,[49] where the earliest depiction is

7-15: Example of Chalcolithic S-spun line and threads. Cave of the Treasure, Naḥal Mishmar: 2002-9206 B 231926.

7-16: Illustration showing splicing technique.

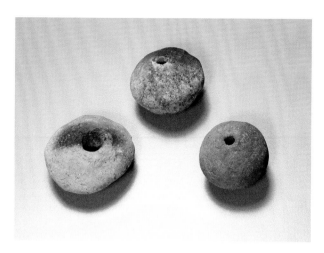

on a bowl from 5000 BCE.[50] It is still in use today, in Turkey and among the Bedouins, for example (fig. 7-18). Because of its size and the shapes of the small beams, Breniquet[51] suggested that the Chalcolithic loom was a backstrap loom (in which one bar is attached to a fixed object and the other to the weaver, usually by means of a strap around the back), but there is no indication of this loom in the Southern Levant. It was and is used in Central and South America.

The predominant weaves[52] found in the Chalcolithic Southern Levant are various types of plain, or tabby, weave, usually characterized by slightly more warp than weft threads per centimeter (fig. 7-19). Some are executed using a balanced tabby weave, in which the number of threads per centimeter in the warp equals that in the weft. A few textiles are warp-faced tabby, in which the number of warp threads per centimeter is significantly higher than the number of wefts. Modern weaving parlance would classify these as medium-density weaves. At the Cave of the Treasure, the number of threads per centimeter ranges between nine and forty-five in the warp, and seven and thirty in the weft. Through all of this variation, weaving faults are rare, indicating a long tradition and the development of considerable expertise.[53]

Finishing: Color, Dying, and Decoration

Most Chalcolithic textiles are undyed, ranging from off-white through cream and beige. A few are bleached. Bleaching was a long process intended to whiten linen textiles, which are naturally of a gray-brown color. The textiles were soaked in cleaning and whitening chemicals and then exposed to the sun for weeks, during which time they became white.[54]

The lack of decoration on most of the textiles is understandable due to the fact that linen does not easily absorb dye, with the exception of blue dye.[55] Textiles were found at the Cave of the Warrior decorated (but not dyed) with black bands of paint or smeared asphalt (see fig. 7-3b). In addition, reddish spots on the shroud of the male burial there have been identified as ochre, possibly sprinkled onto the textile as part of the burial ritual.[56] A textile from the Qarantal cliff (cave VI/46) is decorated with fringes and double "hollow bands"—missing threads hint that color threads, now disintegrated, might have decorated this textile (see page 139).[57]

Use: Textiles in Society

The labor required to produce textiles, from the initial state of flax growth to the last stage of processing, implies both a high level of skill and a huge investment of labor.[58] In all later Ancient Near Eastern societies, the process of spinning and weaving was a craft practiced by the women of the house. Bronze Age Aegean and Near Eastern texts in fact refer to the capture of women to serve in the weaving industries of larger households.[59] Garments, including a kilt and a sash inside the shroud, were found at the Cave of the Warrior,[60] and we assume that the primary use of textiles was as clothing. Some of the textiles at the Cave of the Treasure were employed as shrouds, probably in secondary use. The shroud at the Cave of the Warrior, however, was made especially for that purpose. It is worth mention that among the fragments

7-17: Biconical spindle whorls (3). Clay, Bir Ṣafadi, Shiqmim, and find location unknown. IAA: 1982-1479, 1982-1527, 1987-992. Checklist nos. 144, 146, 151.

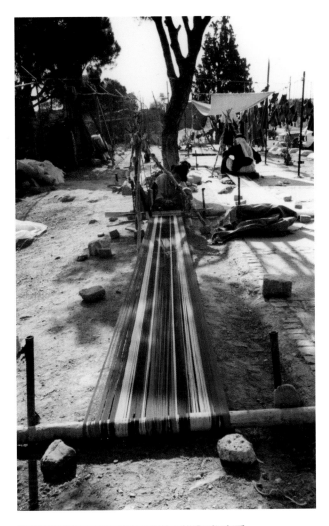

in Judean Desert caves are narrow, cut, band-like specimens, probably in secondary use as ties or bandages. In general, the fragments may have originated from garment items or shrouds. At Ze'elim textiles were used as containers for thousands of beads. In this case as well the textile may have been in secondary use.

Basketry

Chalcolithic-period basketry artifacts made of straw and reeds include mats, sieves, trays, baskets, and ropes (figs. 7-20, 7-21). In addition, impressions of basketry on bases of pottery are known from platters at Tuleilat Ghassul (fig. 7-22) and from ossuaries and platters at other sites, including Peqi'in.[61] Potters often placed freshly shaped pots and ossuaries on mats to dry before they were fired, or sometimes used mats as primitive turntables.[62]

The various basketry techniques revealed by these finds are impressive and complex. Some artisans used coiling (fig. 7-23), which is done by taking a long bundle of grass and winding it around upon itself in a spiral, with each new turn of the coil attached to the preceding one by means of stitches.[63] Others, such as those who created the mat of the "Warrior" (see fig. 7-6) used open simple twining (fig. 7-20) and twill plaiting (fig. 7-23, bottom center). In this case the mat was manufactured using passive-active horizontal elements (wefts) wrapped around stationary vertical elements (warps). The active wefts, usually paired or tripled strands, were manipulated so that they twine about each other to sequentially enclose one passive element, or set of elements. The weft rows are spaced at intervals, leaving portions of the warps exposed.[64] The metal treasure from the Cave of the Treasure was wrapped with a threaded mat (see fig. 7-6) measuring 80 by 120 cm,[65] with the stationary warp elements crowded together in a parallel orientation. The active wefts are spaced at intervals and pass through slits produced in the warp elements.[66] The key point of

7-18: Modern-day horizontal ground loom, Turkey.

7-19: Illustration of a weave with slightly more warp than weft threads per centimeter.

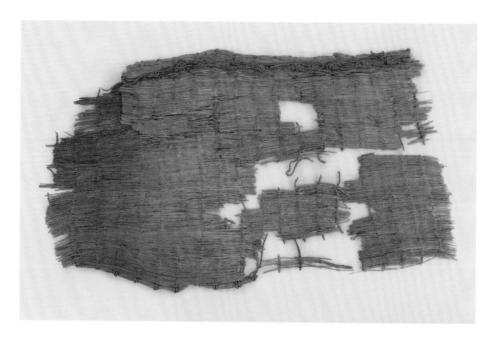

these technical descriptions is that basketry was an advanced process, with all manner of techniques used by skilled artisans to create a variety of effects. This craft skill demonstrates that the Chalcolithic baskets, though they may be among the first examples that have been preserved, are part of a tradition that had been developing for millennia.

Summary and Conclusions

Textiles and baskets dating to the Chalcolithic period are the earliest examples found in Israel, and provide exceptional insight into early production. Earlier textiles were found in Asia Minor—Neolithic Çatal Höyük and Çayönü in Southeastern Turkey.[67] In Mesopotamia textile imprints on clay and bitumen from Jarmo (northern Iraq), dated to 7000 BCE, already suggest the use of a loom.[68] But none of these regions preserved finished textiles of the size and diversity represented in this collection from the Southern Levant. The exceptional preservation of Chalcolithic textiles and baskets makes this collection a critical marker in the study of the development of textile technology.

7-20: Cave of the Treasure threaded mat that wrapped the Treasure, Naḥal Mishmar. IAA: 1961-1181.

7-21: Two fragments of rope. Palm Fiber, Naḥal Mishmar. IAA, Har Hotzvim: 1961-1189. Checklist no. 137.

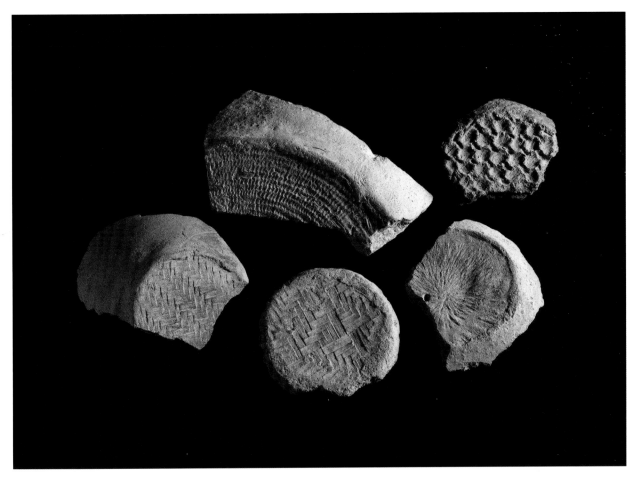

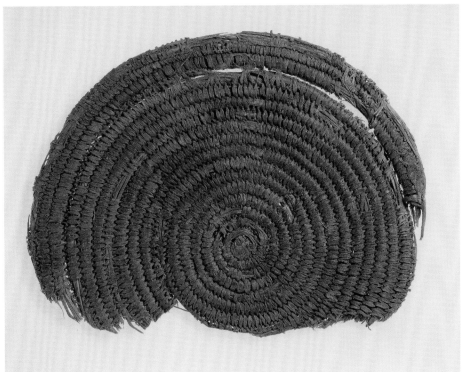

7-22: Jar bases with mat impressions.
Clay. Bottom center: Tuleilat Ghassul. PBI,
Jerusalem. Checklist no. 131.

7-23: Coiled-basket fragment. Reeds,
Naḥal Mishmar. IAA: 1961-1184l.
Checklist no. 136.

Notes

I would like to thank Dr. Antoinette Rast-Eicher for her help with understanding splicing, and Michael Sebbane and Osnat Misch-Brandl for their helpful comments. Conservation of the artifacts from the Cave of the Warrior was done by Olga Nagnvishki at the Conservation Laboratory of the Israel Antiquities Authority. Conservation of the small bag from Naḥal Ze'elim was done by Dr. Smadar Gabrieli. Conservation of all other artifacts was by Olga Nagnvishki and Raisa Vinitsky at the Israel Antiquities Authority.

1 Davidovich 2012; Davidovich 2013.
2 Bar-Adon 1980.
3 Also called a "tabby weave," this weave involves the weft (the active thread that is being woven by the weaver) passing over and under the warp (the stationary thread originally attached to the loom) in an alternating fashion, creating a crisscross pattern.
4 Bar-Adon 1980.
5 This has misled some scholars, such as Frangipane et. al. 2009, 27, who wrote, "The only other very early example of a textile made from animal fibers, from the Naḥal Mishmar Cave, Israel, is dated to the middle of the 4th millennium."
6 Schick 1998.
7 In Bar-Adon 1980, fabric described as "S-spun" refers to textiles from the Roman period, while fabric described as "double S" refers to textiles from the Chalcolithic period.
8 This refers to a method of finishing the edge of a textile (parallel to the warp) in order to keep the textile from unraveling.
9 Schick 1998.
10 Bar-Yosef Mayer and Porat 2010.
11 Aharoni 1961.
12 Eshel and Zissu 2002, 119; Khalaily 2002, 129.
13 Kvavadze et al. 2009; Bar-Yosef et al. 2011.
14 Weiss and Zohary 2011, 249.
15 Abbo et. al. 2013.
16 Bar-Adon 1980, 185; Shamir 2007.
17 Schick 2002, 238.
18 Shamir 1996, 142.
19 Abbo et. al. 2013.
20 Leuzinger and Rast-Eicher 2011, 535.
21 Shamir 2002, 21.*
22 Schick 2002, 238.
23 Shishlina, Orfinskaya, and Golikov 2003, 331, 339.
24 Breniquet 2010, 55.
25 Bonani 1995, 205, gives a date of 10,220 ± 45 based on a sample of the wood from the comb.
26 Schick 1995.
27 Schick 2002, 238.
28 Barber 1997, 47; Leuzinger and Rast-Eicher 2011, 537; Gleba and Mannering 2012, 10.

29 Leuzinger and Rast-Eicher 2011.
30 Gleba and Mannering 2012, 10; Caton-Thompson and Gardner 1934, 46.
31 Barber 1991, 44–48, 53 (figs. 2.5, 2.6); Barber 1997, 192.
32 Hall 1986, 11; Vogelsang-Eastwood 2000, 268.
33 Barber 1991, 145.
34 Vogelsang-Eastwood 2000, 269.
35 Dothan 1963; Perrot, Zori, and Reich 1967, 223; Barber 1991, 48, 77–78; Levy and Gilead 2013, 32–33.
36 Shamir 1996, 149; Levy and Gilead 2013, 32.
37 Leuzinger and Rast-Eicher 2011, 540.
38 Bar-Adon 1980, 183–85.
39 Epstein 1998, 166 (pl. 21, fig. 15); Levy and Gilead 2013, 26–27, 41.
40 Emery 1966, 11–12, cites 20 degrees.
41 See note 3 above.
42 Leuzinger and Rast-Eicher 2011, 540; Rast-Eicher 2012, 381.
43 Schick 1988.
44 Ibid.
45 Barber 1991, 129–32. The horizontal ground loom was replaced by the warp-weighted loom at the Middle Bronze II Age and not before. Kenyon 1981, 368–70; Shamir 1996, 139.
46 Bar-Adon 1980, 178–82.
47 Ibid., 177.
48 Schick 1998, 17.
49 Roth 1951, 3, 8.
50 Vogelsang-Eastwood 2000, 276.
51 Breniquet 2010, 52.
52 See note 3 above.
53 Schick 2002, 224, 231, 235.
54 Forbes 1956, 95.
55 Shamir and Sukenik 2011, 216.
56 Koren 1998, 101.
57 Schick 2002, 234.
58 Shishlina, Orfinskaya, and Golikov 2003, 339.
59 See the summary in Barber 1991, 283–98.
60 Schick 1998.
61 Schick 2013, 447–57.
62 Ösdemir 2007, 74–75.
63 Ibid., 75.
64 Schick 2013, 447–49.
65 Bar-Adon 1980, 192.
66 Schick 2013, 448.
67 McCorriston 1997, 519.
68 Adovasio 1977.

Exhibition Checklist

IAA: Israel Antiquities Authority

IMJ: The Israel Museum, Jerusalem

PBI, Jerusalem: Pontifical Biblical
Institute, Jerusalem

Katzrin Museum: Golan Archaeological
Museum

Tel Aviv University: The Sonia and
Marco Nadler Institute of Archaeology

1. Pottery Sherd with Snake Decoration
Clay
H. 10 cm; W. 15 cm
Tuleilat Ghassul, 4500–3600 BCE
PBI, Jerusalem
(Fig. 4-24)

2. Fragmentary Head from an Animal
Figurine (Ram?)
Clay
H. 3.8 cm; W. 1.5 cm; D. 2.2 cm
Tuleilat Ghassul, 4500–3600 BCE
PBI, Jerusalem

3. Figurine of a Ram
Stone
H. 9.3 cm; L. 17.5 cm; D. 3.9 cm
Azor region, chance find, n.d.,
4500–3600 BCE
IAA: 1939-722, exhibited at IMJ
(Fig. 4-8)

4. Head of a Figurine Wearing an
Elaborate Headdress
Ivory
H. 7.4 cm; W. 3.6 cm; D. 3.6 cm
Be'er Sheva (Bir Ṣafadi), 4500–3600 BCE
IAA: 1958-580, exhibited at IMJ
(Page 41)

5. Stylized Head of a Ram
Limestone
L. 8 cm; W. 3.8 cm; D. 3.1 cm
Kabri, 4500–3600 BCE
IAA: 1994-2656, exhibited at IMJ
(Fig. 4-7)

6. Female Figurine
Bone
H. 9.5 cm; W. 3.5 cm; D. 0.6 cm
Shiqmim, 4500–3600 BCE
IAA: 1996-3495, exhibited at IMJ
(Fig. 2-13)

7. Male (?) Head
Ivory
H. 4.1 cm; W. 2 cm; D. 2.2 cm
Peqi'in, 4500–3600 BCE
IAA: 1997-3572
(Fig. 3-12)

8. Fragment from an Ossuary
Decorated with Two Snake Heads
Clay
L. 19.5 cm; W. 14.3 cm
Tel-Aviv, 4500–3600 BCE
IAA: 2001-6153
(Fig. 4-23a)

9. Male Figurine
Clay
H. 21 cm; W. 2.5 cm; D. 4.1 cm
Qula, 4500–3600 BCE
IAA: 2003-733, exhibited at IMJ
(Figs. 3-13a–b)

10. Female Figurine
Ivory
H. 13.5 cm; W. 3.5 cm; D. 1.2 cm
Be'er Sheva, 4500–3600 BCE
IMJ: 81.1.43
(Fig. 3-11)

11. Libation Vessel in the Shape of a
Ram Carrying Cornets
Clay
H. 22.5 cm; W. 28 cm; D. 10.1 cm
Gilat, 4500–3600 BCE
IAA: 1976-53, exhibited at IMJ
(Figs. 1-1, 4-6)

12. Libation Vessel in the Shape of a
Woman Carrying a Churn
Clay
H. 31.5 cm; W. 11 cm; D. 11 cm
Gilat, 4500–3600 BCE
IAA: 1976-54, exhibited at IMJ
(Page 79, Fig. 4-6)

13. Pendant
Stone
H. 3.5 cm; W. 2.9 cm; D. 0.4 cm
Bir Ṣafadi, 4500–3600 BCE
IAA: 1958-573
(Fig. 5-11)

14. Rectangular Palette
Limestone
H. 17.4 cm; W. 13.5 cm; D. 1.9 cm
Abu Matar, 4500–3600 BCE
IAA: 1958-578
(Fig. 2-9)

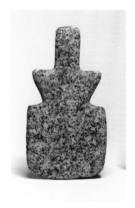

15. Violin-Shaped Figurine
Sandstone
H. 20.6 cm; W. 8 cm; D. 4 cm
Gilat, 4500–3600 BCE
IAA: 1975-1033, exhibited at IMJ
(Fig. 4-3)

16. Violin-Shaped Figurine
Stone
H. 7 cm; W. 4.5 cm; D. 0.8 cm
Gilat, 4500–3600 BCE
IAA: 1975-1034
(Fig. 2-7)

17. Violin-Shaped Figurine
Stone
H. 8 cm; W. 4.5 cm; D. 0.7 cm
Gilat, 4500–3600 BCE
IAA: 1975-1041
(Fig. 2-6)

18. Rectangular Palette
Stone
H. 11.9 cm; W. 9.1 cm; D. 1.5 cm
Gilat, 4500–3600 BCE
IAA: 1975-1044
(Figs. 2-9, 4-4)

19. Rectangular Palette
Granite
H. 12.7 cm; W. 8.3 cm; D. 2.7 cm
Gilat, 4500–3600 BCE
IAA: 1975-1046
(Fig. 2-9)

20. Pendant
Shell (Mother-of-Pearl)
H. 4 cm; W. 3.1 cm; D. 0.3 cm
Patish (Gilat), 4500–3600 BCE
IAA: 1975-1050
(Fig. 4-5)

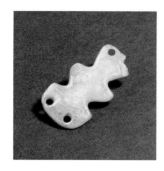

21. Violin-Shaped Pendant
Shell
H. 3.5 cm; W. 1.8 cm
Peqi'in, 4500–3600 BCE
IAA: 1982-1412
(Fig. 2-14)

22. Violin-Shaped Figurine with Breasts
Stone
H. 17 cm; W. 12.2 cm; D. 1.4 cm
Gilat, 4500–3600 BCE
IMJ: 1992-1211
(Fig. 4-3)

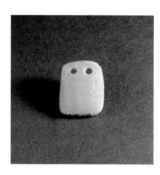

23. Pendant
Stone
H. 2.8 cm; W. 2.2 cm; D. 0.5 cm
Abu Matar, 4500–3600 BCE
IAA: 1993-2350
(Fig. 5-11)

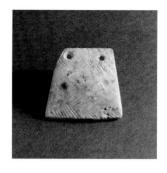

24. Pendant
Shell (Mother-of-Pearl)
H. 4.4 cm; W. 4.4 cm; D. 0.3 cm
Kissufim, 4500–3600 BCE
IAA: 1993-2934
(Fig. 5-11)

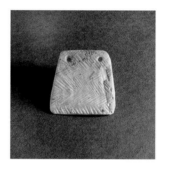

25. Pendant
Shell (Mother-of-Pearl)
H. 4.2 cm; W. 4 cm; D. 0.3 cm
Kissufim, 4500–3600 BCE
IAA: 1993-2943
(Fig. 5-11)

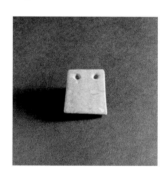

26. Pendant
Greenstone
H. 2.6 cm; W. 2.5 cm; D. 0.4 cm
Find Location Unknown, 4500–3600 BCE
IAA: 1993-5219
(Fig. 5-11)

27. Rectangular Palette
Granite
H. 12.5 cm; W. 9.2 cm; D. 3.6 cm
Gilat, 4500–3600 BCE
IAA: 2000-1844
(Fig. 2-9)

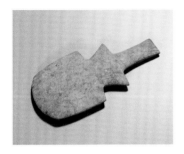

28. Violin-Shaped Figurine
Stone
H. 12.1 cm; W. 5.6 cm; D. 1 cm
Peqi'in, 4500–3600 BCE
IAA: 2005-1308

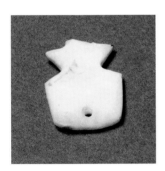

29. Violin-Shaped Pendant
Stone
H. 2.2 cm; W. 1.6 cm
Peqi'in, 4500–3600 BCE
IAA: 2005-1309
(Fig. 2-16)

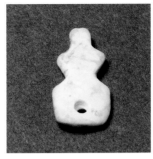

30. Violin-Shaped Pendant
Stone
H. 1.6 cm; W. 0.8 cm
Peqi'in, 4500–3600 BCE
IAA: 2005-1310
(Fig. 2-16)

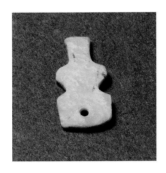

31. Violin-Shaped Pendant
Turquoise
H. 1.6 cm; W. 0.7 cm
Peqi'in, 4500–3600 BCE
IAA: 2005-1312
(Fig. 2-16)

32. Violin-Shaped Figurine
Bone
H. 11.3 cm; W. 2.7 cm; D. 0.5 cm
Peqi'in, 4500–3600 BCE
IAA: 2005-1314
(Fig. 3-14)

33. Pendant
Limestone
H. 4.6 cm; W. 3.7 cm; D. 0.4 cm
Bir Ṣafadi, 4500–3600 BCE
IAA: 2007-1628
(Figs. 3-15, 5-11)

34. Anthropomorphic Stand with Horns
and Pronounced Eyes
Basalt
H. 26 cm; Diam. 17 cm
Seluqiyye, 4500–3600 BCE
IAA: 1981-3017, exhibited at IMJ
(Fig. 4-18)

35. Anthropomorphic Stand with Horns
and Crown Motif
Basalt
H. 34 cm; W. 21 cm
Seluqiyye, 4500–3600 BCE
IAA, Katzrin Museum: 1987-6935
(Fig. 3-10)

36. Anthropomorphic Stand with Horns
and Bearded Face
Basalt
H. 22 cm; Diam. 20.cm
Rasm Ḥarbush, 4500–3600 BCE
IAA: 1987-911, exhibited at IMJ
(Page 63)

37. Miniature Ossuary with Modeled
Nose and Arms
Clay
H. 10.2 cm; W. 7.8 cm; L. 15 cm
Bene-Berak, 4500–3600 BCE
IAA: 1951-50, exhibited at IMJ
(Fig. 1-3)

38. Miniature Ossuary Decorated with
a Snake
Clay
H. 28 cm; Diam. 15 cm
Ben Shemen, 4500–3600 BCE
IAA: 1963-443, exhibited at IMJ
(Fig. 5-10)

39. Miniature Churn
Clay
H. 2.9 cm; W. 14 cm; D. 2.4 cm
Gerar, 4500–3600 BCE
IAA: 2004-2453
(Fig. 4-19)

40. Miniature Churn
Clay
H. 19.5 cm; W. 27 cm; D. 12 cm
Peqi'in, 4500–3600 BCE
IAA: 2007-2133
(Fig. 2-10)

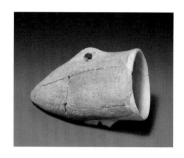

41. Miniature Cornet
Clay
H. 9.4 cm; Diam. 5.4 cm
Shiqmim, 4500–3600 BCE
IAA: 2012-348

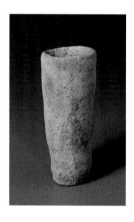

42. Miniature Vessel
Clay
H. 9.2 cm; Diam. 4.8 cm
Shiqmim, 4500–3600 BCE
IAA: 2012-371

43. Miniature Vessel
Clay
H. 8.2 cm; Diam 3.2 cm
Shiqmim, 4500–3600 BCE
IAA: 2012-373

44. Crown with Building-Facade
Decoration and Vultures
Copper
H. 17.5 cm; Diam. 16.8 cm
Naḥal Mishmar, 4500–3600 BCE
IAA: 1961-177, exhibited at IMJ
(Page 19)

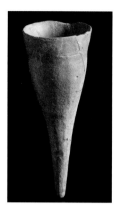

45. Cornet
Clay
H. 18 cm; Diam. (Rim) 7 cm
Tuleilat Ghassul, 4500–3600 BCE
PBI, Jerusalem
(Fig. 4-21)

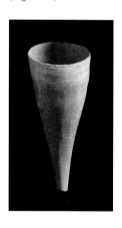

46. Cornet
Clay
H. 14 cm; Diam. (Rim) 6.5 cm
Tuleilat Ghassul, 4500–3600 BCE
PBI, Jerusalem
(Fig. 4-21)

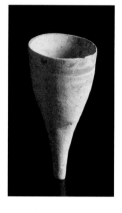

47. Cornet with Painted Bands
Clay
H. 15 cm; Diam. (Rim) 7 cm
Tuleilat Ghassul, 4500–3600 BCE
PBI, Jerusalem
(Fig. 4-21)

48. V-Shaped Bowl
Basalt
H. 20 cm; Diam. (Rim) 48 cm
Bir Ṣafadi, 4500–3600 BCE
IAA: 1963-485
(Fig. 1-15)

49. Pointed Bowl
Clay
H. 18 cm; Diam. 21 cm
Bir Ṣafadi, 4500–3600 BCE
IAA: 1982-1473
(Fig. 1-6)

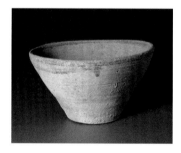

50. V-Shaped Bowl with Painted Band
around Rim
Clay
H. 16.5 cm; Diam. 18.20 cm
Shiqmim, 4500–3600 BCE
IAA: 1982-1613
(Fig. 1-12)

51. Pithos Decorated with Rope Motif
Clay
H. 130 cm; W. 25 cm
Rasm-Harbush, 4500–3600 BCE
IAA, Katzrin Museum: 1990-2144
(Fig. 1-9)

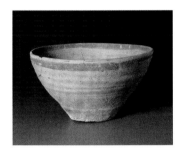

52. V-Shaped Bowl with Painted Band
around Rim
Clay
H. 12 cm; Diam. 20.5 cm
Bir Ṣafadi, 4500–3600 BCE
IAA: 1992-1136
(Fig. 1-12)

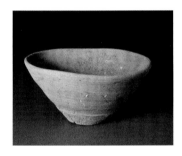

53. V-Shaped Bowl
Clay
H. 7.5 cm; Diam. 11.5 cm
Bir Ṣafadi, 4500–3600 BCE
IAA: 1992-1248
(Fig. 1-12)

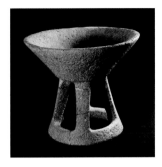

54. Fenestrated and Pedestaled Bowl
Basalt
H. 25.5 cm; Diam. 28.5 cm
Giv'at Ha-Oranim, 4500–3600 BCE
IAA, Tel Aviv University: 1997-3460
(Fig. 1-16)

55. Hole-Mouth Jar with Painted
Decoration and Pierced Lug Handles
Clay
H. 46 cm; Diam. (Max.) 45; Diam. (Rim)
25.5 cm
Giv'at Ha-Oranim, 4500–3600 BCE
IAA, Tel Aviv University: 2000-480
(Fig. 1-2)

56. Cream Ware Juglet with Red
Painted Bands
Clay
H. 16.5 cm; W. 12 cm;
Diam. (Rim) 7.3 cm
Gerar, 4500–3600 BCE
IAA: 2004-2846
(Fig. 1-4)

57. Goblet
Clay
H. 14.8 cm; Diam. 17.5 cm
Gilat, 4500–3600 BCE
IAA: 1912-333
(Fig. 1-7)

58. Churn
Clay
H. 32.5 cm; L. 45 cm; D. 28 cm
Giv'at Ha-Oranim, 4500–3600 BCE
IAA, Tel Aviv University: 2013-1031
(Fig. 1-13)

59. Anthropomorphic Ossuary with
Prominent Male Face
Clay
H. 60 cm; W. 35 cm; D. 60 cm
Peqi'in, 4500–3600 BCE
IAA, Eretz Israel Museum: 2002-1038
(Fig. 5-7)

60. Anthropomorphic Ossuary with
Modeled Arms and Torso
Clay
H. 64 cm; L. 71 cm; W. 40 cm
Peqi'in, 4500–3600 BCE
IAA: 2007-1801, exhibited at IMJ
(Fig. 5-6)

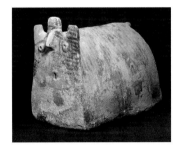

61. Anthropomorphic Ossuary with Tail
and Door-Shaped Lid
Clay
H. 45 cm; W. 30 cm; D. 45 cm
Peqi'in, 4500–3600 BCE
IAA: 2007-1812
(Fig. 3-8)

62. Ossuary with Painted and Sculpted
Facial Features
Clay
H. 62.5 cm; W. 35 cm; D. 48 cm
Peqi'in, 4500–3600 BCE
IAA: 2007-1850, exhibited at IMJ
(Fig. 1-19)

63. Ossuary with Architectural Facade
Clay
H. 65 cm; W. 33 cm; D. 63 cm
Azor, 4500–3600 BCE
IAA: 1971-341, exhibited at IMJ
(Fig. 5-4)

64. Painted Anthropomorphic Ossuary
with Sculpted Nose, Stamped Eyes,
and Gaping Mouth
Clay
H. 63 cm; W. 34 cm; D. 57 cm
Taiyiba, 4500–3600 BCE
IAA: 1990-1129, exhibited at IMJ
(Fig. 3-1)

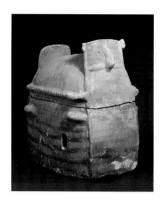

65. Lidded Anthropomorphic Ossuary
Clay
H. 54 cm; W. 34 cm; D. 54 cm
Peqi'in, 4500–3600 BCE
IAA: 1996-2634
(Fig. 3-8)

66. Ossuary with Painted
Anthropomorphic Face
Clay
H. 50 cm; W. 67; D. 35 cm
Peqi'in, 4500–3600 BCE
IAA: 2007-1807, exhibited at IMJ
(Fig. 3-7)

67. Anthropomorphic Stand
Basalt
H. 15.5 cm; W. 11.5 cm; D. 15 cm
Rasm-Ḥarbush, 4500–3600 BCE
IAA: 1981-3016
(Fig. 1-8)

68. Fenestrated Stand with Two Bowls
Clay
H. 80.5 cm; W. 32 cm; D. 23 cm
Peqi'in, 4500–3600 BCE
IAA: 1997-3564
(Fig. 5-9)

69. Fenestrated Bowl with
Painted Motifs
Clay
H. 30.3 cm; Diam. (top) 15.5 cm
Peqi'in, 4500–3600 BCE
IAA: 1997-3567
(Fig. 5-8)

70. Fenestrated Stand with Three
Bowls and Sculpted Motifs
Clay
H. 103 cm; W. 36 cm
Peqi'in, 4500–3600 BCE
IAA: 2005-811, exhibited at IMJ
(Page 101)

71. Burial Jar with Sculpted Nose and
Female Breasts
Clay
H. 40 cm; Diam. 43 cm
Peqi'in, 4500–3600 BCE
IAA: 2007-1692, exhibited at IMJ
(Fig. 3-3)

72. Ossuary with Pierced Rim
Clay
H. 20 cm; L. 65 cm; D. 25 cm
Peqi'in, 4500–3600 BCE
IAA: 2007-1750
(Fig. 1-14)

73. Three-dimensional
Anthropomorphic Head from an
Ossuary
Clay
H. 14.2 cm; W. 11.4 cm
Peqi'in, 4500–3600 BCE
IAA: 2007-2247, exhibited at IMJ
(Figs. 3-5, 5-5)

74. Polished Mace Head
Hematite
H. 3.6 cm; Diam. 3.9 cm
Bene-Berak (Tel Aviv), 4500–3600 BCE
IAA: 1951-053

75. Polished Mace Head
Hematite
H. 3.5 cm; Diam. 4.5 cm
Abu Matar, 4500–3600 BCE
IAA: 1958-595

76. Mace Head with Vertical Rows of
Protruding Knobs
Copper
H. 7.3 cm; Diam. 3.3 cm
Naḥal Mishmar, 4500–3600 BCE
IAA: 1961-108, exhibited at IMJ
(Fig. 6-13)

77. Incised Mace Head
Copper
H. 6.6 cm; Diam. 4.6 cm
Naḥal Mishmar, 4500–3600 BCE
IAA: 1961-114, exhibited at IMJ
(Fig. 6-5)

78. Mace Head with Four Protruding
Cylindrical Bosses
Copper
H. 5.4 cm; W. 11.9 cm; D. 4.4 cm
Naḥal Mishmar, 4500–3600 BCE
IAA: 1961-117, exhibited at IMJ
(Fig. 6-7)

79. Triangular Mace Head
Copper
W. 7.5 cm; Th. 1.9 cm
Naḥal Mishmar, 4500–3600 BCE
IAA: 1961-121, exhibited at IMJ
(Fig. 2-2)

80. Scepter with Plain Shaft and
Spiral Ridges
Copper
H. 20.3 cm; Diam. (Shaft) 2 cm
Naḥal Mishmar, 4500–3600 BCE
IAA: 1961-13, exhibited at IMJ
(Fig. 6-14)

81. Disk-shaped Mace Head
Copper
H. 3.0 cm; Diam. 6.6 cm
Naḥal Mishmar, 4500–3600 BCE
IAA: 1961-131, exhibited at IMJ
(Fig. 6-11)

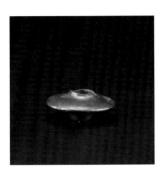

82. Disk-shaped Mace Head
Copper
H. 2.4 cm; Diam. 6.1 cm
Naḥal Mishmar, 4500–3600 BCE
IAA: 1961-180, exhibited at IMJ
(Fig. 6-11)

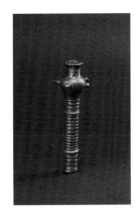

83. Scepter with Grooved Shaft,
Two Horizontal Ridges, and
Five Protruding Bosses
Copper
H. 15.3 cm; W. 4.2 cm; Diam.
(Shaft) 2 cm
Naḥal Mishmar, 4500–3600 BCE
IAA: 1961-190, exhibited at IMJ
(Fig. 6-14)

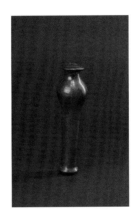

84. Scepter with Plain Shaft and
Spherical Head
Copper
H. 14.8 cm; Diam. (Shaft) 2.1 cm
Naḥal Mishmar, 4500–3600 BCE
IAA: 1961-2, exhibited at IMJ
(Fig. 6-14)

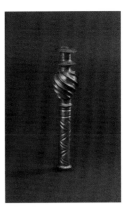

85. Scepter with Grooved Shaft, Spiral
Ridges, and Two Disks
Copper
H. 17.7 cm; Diam. (Shaft) 1.8 cm
Naḥal Mishmar, 4500–3600 BCE
IAA: 1961-27, exhibited at IMJ
(Fig. 6-14)

86. Mace Head
Copper
H. 5.3 cm; Diam. 4.7 cm
Naḥal Mishmar, 4500–3600 BCE
IAA: 1961-297, exhibited at IMJ
(Fig. 6-4)

87. Mace Head
Copper
H. 4.6 cm; Diam. 4.7 cm
Naḥal Mishmar, 4500–3600 BCE
IAA: 1961-313, exhibited at IMJ
(Fig. 6-4)

88. Mace Head
Copper
H. 3.9 cm; Diam. 4.3 cm
Naḥal Mishmar, 4500–3600 BCE
IAA: 1961-316, exhibited at IMJ
(Fig. 6-4)

89. Mace Head
Copper
H. 4.7 cm; Diam. 5.1 cm
Naḥal Mishmar, 4500–3600 BCE
IAA: 1961-330, exhibited at IMJ
(Fig. 6-4)

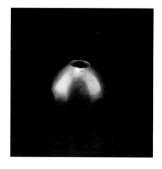

90. Mace Head
Copper
H. 4.6 cm; Diam. 4.9 cm
Naḥal Mishmar, 4500–3600 BCE
IAA: 1961-336, exhibited at IMJ
(Fig. 6-4)

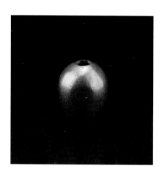

91. Mace Head
Copper
H. 5.5 cm; Diam. 4.3
Naḥal Mishmar, 4500–3600 BCE
IAA: 1961-344, exhibited at IMJ
(Fig. 6-4)

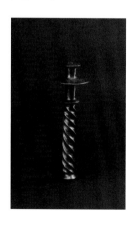

92. Scepter with Shaft Decorated in
Spiral Ridges and Two Projecting Disks
Copper
H. 21.3 cm; Diam. (Shaft) 2.4 cm
Naḥal Mishmar, 4500–3600 BCE
IAA: 1961-69, exhibited at IMJ
(Fig. 6-14)

93. Scepter with Grooved Shaft and
Four Protruding Cylindrical Bosses
Copper
H. 18.5 cm; Diam. (Shaft) 2.1 cm
Naḥal Mishmar, 4500–3600 BCE
IAA: 1961-74

94. Scepter with Grooved Shaft
Decorated in a Human Head and Three
Elongated Bosses
Copper
H. 13.2 cm; Diam. (Shaft) 1.9 cm
Naḥal Mishmar, 4500–3600 BCE
IAA: 1961-84, exhibited at IMJ
(Fig. 4-12)

95. Scepter with Grooved Shaft and
Four Horned Animal-Head Finials
Copper
H. 8.2 cm; Diam. (Shaft) 1.8 cm
Naḥal Mishmar, 4500–3600 BCE
IAA: 1961-86, exhibited at IMJ
(Fig. 6-15)

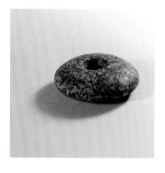

96. Mace Head
Diorite
H. 2.4 cm; D. 7.3 cm
Gilat, 4500–3600 BCE
IAA: 1975-1116
(Fig. 6-12)

97. Mace Head
Granite
H. 4.4 cm; Diam. 6.6 cm
Gerar, 4500–3600 BCE
IAA: 1975-1117
(Fig. 6-12)

98. Polished Mace Head
Hematite
H. 4.2 cm; Diam. 4.9 cm
Rasm-Ḥarbush, 4500–3600 BCE
IAA: 1981-3015

99. Mace Head Decorated with Four
Protruding Knobs
Stone
H. 3.5 cm; W. 4.9 cm; Diam. 4.2 cm
Kibbutz HaZore'a, 4500–3600 BCE
IAA: 1991-351
(Figs. 2-18, 6-9)

100. Polished Mace Head
Limestone
H. 5.3 cm; Diam. 6.5 cm
Abu Matar, 4500–3600 BCE
IAA: 1994-1199
(Figs. 1-5, 2-8)

101. Polished Mace Head
Limestone
H. 5.4 cm; Diam. 5.8 cm
Bir Ṣafadi, 4500–3600 BCE
IAA: 1994-1200
(Fig. 2-18)

102. Polished Mace Head
Limestone
H. 5.3 cm; Diam. (Max.) 4.3 cm
Peqi'in, 4500–3600 BCE
IAA: 2005-1317
(Fig. 2-18)

103. Scepter with Axe Head
Copper
H. 9.6 cm; W. 10 cm; Diam.
(Shaft) 2.2 cm
Naḥal Mishmar, 4500–3600 BCE
IAA: 1961-123, exhibited at IMJ
(Fig. 6-20)

104. Pierced Crescent
Ivory (Hippopotamus)
L. 55 cm; W. 7.8 cm; D. 2.2 cm
Naḥal Mishmar, 4500–3600 BCE
IAA: 1961-161, exhibited at IMJ
(Fig. 4-11)

105. Basket-Shaped Jar with Looped
Handle and Decorative Grooves
Copper
H. 18.6 cm; W. 8.9 cm
Naḥal Mishmar, 4500–3600 BCE
IAA: 1961-164, exhibited at IMJ
(Fig. 6-19)

106. Horn-Shaped Object with Bird
Finial
Copper
H. 13.3 cm; D. 6 cm
Naḥal Mishmar, 4500–3600 BCE
IAA: 1961-167, exhibited at IMJ
(Fig. 1-18)

107. Crown with Two Bands
of Herringbone Motifs and
Horizontal Grooves
Copper
H. 9.1 cm; Diam. 17.3 cm; Th. 0.4 cm
Naḥal Mishmar, 4500–3600 BCE
IAA: 1961-173
(Fig. 6-18)

108. Crown with Plain Walls and
Two Horned Animal Heads Projecting
from the Rim
Copper
H. 9.0 cm; Diam. 17.3 cm; Th. 0.5 cm
Naḥal Mishmar, 4500–3600 BCE
IAA: 1961-175, exhibited at IMJ
(Fig. 1-10)

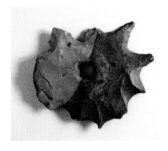

109. Perforated Star-Shaped
Mace Head
Flint
H. 11.5 cm; W. 13.5 cm; Th. (Max.) 1.1
cm
Rasm-Ḥarbush, 4500–3600 BCE
IAA: 1987-1523
(Fig. 2-15)

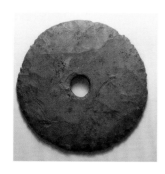

110. Round Mace Head
Flint
Diam. 12.6–12.8 cm; Th. (Max.) 0.9 cm
Majami-El, 4500–3600 BCE
IAA: 1987-1526
(Fig. 2-15)

111. Tool with Chipped Spikes
Flint
L. 13.3 cm; Th. 1.2 cm
Find Location Unknown, 4500–3600 BCE
IMJ: 82.13.849
(Fig. 4-20)

112. Bow
Olive wood
L. 64 cm
Cave of the Warrior, Wadi Makukh,
4500–3600 BCE
IAA
(Fig. 5-2)

113. Beads
Turquoise and Other Stones
Diam. (Max.) 0.5 cm
Ẓe'elim, 4500–3600 BCE
IAA: 1953-1307
(Fig. 7-10)

114. Twine
Linen
L. (Max.) 15 cm
Ẓe'elim, 4500–3600 BCE
IAA: 1953-1307
(Fig. 7-11)

115. Floor Pebble with Painted Line
Pebble, Red Ochre
9.5 cm x 7.2 cm
Bir Ṣafadi, 4500–3600 BCE
IAA: 1955-412

116. Floor Pebble with Painted Dots
Pebble, Red Ochre
9.7 cm x 7.5 cm
Bir Ṣafadi, 4500–3600 BCE
IAA: 1958-574

117. Painted Floor Pebble
with Bar Motif
Pebble, Red Ochre
10.4 cm x 9.8 cm
Bir Ṣafadi, 4500–3600 BCE
IAA: 1958-575

118. Painted Floor Pebble with
Cruciform Motif
Pebble, Red Ochre
16.2 cm x 8.5 cm
Bir Ṣafadi, 4500–3600 BCE
IAA: 1958-576

119. Painted Floor Pebble with
Bar Motif
Pebble, Red Ochre
9.9 cm x 3.5 cm
Bir Ṣafadi, 4500–3600 BCE
IAA: 1958-589

120. Asymmetrical Bowl
Tabor Oak (*Quercus ithaburensis*)
H. 7.5–9.0 cm; Diam. 18.5–21.5 cm
Cave of the Warrior, Wadi Makukh,
4500–3600 BCE
IAA: 1961-1181
(Fig. 5-1)

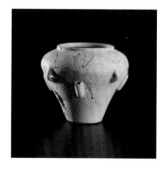

121. Cream Ware Jar with
Tubular Handles
Clay
H. 12.5 cm; Diam. 8.5 cm
Shiqmim, 4500–3600 BCE
IAA: 1980-569, exhibited at IMJ

122. Painted Floor Pebble with
Cruciform Motif
Pebble, Red Ochre
11 cm x 9.1 cm
Bir Ṣafadi, 4500–3600 BCE
IAA: 1994-3724

123. Painted Floor Pebble with
Cruciform Motif
Pebble, Red Ochre
13.5 cm x 7.6 cm
Bir Ṣafadi, 4500–3600 BCE
IAA: 1994-3730

124. Painted Floor Pebble with
Cruciform Motif
Pebble, Red Ochre
14.2 cm x 10.2 cm
Bir Ṣafadi, 4500–3600 BCE
IAA: 1994-3731

125. Basket
Straw, Cow Leather, Linen Thread
H. 17 cm; Diam. 23.5 cm
Cave of the Warrior, Wadi Makukh,
4500–3600 BCE
IAA: 607/48
(Fig. 5-3)

126. Sandals
Cow Leather
L. (Max.) 25 cm; W. 13 cm; H 7 cm
Cave of the Warrior, Wadi Makukh,
4500–3600 BCE
IAA: 607/74/1,2
(Fig. 7-8)

127. Fragment of a Mat
Reeds and Sorghum
L. (Max) 62 cm; W. 41 cm
Cave of the Warrior, Wadi Makukh,
4500–3600 BCE
IAA: 607/83
(Fig. 7-6)

128. Shroud Fragments
Linen
L. 37 cm; W. 31 cm
Cave of the Warrior, Wadi Makukh,
4500–3600 BCE
IAA: 60775

129. Blade
Flint
L. 30 cm; W. 3 cm
Cave of the Warrior, Wadi Makukh,
4500–3600 BCE
IAA: K-23995
(Fig. 7-7)

130. Walking Stick
Wood
L. 103 cm
Cave of the Warrior, Wadi Makukh,
4500–3600 BCE
IAA, Jerusalem: K23992

131. Jar Base with Mat Impression
Clay
Diam. 9.5 cm; Th. (Base): 0.7 cm
Tuleilat Ghassul, 4500–3600 BCE
PBI, Jerusalem
(Fig. 7-22)

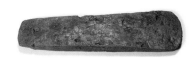

132. Axe
Copper
L. 15.5 cm; W. 3.5 cm
Meser, 4500–3600 BCE
IAA: 1956-958
(Fig. 6-1)

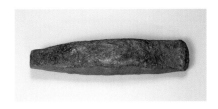

133. Axe
Copper
L. 14.5 cm; W. 2.9 cm
Meser, 4500–3600 BCE
IAA: 1956-960
(Fig. 6-1)

134. Warp Beam for Horizontal
Ground Loom
Wood
L. 34.5 cm
Naḥal Mishmar, 4500–3600 BCE
IAA: 1961-1172
(Fig. 7-1)

135. Cylindrical Stick for Warp-
Weighted Loom
Wood
L. 33.5 cm
Naḥal Mishmar, 4500–3600 BCE
IAA: 1961-1174
(Fig. 7-2)

136. Coiled-Basket Fragment
Reeds
Diam. 15 cm
Naḥal Mishmar, 4500–3600 BCE
IAA: 1961-1184
(Fig. 7-23)

137. Two Fragments of Rope
Palm Fiber
L. 8 cm, 9 cm
Naḥal Mishmar, 4500–3600 BCE
IAA: 1961-1189
(Fig. 7-21)

138. Mat Fragment
Straw
L. 25 cm; W. 16 cm; Th. 4 cm
Naḥal Mishmar, 4500–3600 BCE
IAA: 1961-208
(Fig. 1-11)

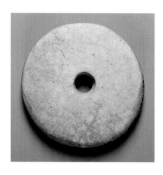

139. Disk-Shaped Spindle Whorl
Stone
Diam. 6 cm; Th. 0.9 cm
Patish (Gilat), 4500–3600 BCE
IAA: 1975-1061
(Fig. 2-11)

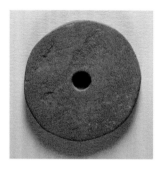

140. Disk-Shaped Spindle Whorl
Stone
Diam. 5.5 cm; Th. 0.7 cm
Patish (Gilat), 4500–3600 BCE
IAA: 1975-1064
(Fig. 2-11)

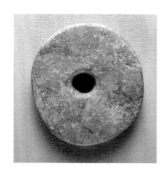

141. Disk-Shaped Spindle Whorl
Stone
Diam. 5.1 cm; Th. 0.7 cm
Patish (Gilat), 4500–3600 BCE
IAA: 1975-1065
(Fig. 2-11)

142. Axe
Flint
L. 11.3 cm; W. 4.6 cm
Gilat, 4500–3600 BCE
IAA: 1976-1688
(Fig. 2-1)

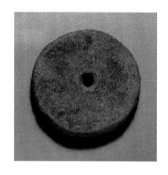

143. Disk-Shaped Spindle Whorl
Clay
Diam. 6.5 cm; Th. 0.7 cm
Rasm-Ḥarbush, 4500–3600 BCE
IAA: 1981-3009
(Fig. 2-11)

144. Biconical Spindle Whorl
Clay
H. 3.9 cm; Diam. 5.1 cm
Bir Ṣafadi, 4500–3600 BCE
IAA: 1982-1479
(Fig. 7-17)

145. Beads
Shell, Bone, Carnelian
Diam. 0.5 cm
Bir Ṣafadi, 4500–3600 BCE
IAA: 1982-1488
(No image available.)

146. Biconical Spindle Whorl
Clay
H. 3.4 cm; Diam. 5.7 cm
Shiqmim, 4500–3600 BCE
IAA: 1982-1527
(Fig. 7-17)

147. Chisel
Copper
L. 19.5 cm; W. 1.5 cm
Shiqmim, 4500–3600 BCE
IAA: 1982-1652
(Fig. 2-17)

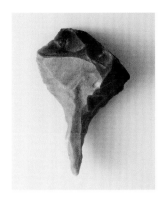

148. Awl
Flint
L. 5.4 cm; W. 3.5cm; Th. 1.4 cm
Rasm-Ḥarbush, 4500–3600 BCE
IAA: 1987-1522

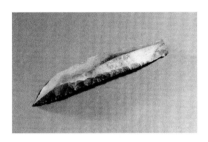

149. Blade
Flint
L. 13.8 cm; W. 2.7 cm; Th. 1.1 cm
'Ein el-Ḥariri, 4500–3600 BCE
IAA: 1987-1529

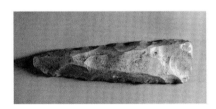

150. Adze
Flint
L. 14.3 cm; W. 3.6 cm
Rasm-Ḥarbush, 4500–3600 BCE
IAA: 1987-1536
(Fig. 2-1)

151. Biconical Spindle Whorl
Clay
H. 3.4 cm; Diam. 4.2 cm
El Hariri, 4500–3600 BCE
IAA: 1987-922
(Fig. 7-17)

152. Axe
Copper
L. 10.5 cm; W. 2.9 cm
Giv'at Ha-Oranim, 4500–3600 BCE
IAA: 1997-3463
(Figs. 1-21, 6-1)

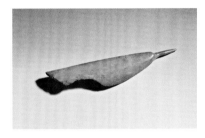

153. Awl
Bone
H. 7 cm; W. 1.7 cm; D. 0.7 cm
Bir Ṣafadi, 4500–3600 BCE
IAA: 2007-1598
(Fig. 2-12)

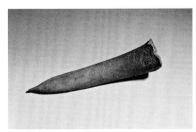

154. Awl
Bone
H. 7.6 cm; W. 1.8 cm; D. 1.4 cm
Bir Ṣafadi, 4500–3600 BCE
IAA: 2007-1621
(Fig. 2-12)

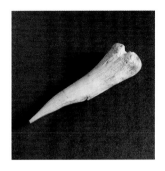

155. Awl
Bone
H. 6.6 cm; W. 1.8 cm; D. 1.3 cm
Bir Ṣafadi, 4500–3600 BCE
IAA: 2012-782
(Fig. 2-12)

156. Knotted Textile Fragment
Linen
L. 29 cm; W. 19 cm
Cave of the Sandal, Jordan Valley,
4500–3600 BCE
IAA: B970/1
(Fig. 7-14)

157. Fringed Textile Fragment
Linen
W. (Object) 15.5 cm; L. (Fringe) 13 cm
Cave of the Sandal, Jordan Valley,
4500–3600 BCE
IAA: K33645
(Page 139)

Bibliography

Aardsma 2001
Aardsma, E. G. "New Radiocarbon Dates for the Reed Mat from the Cave of the Treasure, Israel." *Radiocarbon* 43: 1247–54.

Abbo et al. 2013
Abbo, S., et al. "Harvest and Fibre Extraction of Wild Flax in Israel: Bearing on Plant Domestication." *Israel Journal of Plant Sciences* 61 (forthcoming).

Adams 1974
Adams, B. *Ancient Hierakonpolis*. Warminster: Aris & Phillips.

Adovasio 1977
Adovasio, J. M. "The Textile and Basketry Impressions from Jarmo." *Paleorient* 3: 223–30.

Agelarikis et al. 1998
Agelarakis, A. P., et al. "The Chalcolithic Burial Cave in Ma'avarot, Israel, and Its Paleoanthropological Implications." *International Journal of Osteoarchaeology* 8: 431–43.

Aharoni 1961
Aharoni, Y. "The Expedition to the Judean Desert." *Israel Exploration Journal* 11: 11–24.

Akkermans and Schwartz 2003
Akkermans, P. M. M. G., and G. M. Schwartz. *The Archaeology of Syria: From Complex Hunter-Gatherers to Early Urban Societies (ca. 16,000–300 BC)*. Cambridge: Cambridge University Press.

Albright 1931
Albright, W. F. "Recent Progress in the Late Prehistory of Palestine." *Bulletin of the American Schools of Oriental Research* 42: 13–15.

Albright 1932
Albright, W. F. "The Chalcolithic Age in Palestine." *Bulletin of the American Schools of Oriental Research* 48: 10–13.

Alon 1961
Alon, D. "Settlements of the Fourth Millenium in Nahal Grar and Nahal Patish. *Mibifnim* 24: 87–96 (in Hebrew).

Alon and Levy 1980
Alon, D., and T. E. Levy. "Preliminary Note on the Distribution of Chalcolithic Sites on the Wadi Beersheva–Lower Wadi Besor Drainage System." *Israel Exploration Journal* 30: 140–47.

Alon and Levy 1989
Alon, D., and T. E. Levy. "The Archaeology of Cult and the Chalcolithic Sanctuary at Gilat." *Journal of Mediterranean Archaeology* 2: 163–221.

Alon and Levy 1991a
Alon, D., and T. E. Levy. "The Gilat Sanctuary: Its Centrality and Influence in the Southern Levant during the Late 5th–Early 4th Millennium BCE." *Eretz-Israel* 21: 23–40 (in Hebrew).

Alon and Levy 1991b
Alon, D., and T. E. Levy. "Violin-Shaped Figurines and the Cult at Chalcolithic Gilat." *Ariel* 10–101: 166–71 (in Hebrew).

Amiran 1969
Amiran, R. *Ancient Pottery of the Holy Land*. Jerusalem: Massada.

Amiran 1970
Amiran, R. *Ancient Pottery of the Holy Land: From Its Beginnings in the Neolithic Period to the End of the Iron Age*. New Brunswick, NJ: Rutgers University Press.

Amiran 1972
Amiran, R. "A Cult Stele from Arad." *Israel Exploration Journal* 22: 86–88.

Amiran 1985
Amiran, R. "A Suggestion to See the Copper 'Crowns' of the Judean Desert Treasure as Drums of Stand-like Altars." In *Palestine in the Bronze and Iron Ages: Papers in Honour of Olga Tufnell*, ed. J. N. Tubb, 10–14. London: Institute of Archaeology.

Amiran 1986
Amiran, R. "A New Type of Chalcolithic Ritual Vessel and Some Implications for the Nahal Mishmar Hoard." *Bulletin of the American Schools of Oriental Research* 262: 83–87.

Avrutis 2012
Avrutis V. W. *Late Chalcolithic and Early Bronze Age I Remains at Nesher-Ramle Quarry, Haifa*. Haifa: Zinman Institute of Archaeology.

Banning 2003
Banning, E. B. "Housing Neolithic Farmers." *Near Eastern Archaeology* 66: 4–21.

Banning 2011
Banning, E. B. "So Fair a House: Gobekli Tepe and the Identification of Temples in the Pre-Pottery Neolithic of the Near East." *Current Anthropology* 52: 619–60.

Bar-Adon 1962
Bar-Adon, P. "Expedition C—The Cave of the Treasure." *Israel Exploration Journal* 12: 213–26.

Bar-Adon 1980
Bar-Adon, P. *The Cave of the Treasure: The Finds from the Caves in Nahal Mishmar*. Jerusalem: Israel Exploration Society.

Barber 1991
Barber, E. J. W. *Prehistoric Textiles: The Development of Cloth in the Neolithic and Bronze Ages, with Special Reference to the Aegean*. Princeton: Princeton University Press.

Barber 1997
Barber, E. J. W. "Textiles of the Neolithic through Iron Ages." In *The Oxford Encyclopedia of Archaeology in the Near East*, ed. E. M. Meyers, vol. 5, 191–95. Oxford: Oxford University Press.

Barkai 2005
Barkai, R. *Flint and Stone Axes as Cultural Markers: Socio-Economic Changes as Reflected in Holocene Flint Tool Industries of the Southern Levant*. Studies in Early Near Eastern Production, Subsistence, and Environment 11. Berlin: Ex Oriente.

Bar-Yosef and Ayalon 2001
Bar-Yosef, O., and E. Ayalon. "Chalcolithic Ossuaries: What Do They Imitate and Why?" *Qadmoniot* 34: 34–43 (in Hebrew).

Bar-Yosef et al. 2011
Bar-Yosef, O., et al. " Dzudzuana: An Upper Palaeolithic Cave Site in the Caucasus Foothills (Georgia)." *Antiquity* 328: 331–49.

Bar-Yosef Mayer and Porat 2010
Bar-Yosef Mayer, D. E, and Porat, N. "Glazed Steatite Paste Beads in the Chalcolithic of the Levant: Long Distance Trade and Manufacturing Processes." In *Techniques and People: Anthropological Perspectives on Technology in the Archaeology of the Proto-historic and Early Historic Periods in the Southern Levant*, ed. V. Roux and S. Rosen, 111–23. Mémoires et travaux du Centre de recherche français à Jérusalem 9. Paris: De Boccard.

Bar-Yosef Mayer et al. 2004
Bar-Yosef Mayer, D. E., et al. "Steatite Beads at Peqi'in: Long Distance Trade and Pyro-technology during the Chalcolithic of the Levant." *Journal of Archaeological Science* 31: 493–502.

Baumgartel 1960
Baumgartel, E. J. *The Cultures of Prehistoric Egypt*. Volume 2. Oxford: published on behalf of the Griffith Institute, Ashmolean Museum, by Oxford University Press.

Beck 1989
Beck, P. "Notes on the Style and Iconography of the Chalcolithic Hoard from Nahal Mishmar." In *Essays in Ancient Civilization Presented to Helene J. Kantor*, ed. A. Leonard Jr. and B. B. Williams, 39–54. Studies in Ancient Oriental Civilization 47. Chicago: Oriental Institute of the University of Chicago.

Bilu 2006
Bilu, Y. "The Rise of a New Negev Cult Center Today: Baba Sali's Sanctuary in Netivot, Israel." In *Archaeology, Anthropology and Cult: The Sanctuary at Gilat, Israel,* ed. T. E. Levy, 75–92. London: Equinox.

Bonani 1995
Bonani, G. S. "AMS Analysis Procedures." *'Atiqot* 27: 205–6.

Bourke 2001
Bourke, S. "The Chalcolithic Period."
In *The Archaeology of Jordan*, ed.
B. Macdonald, R. B. Adams, and
P. Bienkowski, 107–62. Sheffield:
Sheffield Academic Press.

Bourke et al. 2004
Bourke, S. J., et al. "The End of the
Chalcolithic Period in the South Jordan
Valley: New 14C Determinations from
Teleilat Ghassul, Jordan." *Radiocarbon*
46: 315–23.

Braun and van den Brink 2008
Braun, E., and E. C. M. van den Brink.
"Appraising South Levantine–Egyptian
Interaction: Recent Discoveries
from Israel and Egypt." In *Egypt at
Its Origins, 2. Proceedings of the
International Conference "Origin of the
State, Predynastic and Early Dynastic
Egypt," Toulouse, 5th–8th September
2005*, ed. B. Midant-Reynes and Y.
Tristant, 644–50. Leuven: Peeters.

Braun-Holzinger 1991
Braun-Holzinger, E. A. *Mesopotamische
Weihgaben der frühdynastischen bis
altbabylonischen Zeit*. Heidelberger Stu-
dien zum alten Orient 3. Heidelberg:
Heidelberger Orientverlag.

Breniquet 2010
Breniquet, C. "Weaving in Meso-
potamia during the Bronze Age:
Archaeology, Techniques, Iconogr-
aphy." In *Textile Terminologies in the
Ancient Near East and Mediterranean
from the Third to the First Millennnia BC*,
ed. M.-L. Nosch and C. Michel, 52–67.
Ancient Textiles Series 8. Oxford:
Oxbow.

Bronk Ramsey 2009
Bronk Ramsey, C. "Bayesian Analysis
of Radiocarbon Dates." *Radiocarbon*
51: 337–60.

Brown 1995
Brown, J. "On Mortuary Analysis—with
Special Reference to the Saxe-Binford
Research Program." In *Regional
Approaches to Mortuary Analysis*, ed. L.
A. Beck, 3–26. New York: Plenum.

Burton 2004
Burton, M. "Collapse and Continuity:
Tracking Social Change through
Ceramic Analysis: Case Studies of Late
5th–Early 4th Millennium Societies
in the Southern Levant." Ph.D. diss.,
University of California, San Diego.

Burton and Levy 2001
Burton, M., and T. E. Levy. "The
Chalcolithic Radiocarbon Record
and Its Use in Southern Levantine
Archaeology." *Radiocarbon* 43:
1223–46.

Burton and Levy 2006
Burton, M, and T. E. Levy. "Organic
Residue Analysis of Selected Vessels
from Gilat: Gilat Torpedo Jars." In
*Archaeology, Anthropology and Cult:
The Sanctuary at Gilat, Israel*, ed. T. E.
Levy, 849–62. London: Equinox.

Burton and Levy 2011
Burton, M., and T. E. Levy. "The End
of the Chalcolithic Period (4500–3600
BC) in the Northern Negev Desert,
Israel." In *Culture, Chronology and the
Chalcolithic: Theory and Transition*, ed.
J. L. Lovell and Y. M. Rowan, 178–
91. Levant Supplementary Series 9.
Oxford: Oxbow.

Cameron 1981
Cameron, D. O. *The Ghassulian Wall
Paintings*. London: Kenyon-Deane.

Carneiro 1981
Carneiro, R. L. "The Chiefdom:
Precursor of the State." In *The
Transition to Statehood in the New
World*, ed. G. D. Jones and R. R.
Kautz, 37–79. Cambridge: Cambridge
University Press.

Caton-Thompson and Gardner 1934
Caton-Thompson, G., and E. W.
Gardner. *The Desert Fayum*. London:
Royal Anthropological Institute of
Great Britain and Ireland.

Childe 1951
Childe, V. G. *Man Makes Himself*. New
York: New American Library.

Cialowicz 1987
Cialowicz, K. M. *Les têtes de massues
des périodes prédynastique et archaïque
dans la vallée du Nil*. Zeszyty naukowe
Uniwersytetu Jagiellońskiego 829.
Warsaw: Nakladem Uniwersytetu
Jagiellonskiego.

Cialowicz 1989
Cialowicz, K. M. "Predynastic Mace
Heads in the Nile Valley." In *Late
Prehistory of the Nile Basin and the
Sahara*, ed. I. Przyzaniak and M. Kobu-
siewicz, 261–66. Poznan: Poznan
Archaeological Museum.

Cialowicz 1992
Cialowicz, K. M. "La composition, le
sens et la symbolique des scènes zoo-
morphes prédynastiques en relief: Les
manches de couteaux." In *The Fol-
lowers of Horus: Studies Dedicated to
Michael Allen Hoffman, 1944–1990*, ed.
R. Friedman and B. Adams, 247–58.
Egyptian Studies Association Publica-
tion 2; Oxbow Monograph 20. Oxford:
Oxbow.

Cialowicz 2011
Cialowicz, K. M. "The Predynastic/
Early Dynastic Period at Tell el-Farkha."
In *Before the Pyramids: The Origins
of Egyptian Civilization*, ed. E. Tee-
ter, 55–64. Oriental Institute Museum
Publications 33. Chicago: Oriental
Institute.

Cohen 1972
Cohen, R. "The Ze'elim Site." *Hadashot
Arkheologiyot* 61–62: 42 (in Hebrew).

Commenge 2006
Commenge, C. "Gilat's Ceramics:
Cognitive Dimensions of Pottery Pro-
duction." In *Archaeology, Anthropology
and Cult: The Sanctuary at Gilat, Israel*,
ed. T. E. Levy, 394–506. London:
Equinox.

Commenge et al. 2006
Commenge, C., et al. "Gilat's Figurines:
Exploring the Social and Symbolic
Dimensions of Representation." In
*Archaeology, Anthropology and Cult:
The Sanctuary at Gilat, Israel*, ed. T. E.
Levy, 739–30. London: Equinox.

Commenge-Pellerin 1990
La potterie de Safadi (Beershéva) au IVe millénaire avant l'ère chrétienne. Les Cahiers du Centre de recherche français de Jérusalem 5. Paris: Association Paléorient.

Cordova 2007
Cordova, C. E. *Millennial Landscape Change in Jordan: Geoarchaeology and Cultural Ecology.* Tucson: University of Arizona Press.

Curry 2008
Curry, A. "Gobekli Tepe: The World's First Temple?" *Smithsonian,* www.smithsonianmag.com/history-archaeology/gobekli-tepe.html.

Curry 2013
Curry, A. "The Milk Revolution." *Nature* 500: 20–22.

D'Altroy and Earle 1985
D'Altroy, T. N., and T. K. Earle. "Staple Finance, Wealth Finance, and Storage in the Inca Political Economy." *Current Anthropology* 26: 187–206.

Davidovich 2012
Davidovich, U. "The Early Bronze IB in the Judean Desert Caves." *Tel Aviv* 39: 3–19.

Davidovich 2013
Davidovich, U. "The Chalcolithic–Early Bronze Age Transition: A View from the Judean Desert Caves, Southern Levant." *Paleorient* 39: 125–138.

Davidovich et al. 2013
Davidovich, U., et al. "Dating and Interpreting Desert Structures: The Enclosures of the Judean Desert, Southern Levant, Re-Evaluated." *Archaeometry* (forthcoming).

Davidzon and Gilead 2009
Davidzon, A., and I. Gilead. "The Chalcolithic Workshop at Beit Eshel: Preliminary Refitting Studies and Possible Socio-Economic Implications." In *Techniques and People: Anthropological Perspectives on Technology in the Archaeology of the Proto-historic and Early Historic Periods in the Southern Levant,* ed. V. Roux and S. Rosen, 25–40. Mémoires et travaux du Centre de recherche français à Jérusalem 9. Paris: De Boccard.

Dawson, Levy, and Smith 2003
Dawson, L., T. E. Levy, and P. Smith. "Evidence of Interpersonal Violence at the Chalcolithic Village of Shiqmim (Israel)." *International Journal of Osteoarchaeology* 13: 115–19.

Dee et al. 2013
Dee, M., et al. "An Absolute Chronology for Early Egypt Using Radiocarbon Dating and Bayesian Statistical Modeling." *Proceedings of the Royal Society* 469, doi: 10.1098/rspa.2013.0395.

Delougaz 1940
Delougaz, P. *The Temple Oval at Khafajah.* University of Chicago Oriental Institute Publications 53. Chicago: University of Chicago Press.

Delougaz 1942
Delougaz, P. "The Khafajan Temples." In *Pre-Sargonid Temples in the Diyala Region,* ed. Delougaz and S. Lloyd. Chicago, 1–152. Chicago: University of Chicago Press.

Dollfus and Kafafi 1986
Dollfus, G., and Z. Kafafi. "Abu Hamid, Jordanie: Premiers résultats." *Paleorient* 12: 89–98.

Dollfus and Kafafi 1993
Dollfus, G., and Z. Kafafi. "Recent Researches at Abu Hamid." *Annual of the Department of Antiquities of Jordan* 37: 241–62.

Dothan 1959
Dothan, M. "Excavations at Horvat Beter (Beersheba)." *'Atiqot* 2: 1–42.

Dothan 1963
Dothan, T. 1963. "Spinning-Bowls." *Israel Exploration Journal* 13: 97–112.

Dreyer 1999
Dreyer, G. "Motive und Datierung der dekorierten prädynastischen Messergriffe." In *L'Art de l'Ancien Empire égyptien: Actes du colloque, 3 et 4 Avril 1998,* ed. C. Ziegler, 195–226. Paris: Documentation Française.

Earle 1997
Earle, T. *How Chiefs Come to Power: The Political Economy in Prehistory.* Stanford: Stanford University Press.

Edmonds 1990
Edmonds, M. "Description, Understanding, and the Chaine Operatoire." *Archaeological Review from Cambridge* 9: 55–70.

Eisenberg, Gopher, and Greenberg 2001
Eisenberg, I., A. Gopher, and R. Greenberg. *Tel Te'o: A Neolithic, Chalcolithic, and Early Bronze Age Site in the Hula Valley.* IAA Reports 13. Jerusalem: Israel Antiquities Authority.

Eldar and Baumgarten 1985
Eldar, I., and Y. Baumgarten. "Neve Noy: A Chalcolithic Site of the Beersheba Culture." *Biblical Archaeologist* 48: 134–39.

Eliade 1978
Eliade, M. *The Forge and the Crucible: The Origins and Structures of Alchemy.* Chicago: University of Chicago Press.

Elliott 1977
Elliott, C. "The Religious Beliefs of the Gassulians, c. 4000–3100." *Palestine Exploration Quarterly* 109: 3–25.

Emery 1966
Emery, I. *The Primary Structure of Fabrics: An Illustrated Classification.* Washington, DC: Textile Museum.

Engberg and Shipton 1934
Engberg, A. M., and G. M. Shipton. *Notes on the Chalcolithic and Early Bronze Age Pottery of Meggido.* The Oriental Institute of the University of Chicago: Studies in Ancient Oriental Civilization 10. Chicago: University of Chicago.

Epstein 1977
Epstein, C. "The Chalcolithic Culture of the Golan." *Biblical Archaeologist* 40: 57–62.

Epstein 1978
Epstein, C. "Aspects of Symbolism in Chalcolithic Palestine." In *Archaeology in the Levant: Essays for Kathleen Kenyon,* ed. P. R. S. Moorey and P. Parr, 23–35. Warminster: Aris & Phillips.

Epstein 1982
Epstein, C. "Cult symbols in Chalcolithic Palestine." *Bolletino del Centro Camuno di Studi Preistorici* 19: 63–82.

Epstein 1985
Epstein, C. "Laden Animal Figurines from the Chalcolithic Period in Palestine." *Bulletin of the American Schools of Oriental Research* 258: 53–61.

Epstein 1998
Epstein, C. *The Chalcolithic Culture of the Golan.* IAA Reports 4. Jerusalem: Israel Antiquities Authority.

Eshel and Zissu 2002
Eshel, H., and Zissu, B. "Region VIII: Survey and Excavations of Caves along the Cliff Slopes of the Triangulation Point 86, on the Fringes of Jebel Ma'ar el-Bas." In "Survey and Excavations of Caves in the Northern Judean Desert (CNJD)–1993 (Part II)," ed. L. Wexler. *'Atiqot* 41: 117–23.

Evershed et al. 2008
Evershed, R. P., et al. "Earliest Date for Milk Use in the Near East and Southeastern Europe Linked to Cattle Herding." *Nature* 455: 528–31.

Faltings 2002
Faltings, D. A. "The Chronological Frame and Social Structure of Buto in the Fourth Millennium." In *Egypt and the Levant: Interrelations from the 4th through the Early 3rd Millennium BCE,* ed. E. C. M. van den Brink and T. E. Levy, 165–70. London: Leicester University Press.

Fitzgerald 1935
Fitzgerald, G. M. "Beth-Shan: Earliest Pottery". *The Museum Journal* 24, no. 1. Philadelphia: University of Pennsylvania.

Flannery 1999
Flannery, K. V. "Chiefdoms in the Early Near East: Why It's So Hard to Identify Them." In *The Iranian World: Essays on Iranian Art and Archaeology; Presented to Ezat O. Negahban,* ed. A. Alizadeh, Y. Majidzadeh, and S. M. Shahmirzadi, 44–58. Tehran: Iran University Press.

Flannery 2002
Flannery, K. V. "The Origins of the Village Revisited: From Nuclear to Extended Households." *American Antiquity* 67: 417–33.

Flannery and Marcus 2012
Flannery, K. V., and J. Marcus. *The Creation of Inequality: How Our Prehistoric Ancestors Set the Stage for Monarchy, Slavery, and Empire.* Cambridge, MA: Harvard University Press.

Forbes 1956
Forbes, R. J. *Studies in Ancient Technology.* Vol. 4. Leiden: Brill.

Frangipane et al. 2009
Frangipane, M., et al. "Arslantepe, Malatya (Turkey): Textiles, Tools, and Imprints of Fabrics from the 4th to the 2nd Millennium BCE." *Paléorient* 35: 5–29.

Gal, Smithline, and Shalem 1996
Gal, Z., H. Smithline, and D. Shalem. "A Chalcolithic Burial Cave in Peqi'in." *Qadmoniot* 111: 19–24 (in Hebrew).

Gal, Smithline, and Shalem 1997
Gal, Z., H. Smithline, and D. Shalem. "A Chalcolithic Burial Cave in Peqi'in, Upper-Galilee." *Israel Exploration Journal* 47: 145–54.

Gal, Smithline, and Shalem 1999
Gal, Z., H. Smithline, and D. Shalem. "New Iconographic Aspects of Chalcolithic Art: Preliminary Observations on Finds from the Peqi'in Cave." *'Atiqot* (English series) 37: 1*–16.*

Garfinkel 1994
Garfinkel, Y. "Ritual Burial of Cultic Objects: The Earliest Evidence." *Cambridge Archaeological Journal* 4: 159–88.

Garfinkel 1999
Garfinkel, Y. *Neolithic and Chalcolithic Pottery of the Southern Levant.* Qedem 39. Jerusalem: Institute of Archaeology, The Hebrew University.

Garfinkel and Miller 2002
Garfinkel, Y., and M. Miller. *Sha'ar Hagolan.* Vol. 1, *Neolithic Art in Context.* Oxford: Oxbow.

Garstang 1935
Garstang, J. "Jericho: City and Necropolis; Fifth Report." *Annals of Archaeology and Anthropology* 22: 143–84.

Gates 1992
Gates, M. H. "Nomadic Pastoralists and the Chalcolithic Hoard from Nahal Mishmar." *Levant* 24: 131–39.

Giddens 1984
Giddens, A. *The Constitution of Society: Outline of the Theory of Structuration.* Berkeley: University of California Press.

Gilbert 2004
Gilbert, G. P. *Weapons, Warriors and Warfare in Early Egypt.* BAR International Series 1208. Oxford: Archaeopress.

Gilead 1988
Gilead, I. "The Chalcolithic Period in the Levant." *Journal of World Prehistory* 2: 397–443.

Gilead 1989
Gilead, I. "Grar: A Chalcolithic Site in the Northern Negev, Israel." *Journal of Field Archaeology* 16: 377–94.

Gilead 1995
Gilead, I., ed. *Grar: A Chalcolithic Site in the Northern Negev.* Beer-Sheva 7. Beer-Sheva: Ben-Gurion University of the Negev Press.

Gilead 2011
Gilead, I. "Chalcolithic Culture History: Ghassulian and Other Entities in the Southern Levant." In *Culture, Chronology and the Chalcolithic: Theory and Transition,* ed. J. L. Lovell and Y. M. Rowan, 12–24. Levant Supplementary Series 9. Oxford: Oxbow.

Gilead and Fabian 2001
Gilead, I., and P. Fabian. "Nevatim: A Site of the Chalcolithic Period in the Northern Negev." In *Settlement, Civilization and Culture: Proceedings of the Conference in Memory of David Alon,* ed. A. M. Maeir and E. Baruch, 67–86. Ramat-Gan: Bar-Ilan University Press.

Gleba and Mannering 2012
Gleba, M., and Mannering, U. *Textiles and Textile Production in Europe: From Prehistory to AD 400*. Ancient Textiles Series 11. Oxford: Oxbow.

Golani and Naggar 2011
Golani, A., and Y. Naggar. "Newly Discovered Burials of the Chalcolithic and the Early Bronze Age I in Southern Canaan: Evidence of Cultural Continuity?" In *Culture, Chronology and the Chalcolithic: Theory and Transition*, ed. J. L. Lovell and Y. M. Rowan, 84–96. Oxford: Oxbow Books.

Goldberg and Rosen 1987
Goldberg, P., and A. M. Rosen. "Early Holocene Paleoenvironments of Israel." In *Shiqmim I: Studies Concerning Chalcolithic Societies in the Northern Negev Desert, Israel (1982–1984)*, ed. T. E. Levy, 219–41. BAR International Series 356. Oxford: Archaeopress.

Golden 2009
Golden, Jonathan. "New Light on the Development of Chalcolithic Metal Technology in the Southern Levant." *Journal of World Prehistory* 22: 283–300.

Golden 2010
Golden, J. M. *Dawn of the Metal Age: Technology and Society during the Levantine Chalcolithic*. London: Equinox.

Golden, Levy, and Hauptmann 2001
Golden, J., T. E. Levy, and A. Hauptmann. "Recent Discoveries Concerning Chalcolithic Metallurgy at Shiqmim, Israel." *Journal of Archaeological Science* 28: 1–13.

Gopher 2012
Gopher, A., ed. *Village Communities of the Pottery Neolithic Period in the Menashe Hills, Israel: Archaeological Investigations at the Sites of Nahal Zehora*. 3 vols. Monograph Series of the Institute of Archaeology 12. Tel Aviv: Institute of Archaeology, Tel Aviv University.

Gopher and Orelle 1995
Gopher, A., and E. Orelle. "New Data on Burials from the Pottery Neolithic Period (Sixth–Fifth Millennium BC) in Israel." In *The Archaeology of Death in the Ancient Near East*, ed. S. Campbell and A. Green, 24–28. Oxbow Monograph 51. Oxford: Oxbow.

Gopher and Tsuk 1996
Gopher, A., and T. Tsuk, eds. *The Nahal Qanah Cave: Earliest Gold in the Southern Levant*. Monograph Series 12. Tel Aviv: Institute of Archaeology, Tel Aviv University.

Gophna 1974
Gophna, R. "The Settlement of the Costal Plain of Eretz Israel during the Early Bronze Age." Ph. D. diss., University of Tel Aviv.

Gophna 1979
Gophna, R. "The Process of Settling in the Northwest Negev during the Chalcolithic Period." In *Erets ha-Negev: Adam u-midbar/The Land of the Negev: Man and Desert*, ed. A. Shemueli and Y. Gradus, 203–8. Tel Aviv: Ministry of Defense.

Gophna 1989
Gophna, R. "From Village to Town in the Lod Valley: A Case Study." In *L'urbanisation de la Palestine à l'âge du Bronze ancien: Bilan et prospectives des recherches actuelles*, ed. P. de Miroschedji, 97–109. BAR International Series 527. Oxford: British Archaeological Reports.

Gophna and Kislev 1979
Gophna, R., and M. Kislev. "Tel Saf (1977–1978)." *Revue Biblique* 86: 112–14.

Gophna and Lifshitz 1980
Gophna, R. and Lifshitz, S. "A Chalcolithic Burial Cave at Palmahim." *'Atiqot* (English series) 14: 1*–8.*

Gophna and Sadeh 1988/89
Gophna, R., and S. Sadeh. "Excavations at Tel Tsaf: An Early Chalcolithic Site in the Jordan Valley." *Journal of the Tel Aviv University Institute of Archaeology* 15/16: 3–36.

Goren 1995
Goren, Y. "Shrines and Ceramics in Chalcolithic Israel: The View through the Petrographic Microscope." *Archaeometry* 37: 287–305.

Goren 2008
Goren, Y. "The Location of Specialized Copper Production by the Lost Wax Technique in the Chalcolithic Southern Levant." *Geoarchaeology* 23: 374–97.

Goren and Fabian 2002
Goren, Y., and P. Fabian. *Kissufim Road: A Chalcolithic Mortuary Site*. IAA Reports 16. Jerusalem: Israel Antiquities Authority.

Gorzalczany 2006
Gorzalczany, A. "A Chalcolithic Burial Ground at Palmahim." *Qadmoniot* 132: 87–89 (in Hebrew).

Gosden 1989
Gosden, C. "Debt, Production and Prehistory." *Journal of Anthropological Archaeology* 8: 355–87.

Graham 2008
Graham, P. *Tell El-Dab'a XV: Metalwork and Metalworking Evidence of the Late Middle Kingdom and the Second Intermediate Period*. Denkschriften der Gesamtakademie 36. Vienna: Verlag der Österreichischen Akademie der Wissenschaften.

Grigson 1987a
Grigson, C. "Different Herding Strategies for Sheep and Goats in the Chalcolithic of Beersheva." *Archaeozoologia* 1: 115–26.

Grigson 1987b
Grigson, C. "Shiqmim: Pastoralism and Other Aspects of Animal Management in the Chalcolithic of the Northern Negev." In *Shiqmim I: Studies Concerning Chalcolithic Societies in the Northern Negev Desert, Israel (1982–1984)*, ed. T. E. Levy, 219–41. BAR International Series 356. Oxford: Archaeopress.

Grigson 1995
Grigson, C. "Plough and Pasture in the Early Economy of the Southern Levant." In *The Archaeology of Society in the Holy Land*, ed. T. E. Levy, 245–68. London: Leicester University Press.

Grigson 2006
Grigson, C. "Farming? Feasting? Herding? Large Mammals from the Chalcolithic of Gilat." In *Archaeology, Anthropology and Cult: The Sanctuary at Gilat, Israel*, ed. T. E. Levy, 215–319. London: Equinox.

Hadad 2012
Hadad, M. "When the Dead Come to Visit." *Masa Acher—The Israeli Geographical Magazine* 251: 88–96 (in Hebrew).

Haerinck and Overlaet 1996
Haerinck, E., and B. Overlaet. *The Chalcolithic Period: Parchinah and Hakalan; Belgian Archaeological Mission in Iran; The Excavations in Luristan, Pusht-i Kuh (1965–1979)*. Luristan Excavation Documents 1. Brussels: Royal Museums of Art and History.

Hall 1986
Hall, R. *Egyptian Textiles*. Shire Egyptology 4. Aylesbury, Bucks, UK: Shire.

Harke 1997
Harke, H. "The Nature of Burial Data." In *Burial and Society: The Chronological and Social Analysis of Archaeological Burial Data*, ed. C. K. Jensen and K. H. Nielsen, 19–27. Aarhus: Aarhus University Press.

Hauptmann 1993
Hauptmann, H. "Ein Kultgebäude in Nevali Çori." In *Between the Rivers and over the Mountains: Archaeologica anatolica et mesopotamica Alba Palmieri dedicata*, ed. M. Frangipane et al., 37–69. Rome: Dipartimento di Scienze Storiche Archeologiche e Antropologiche dell'Antichità, Università di Roma "La Sapienza."

Hauptmann 2007
Hauptmann, A. *The Archaeo-metallurgy of Copper: Evidence from Faynan, Jordan*. New York: Springer.

Hauptmann, Khalil, and Schmitt-Strecker 2004
Hauptmann, A., L. Khalil, and S. Schmitt-Strecker. "Evidence for Late Chalcolithic/Early Bronze Age I Copper Production from Timna Ores at Tall Magass, Aqaba." In *Prehistoric Aqaba I*, ed. Khalil and Schmidt-Strecker, 295–304. Rahden: Leidorf.

Hauptmann et al. 1992
Hauptmann, A., et al. "Early Copper Produced at Feinan, Wadi Araba, Jordan: The Composition of Ores and Copper." *Archaeomaterials* 6: 1–33.

Hennessy 1982
Hennessy, B. "Teleilat Ghassul: Its Place in the Archaeology of Jordan." In *Studies in the History and Archaeology of Jordan*, ed. A. Hadidi et al., 55–58. Amman: Department of Antiquities.

Hesse 1990
Hesse, B. "Pig Lovers and Pig Haters: Patterns of Palestinian Pork Production." *Journal of Ethnobiology* 10: 195–225.

Hestrin and Tadmor 1963
Hestrin, R., and M. Tadmor. "A Hoard of Tools and Weapons from Kfar Monash." *Israel Exploration Journal* 13 (1963): 263–88.

Ilan 1994
Ilan, D. "Temples, Treasures and Subterranean Villages: Death's Dominion in the Chalcolithic of Canaan." Paper presented at the Annual Meeting of the American Schools of Oriental Research, Chicago.

Ilan and Rosenfeld 1994
Ilan, S., and Rosenfeld, A. "Ore Source of Arsenic Copper Tools from Israel during Chalcolithic and Early Bronze Ages." *Terra Nova* 6: 177–79.

Ilan and Rowan 2012
Ilan, D., and Y. M. Rowan. "Deconstructing and Recomposing the Narrative of Spiritual Life in the Chalcolithic of the Southern Levant (4500–3700 BC)." In *Beyond Belief: The Archaeology of Religion and Ritual*, ed. Rowan, 89–113. Archaeological Papers of the American Anthropological Association 21. Hoboken, NJ: Wiley.

Ilan and Sebbane 1989
Ilan, O., and M. Sebbane. "Copper Metallurgy, Trade and the Urbanization of Southern Canaan in the Chalcolithic and Early Bronze Age." In *L'urbanisation de la Palestine à l'âge du Bronze ancien*, ed. P. de Miroschedji, 162–39. BAR International Series 527. Oxford: British Archaeological Reports.

Joffe 1993
Joffe, A. H. *Settlement and Society in Early Bronze I and II, Southern Levant: Complementarity and Contradiction in a Small-Scale Complex Society*. Sheffield: Sheffield Academic Press.

Jull et al. 1998
Jull, A. J. T., et al. "Radiocarbon Dating of Finds." In *The Cave of the Warrior: A Fourth Millennium Burial in the Judean Desert*, ed. T. Schick, 110–12. IAA Reports 5. Jerusalem: Israel Antiquities Authority.

Kaplan 1959
Kaplan, Y. *The Archaeology and History of Tel-Aviv–Jaffa*. Tel Aviv: Masada.

Kenyon 1956
Kenyon, K. "Jericho and Its Setting in Near Eastern History." *Antiquity* 30: 184–95.

Kenyon 1981
Kenyon, K. M. "The Middle Bronze Age." In *Excavations at Jericho*, vol. 3, *The Architecture and Stratigraphy of the Tell*, 346–71. London: British School of Archaeology in Jerusalem.

Kerner 2001
Kerner, S. *Das Chalkolithikum in der südlichen Levante: Die Entwicklung handwerklicher Spezialisierung und ihre Beziehung zu gesellschaftlicher Komplexität*. Orient-Archäologie 8. Rahden: Leidorf.

Key 1980
Key, C. A. "The Trace-Element Composition of the Copper and Copper Alloy Artifacts of the Nahal Mishmar Hoard." In *The Cave of the Treasure: The Finds from the Caves in Nahal Mishmar*, ed. P. Bar-Adon, 238–43. Jerusalem: Israel Exploration Society.

Khalaily 2002
Khalaily, H. "Chalcolithic and Early Bronze Age Pottery and Other Finds from Caves VIII/9 and VIII/28." In "Survey and Excavations of Caves in the Northern Judean Desert (CNJD)–1993 (Part II)," ed. L. Wexler. 'Atiqot 41: 129–41.

Khalil and Eichmann 2001
Khalil, L., and R. Eichmann. "Archaeological Survey and Excavation at the Wadi al-Yutum and Magass Area–Al-'Aqaba (ASEYM): A Preliminary Report on the Second Season in 2000." Annual of the Department of Antiquities of Jordan 45: 195–204.

King 1983
King, P. J. American Archaeology in the Middle East: A History of the American Schools of Oriental Research. Philadelphia: The American Schools of Oriental Research.

Kislev 1987
Kislev, M. "Chalcolithic Plant Husbandry and Ancient Vegetation at Shiqmim." In Shiqmim I: Studies Concerning Chalcolithic Societies in the Northern Negev Desert, Israel (1982–1984), ed. T. E. Levy, 251–79. BAR International Series 356. Oxford: Archaeopress.

Koren 1998
Koren, Z. C. "Color Analysis of the Textiles." In The Cave of the Warrior: A Fourth Millennium Burial in the Judean Desert, ed. T. Schick, 100–106. IAA Reports 5. Jerusalem: Israel Antiquities Authority.

Kujit 2000
Kuijt, I., ed. Life in Neolithic Farming Communities: Social Organization, Identity, and Differentiation. New York: Kluwer Academic/Plenum.

Kvavadze et al. 2009
Kvavadze, E., et al. "30,000-Year-Old Wild Flax Fibers." Science 325: 1359.

Laneri 2007
Laneri, N., ed. Performing Death: Social Analyses of Funerary Traditions in the Ancient Near East and Mediterranean. Oriental Institute Seminars 3. Chicago: The Oriental Institute of the University of Chicago.

Leuzinger and Rast-Eicher 2011
Leuzinger, U., and Rast-Eicher, R. "Flax Processing in the Neolithic and Bronze Age Pile-dwelling Settlements of Eastern Switzerland." Vegetation History and Archaeobotany 20: 535–42.

Lev-Tov, Gopher, and Smith 2003
Lev-Tov, N., A. Gopher, and P. Smith. "Dental Evidence for Dietary Practices in the Chalcolithic Period: The Findings from a Burial Cave in Peqi'in (Northern Israel)." Paleorient 29: 121–34.

Levy and Gilead 2013
Levy, J., and Gilead, I. "The Emergence of the Ghassulian Textile Industry in the Southern Levant Chalcolithic Period (c. 4500–3900 BCE). In Textile Production and Consumption in the Ancient Near East: Archaeology, Epigraphy, Iconography, ed. M.-L. Nosch, H. Koefoed, and E. Andersson Strand, 26–44. Ancient Textiles Series 12. Oxford: Oxbow.

Levy 1981
Levy, T. E. "Chalcolithic Settlement and Subsistence in the Northern Negev Desert, Israel." Ph.D. diss., University of Sheffield.

Levy 1983
Levy, T. E. "The Emergence of Specialized Pastoralism in the Southern Levant." World Archaeology 15: 15–36.

Levy 1986
Levy, T. E. "Archaeological Sources for the History of Palestine: The Chalcolithic Period." Biblical Archaeologist 49: 83–108.

Levy 1987a
Levy, T. E., ed. Shiqmim I: Studies Concerning Chalcolithic Societies in the Northern Negev Desert, Israel (1982–1984). BAR International Series 356. Oxford: Archaeopress.

Levy 1987b
Levy, T. E. "Settlement Patterns along the Nahal Beersheba–Lower Nahal Besor: Models of Subsistence in the Northern Negev." In Levy 1987a, 45–138.

Levy 1992
Levy, T. E. "Transhumance, Subsistence, and Social Evolution in the Northern Negev Desert." In Pastoralism in the Levant: Archaeological Material in Anthropological Perspective, ed. A. Khaznov and O. B. Yosef, 65–82. Madison: Prehistory Press.

Levy 1993
Levy, T. E. "Production, Space and Social Change in Protohistoric Palestine." In Spatial Boundaries and Social Dynamics: Case Studies from Food-producing Societies, ed. A. Holl and T. E. Levy, 63–81. Ethnoarchaeological Series 2. Ann Arbor: International Monographs in Prehistory.

Levy 1995
Levy, T. E. "Cult, Metallurgy, and Rank Societies—Chalcolithic Period (ca. 4500–3500 BCE)." In The Archaeology of Society in the Holy Land, ed. T. E. Levy, 226–43. London: Leicester University Press.

Levy 2005
Levy, T. E. "The View from the End of the Trajectory." Comment. Neo-Lithics 2: 37–39.

Levy 2006a
Levy, T., ed. Archaeology, Anthropology and Cult: The Sanctuary at Gilat, Israel. London: Equinox.

Levy 2006b
Levy, T. "Archaeology, Anthropology and Cult: Exploring Religion in Formative Middle Range Societies." In Levy 2006a, 3–33.

Levy 2006c
Levy, T. "The Emergence of Social Inequality: The Chalcolithic Period." In *The Archaeological History of the Southern Levant*, ed. D. C. Hopkins, 1–46. Archaeological Sources for the History of Palestine 3. Boston: American Schools of Oriental Research.

Levy 2007
Levy, T. E. *Journey to the Copper Age: Archaeology in the Holy Land*. Exh. cat. San Diego: San Diego Museum of Man.

Levy 2013
Levy, T. E. "Cyber-Archaeology and World Cultural Heritage: Insights from the Holy Land." *Bulletin of the American Academy of Arts and Sciences* 66: 26–33.

Levy and Alon 1982
Levy, T. E., and D. Alon. "The Chalcolithic Mortuary Site near Mezad Aluf, Northern Negev Desert: A Preliminary Study." *Bulletin of the American Schools of Oriental Research* 248: 37–59.

Levy and Alon 1985a
Levy, T. E., and D. Alon. "The Chalcolithic Mortuary Site Near Mezad Aluf, Northern Negev Desert: Third Preliminary Report, 1982 Season." *Bulletin of the American Schools of Oriental Research: Supplementary Studies*: 121–35.

Levy and Alon 1985b
Levy, T., and D. Alon. "Shiqmim: A Chalcolithic Village and Mortuary Centre in the Northern Negev." *Paleorient* 11: 71–83.

Levy and Alon 1987
Levy, T. E., and D. Alon. "Settlement Patterns along the Nahal Beersheva–Lower Nahal Besor: Models of Subsistence in the Northern Negev." In Levy 1987a, 45–138.

Levy and Alon 1992
Levy, T. E., and D. Alon. "A Corpus of Ivories from Shiqmim." *Eretz-Israel* 23: 65–71.

Levy and Burton 2006
Levy, T. E., and M. Burton. "Radiocarbon Dating of Gilat." In Levy 2006a, 863–66.

Levy, Burton, and Rowan 2006
Levy, T. E., M. Burton, and Y. M. Rowan. "Chalcolithic Hamlet Excavations near Shiqmim, Negev Desert, Israel. *Journal of Field Archaeology* 31: 41–60.

Levy and Freedman 2009
Levy, T. E., and D. N. Freedman. "William Foxwell Albright: A Biographical Essay." In *Biographical Memoirs*, vol. 91, 1–29. Washington, DC: National Academies Press, Proceedings of the National Academy of Science.

Levy and Menachem 1987
Levy, T. E., and N. Menachem. "The Pottery from Shiqmim Village." In Levy 1987a, 313–31.

Levy and Shalev 1989
Levy, T. E., and S. Shalev. "Prehistoric Metalworking in the Southern Levant: Archaeometallurgical and Social Perspectives." In "Archaeometallurgy." Special issue. *World Archaeology* 20: 352–72.

Levy et al. 1991
Levy, T. E., et al. "Subterranean Settlement in the Negev Desert, ca. 4500–3700." *Research and Exploration* 7: 394–413.

Levy et al. 2006
Levy, T. E., et al. "The Sanctuary Sequence: Excavations at Gilat: 1975–77, 1989, 1990–92." In Levy 2006a, 95–212.

Levy et al. 2008
Levy, T. E., et al. *Masters of Fire: Hereditary Bronze Casters of South India*. Veröeffentlichungen aus dem Deutschen Bergbau-Museum Bochum 162. Bochum: Deutsches Bergbau Museum.

Lloyd 1942
Lloyd, S. "The Shara Temple at Tell Agrab." In *Pre-Sargonid Temples in the Diyala Region*, by P. Delougaz and Lloyd, 218–87. Oriental Institute Publications 58. Chicago: University of Chicago Press.

Lovell 2001
Lovell, J. L. *The Late Neolithic and Chalcolithic Periods in the Southern Levant: New Data from the Site of Teleilat Ghassul, Jordan*. BAR International Series 974. Oxford: Archaeopress.

Lovell 2009
Lovell, J. L. "Chalcolithic Caves Discovered East of the River Jordan." *Antiquity* 83, http://antiquity.ac.uk/projgall/lovell322.

Macdonald, Starkey, and Lankester-Harding 1932
Macdonald, E., J. L. Starkey, and G. L. Lankester-Harding. *Beth Pelet II: Prehistoric Fava*. Publications of the British School of Archaeology in Egypt and Egyptian Research Account 52. London.

Maher et al. 2011
Maher, L. A., et al. "A Unique Human-Fox Burial from a Pre-Natufian Cemetery in the Levant (Jordan)." PLoS ONE 6 (1): e15815. doi: 10.1371/journal.pone.0015815.

Mallon 1931
Mallon, A. "Les fouilles de l'Institut Biblique Pontifical dans la vallée du Jourdain: Rapport préliminaire de la troisième campagne." *Biblica* 12: 257–70.

Mallon 1932a
Mallon, A. "The Five Cities of the Plain (Genesis XIV)." In *Palestine Exploration Fund*, 52–56. London: Palestine Exploration Fund.

Mallon 1932b
Mallon, A. "Les places fortes du sud-est de la Vallee du Jourdain au temps d'Abraham." In *Biblica* 13: 194–201.

Mallon, Koeppel, and Neuville 1934
Mallon, A., R. Koeppel, and R. Neuville. *Teleilat Ghassul I: Compte rendu des fouilles de l'Institut Biblique Pontifical, 1929–1932*. Rome: Pontificium Institutum Biblicum.

Marcus 2008
Marcus, J. "The Archaeological Evidence for Social Evolution." *Annual Review of Anthropology* 37: 251–66.

Marquet-Krause 1949
Marquet-Krause, J. *Les fouilles de 'Ay (et-Tell), 1933–1935: Entreprises par le baron Edmond de Rothschild…la résurrection d'une grande cité biblique.* Bibliothèque archéologique et historique 45. Paris: Geuthner.

Marx 2006
Marx, E. "Tribal Pilgrimages to Saints' Tombs in South Sinai." In *Archaeology, Anthropology and Cult: The Sanctuary at Gilat, Israel*, ed. T. E. Levy, 54–74. London: Equinox.

Mazar 2000
Mazar, A. "A Sacred Tree in the Chalcolithic Shrine at En Gedi: A Suggestion." In *Bulletin of the Anglo-Israel Archaeological Society* 18: 31–36.

McCorriston 1997
McCorriston, J. "The Fiber Revolution: Textile Extensification, Alienation, and Social Stratification in Ancient Mesopotamia." *Current Anthropology* 38: 517–49.

Merhav 1993
Merhav, R. "Powerful Sceptres in the Treasure of Nahal Mishmar." In *Studies in the Archaeology and History of Ancient Israel in Honour of Moshe Dothan*, ed. M. Helzer, A. Segal, and D. Kaufman, 21–42. Haifa: Haifa University Press (in Hebrew).

Metcalf and Huntington 1991
Metcalf, R., and R. Huntington. *Celebrations of Death: The Anthropology of Mortuary Ritual*. 2nd ed. Cambridge: Cambridge University Press.

Midant-Reynes 2000
Midant-Reynes, B. *The Prehistory of Egypt from the First Egyptians to the First Pharaohs*. Oxford: Blackwell.

Milevski 2002
Milevski I. "A New Fertility Figurine and New Animal Motifs from the Chalcolithic in the Southern Levant: Finds from Cave K-1 at Quleh, Israel." *Paleorient* 28: 133–41.

Milevski 2009
Milevski, I. "The Copper Age and Inequality in the Southern Levant: A Review Article." *Journal of the Israel Prehistoric Society* 39: 159–80.

Milevski 2010
Milevski, I. "Visual Expressions of Craft Production in the Chalcolithic of the Southern Levant." In *Proceedings of the 6th International Congress of the Archaeology of the Ancient Near East, 5 May–10 May 2009, Sapienza–Universita di Roma*. Vol. 3, ed. P. Matthiae et al., 423–29. Wiesbaden: Harrassowitz Verlag.

Miron 1992
Miron, E. *Axes and Adzes from Canaan*. Prähistorische Bronzefunde 9, no. 19. Stuttgart: Steiner.

de Miroschedji 1993
de Miroschedji, P. R. "Cult and Religion in the Chalcolithic and Early Bronze Age." In *Biblical Archaeology Today, 1990*, 208–20. Jerusalem: Israel Exploration Society.

Moorey 1971
Moorey, P. R. S. *Catalogue of the Ancient Persian Bronzes in the Ashmolean Museum*. Oxford: Clarendon.

Moorey 1985
Moorey, P. R. S. *Materials and Manufacture in Ancient Mesopotamia: The Evidence of Archaeology and Art; Metals and Metalwork, Glazed Materials and Glass*. BAR International Series 237. Oxford: British Archaeological Reports.

Moorey 1988
Moorey, P. R. S. "The Chalcolithic Hoard from Nahal Mishmar, Israel, in Context." *World Archaeology* 20: 171–89.

Moorey 1994
Moorey, P. R. S. *Ancient Mesopotamian Materials and Industries: The Archaeological Evidence*. Oxford: Clarendon.

Morris 1987
Morris, I. *Burial and Ancient Society: The Rise of the Greek City-State*. New Studies in Archaeology. Cambridge: Cambridge University Press.

Muhly 1988
Muhly, J. D. "The Beginnings of Metallurgy in the Old World." In *The Beginning of the Use of Metals and Alloys: Papers from the Second International Conference on the Beginning of the Use of Metals and Alloys, Zhengzhou, China, 21–26 October 1986*, ed. R. Maddin, 2–20. Cambridge, MA: MIT Press.

Muscarella 1988
Muscarella, O. *Bronze and Iron: Ancient Near Eastern Artifacts in the Metropolitan Museum of Art*. New York: The Museum.

Muscarella 1989
Muscarella, O. "Warfare at Hasanlu in the Late 9th Century B.C." *Expedition* 31: 24–36.

Nagar and Eshed 2001
Nagar, Y., and V. Eshed. "Where Are the Children? Age-dependent Burial Practices in Peqi'in." *Israel Exploration Journal* 51: 27–35.

Namdar et al. 2004
Namdar, D., et al. "Chalcolithic Copper Artefacts." In *Gi'vat Ha-Oranim: A Chalcolithic Site*, ed. N. Scheftelowitz and R. Oren, 70–83. Salvage Excavation Reports 1. Tel Aviv: Tel Aviv University.

Namdar et al. 2009
Namdar, D., et al. "The Contents of Unusual Cone-shaped Vessels (Cornets) from the Chalcolithic of the Southern Levant." *Journal of Archaeological Science* 36: 629–36.

Nativ 2008
Nativ, A. "A Note on Chalcolithic Ossuary Jars: A Metaphor for Metamorphosis." *Tel Aviv* 35: 209–14.

Neef 1990
Neef, R. "Introduction, Development and Environmental Implications of Olive Culture: The Evidence from Jordan." In *Man's Role in the Shaping of the Eastern Mediterranean Landscape*, ed. S. G. Bottema, G. Entjes-Nieborg, and W. van Zeist, 295–306. Rotterdam: A. A. Balkema.

Negahban 1996
Negahban, E. O. *Marlik: The Complete Excavation Report.* 2 vols. Philadelphia: University Museum, University of Pennsylvania.

Neuville 1930a
Neuville, R. "La necropole Megalithique d'el-Adeimeh." *Biblica* 9: 249–65.

Neuville 1930b
Neuville, R. "Notes de prehistoire Palestinienne." *Journal of the Palestine Oriental Society* 10: 114–21.

North 1961
North, R. *Ghassul 1960 Excavation Report.* Analecta Biblica 14. Rome: Pontificium Institutum Biblicum, 1961.

O'Connor 1992
O'Connor, D. "The Status of Early Egyptian Temples: An Alternative Theory." In *The Followers of Horus: Studies Dedicated to Michael Allen Hoffman, 1944–1990*, ed. R. Friedman and B. Adams, 83–98. Egyptian Studies Association Publication 2; Oxbow Monograph 20. Oxford: Oxbow.

Özdemir 2007
Özdemir, A. "An Experimental Study of Mat Impressions on Pot Bases from Chalcolithic Gülpinar (Smintheion)." In *Ethnoarchaeological Investigations in Rural Anatolia*, ed. T. Takaoglu, vol. 4, 73–86. Cihangir, Istanbul: Ege Yayınlar.

Parker Pearson 2000
Parker Pearson, M. *The Archaeology of Death and Burial.* Texas A & M University Anthropology Series 3. College Station: Texas A&M University Press.

Perrot 1955
Perrot, J. "The Excavations at Tell Abu Matar, Near Beersheba." *Israel Exploration Journal* 5: 17–41, 73–84, 167–89.

Perrot 1956
Perrot, J. "Beersheba: Bir es-Safadi." *Israel Exploration Journal* 6: 126–27.

Perrot 1964
Perrot, J. "Les ivoires de la 7e campagne de fouilles à Safadi près de Beersheba." *Eretz-Israel* 7: 92–93.

Perrot 1965
Perrot, J. "Tombes à ossuaries du IVe millenaire en Palestine." *Comptes-rendus des Séances—Academie des inscriptions et belles-lettres* (June): 15–26.

Perrot 1968
Perrot, J. *La prehistoire Palestiniene: Extrait du Supplément au Dictionnaire de la Bible.* Paris: Letouzey & Ane.

Perrot 1979
Perrot, J. *Syria-Palestine I: From the Origins to the Bronze Age.* Translated by James Hogarth. Geneva: Nagel.

Perrot 1984
Perrot, J. "Structures d'habitat, mode de vie et d'environment: Les villages souterrains des pasteurs de Beershéva, dans le sud d'Israël, au IVe millénaire avant l'ère chrétienne." *Paléorient* 10: 75–96.

Perrot 1992
Perrot, J. "Umm Qatafa and Umm Qala'a: Two 'Ghassulian' Caves in the Judean Desert." *Eretz-Israel* 23: 100*–11* (in Hebrew).

Perrot and Ladiray 1980
Perrot, J., and D. Ladiray. *Tombes à ossuaires de la région côtière Palestinienne au IVe millénnaire avant l'ère chrétienne.* Mémoires et travaux du Centre de recherches préhistoriques français de Jérusalem 1. Paris: Association Paléorient.

Perrot, Zori, and Reich 1967
Perrot, J., N. Zori, and Y. Reich. "Neve Ur: Un nouvel aspect du Ghassulian." *Israel Exploration Journal* 17: 202–32.

Perrot et al. 1967
Perrot, J., et al. "Un nouvel aspect du Ghassoulien." *Israel Exploration Journal* 17: 201–32.

Petrie 1920
Petrie, W. M. F. *Prehistoric Egypt: Illustrated by Over 1,000 Objects in University College, London.* London: British School of Archaeology in Egypt.

Pfeiffer 2009
Pfeiffer, K. "The Technical Ceramic for Metallurgical Activities in Tall Hujayrat al Ghuzlan and Comparable Sites in Southern Jordan." In *Prehistoric Aqaba I*, ed. L. Khalil and K. Schmidt, 305–38. Orient-Archäologie 23. Rahden: Verlag Marie Leidorf.

Philip and Williams-Thorpe 2001
Philip, G., and O. Williams-Thorpe. "The Production and Consumption of Basalt Artefacts in the Southern Levant during the 5th–4th Millennia BC: A Geochemical and Petrographic Investigation." In *Archaeological Sciences '97: Proceedings of the Conference Held at the University of Durham, 2nd–4th September 1997*, ed. A. R. Millard, 11–30. BAR International Series 939. Oxford: Archaeopress.

Piggott 1969
Piggott, S. Conclusion. *The Domestication and Exploitation of Plants and Animals*, ed. P. J. Ucko and G. Dimbelby, 555–60. London: Duckworth.

Piggott 1999
Pigott, V. C. "A Heartland of Metallurgy: Neolithic/Chalcolithic Metallurgical Origins on the Iranian Plateau." In *The Beginnings of Metallurgy: Proceedings of the International Conference "The Beginnings of Metallurgy," Bochum, 1995*, ed. A. Hauptmann et al., 107–20. Der Anschnitt 9; Veröffentlichungen aus dem Deutschen Bergbau-Museum 84. Bochum: Deutsches Bergbau-Museum.

Pittman 1996
Pittman, H. "Constructing Context: The Gebel el-Arak Knife; Greater Mesopotamian and Egyptian Interaction in the Late Fourth Millennium B.C.E." In *The Study of the Ancient Near East in the Twenty-First Century: The William Foxwell Albright Centennial Conference*, ed. J. S. Cooper and G. M. Schwartz, 9–32. Winona Lake, IN: Eisenbrauns.

Principe 2013
Principe, L. M. *The Secrets of Alchemy*. Chicago: University of Chicago Press.

Quibell 1900
Quibell, J. E. *Hierakonpolis: I, Plates of Discoveries in 1898*. Egyptian Research Account 4. London: Quaritch.

Quibell and Green 1902
Quibell, J. E., and Green, F. W. *Hierakonpolis: Part II*. London: Quaritch.

Rakita and Buikstra 2005
Rakita, G. F. M., and J. E. Buikstra. Introduction. *Interacting with the Dead: Perspectives on Mortuary Archaeology for the New Millennium*, ed. Rakita, 1–11. Gainseville: University Press of Florida.

Rast-Eicher 2012
Rast-Eicher, R. "Switzerland: Bronze and Iron Ages." In *Textiles and Textile Production in Europe: From Prehistory to AD 400*, ed. M. Gleba and U. Mannering, 378–96. Ancient Textiles Series 11. Oxford: Oxbow.

Regev et al. 2012
Regev, J., et al. "Chronology of the Early Bronze Age in the South Levant: New Analysis for a High Chronology." *Radiocarbon* 54: 525–66.

Renfrew and Bahn 1991
Renfrew, C., and Bahn, P. *Archaeology: Theories, Methods and Practice*. London: Thames and Hudson.

Robb 2007
Robb, J. "Burial Treatment as Transformations of Bodily Ideology." In *Performing Death: Social Analyses of Funerary Traditions in the Ancient Near East and Mediterranean*, ed. N. Laneri, 287–97. Oriental Institute Seminars 3. Chicago: Oriental Institute of the University of Chicago.

Rollefson 2000
Rollefson, G. "Ritual and Social Organization at Neolithic 'Ain Ghazal." In *Life in Neolithic Farming Communities: Social Organization, Identity, and Differentiation*, ed. I. Kujit, 165–90. New York: Kluwer Academic/ Plenum.

Rollefson 2005
Rollefson, G. "Early Neolithic Ritual Centers in the Southern Levant." *Neo-Lithics* 2: 3–13.

Rollefson 2008
Rollefson, G. "The Neolithic Period." In *Jordan: An Archaeological Reader*, ed. R. B. Adams, 71–108. London: Equinox.

Rosen 1983
Rosen, S. A. "Tabular Scraper Trade: A Model of Material Cultural Dispersion." *Bulletin of the American Schools of Oriental Research* 249: 79–86.

Rosen 1987
Rosen, A. "Phytolith Studies at Shiqmim." In *Shiqmim I: Studies Concerning Chalcolithic Societies in the Northern Negev Desert, Israel (1982–1984)*, ed. T. E. Levy, 243–50. BAR International Series 356. Oxford: Archaeopress.

Rosen 1989
Rosen, S. A. "The Origins of Craft Specialization: Lithic Perspectives." In *People and Culture in Change: Proceedings of the Second Symposium on Upper Palaeolithic, Mesolithic, and Neolithic Populations of Europe and the Mediterranean Basin*, ed. I. Herskovitz, vol. 1, 107–14. BAR International Series 508. Oxford: Archaeopress.

Rosen 2002
Rosen, B. "The Beginnings of Milk Exploration and Milk-Related Products: A Techno-cultural Perspective." In *Daily Life in Ancient Israel: Food, Nutrition, and Diet*, ed. Y. Ben-Zvi, 4. Jerusalem: Israel Antiquities Authority (in Hebrew).

Rosen 2007
Rosen, A. *Civilizing Climate: Social Response to Climate Change in the Ancient Near East*. Lanham: Altamira.

Rosen 2011
Rosen, S. A. "Desert Chronologies and Periodization Systems." In *Culture, Chronology and the Chalcolithic: Theory and Transition*, ed. J. L. Lovell and Y. M. Rowan, 69–81. Levant Supplementary Series 9. Oxford: Oxbow.

Roth 1951
Roth, H. L. *Ancient Egyptian and Greek Looms*. Halifax: Bankfield Museum.

Roux 2003
Roux, V. "A Dynamic Systems Framework for Studying Technological Change: Application to the Emergence of the Potter's Wheel in the Southern Levant." *Journal of Archaeological Method and Theory* 10: 1–30.

Rowan 2005
Rowan, Y. M. "Basalt Bowls and Ground Stone Assemblage." In *Shoham (North): Late Chalcolithic Burial Caves in the Lod Valley, Israel*, ed. E. C. M. van den Brink and R. Gophna, 113–39. IAA Reports 27. Jerusalem: Israel Antiquities Authority.

Rowan and Ebeling 2008
Rowan, Y. M., and J. R. Ebeling. "Introduction: The Potential of Ground Stone Studies." In *New Approaches to Old Stones: Recent Studies of Ground Stone Artifacts*, ed. Rowan and Ebeling, 1–15. London: Equinox.

Rowan and Golden 2009
Rowan, Y. M., and J. Golden. "The Chalcolithic Period of the Southern Levant: A Synthetic Review." *Journal of World Prehistory* 22: 1–92.

Rowan and Ilan 2013
Rowan, Y. M., and D. Ilan. "The Subterranean Landscape of the Southern Levant during the Chalcolithic Period." In *Sacred Darkness: A Global Perspective on the Ritual Use of Caves*, ed. H. Moyes, 87–107. Boulder: University Press of Colorado.

Rowan et al. 2006
Rowan, Y. M., et al. "Gilat's Ground Stone Assemblage: Stone Fenestrated Stands, Bowls, Palettes, and Related Artifacts." In *Archaeology, Anthropology, and Cult: The Sanctuary at Gilat, Israel*, ed. T. E. Levy, 575–684. London: Equinox.

Roy and Chaffin 1987
Roy, C., and F. Chaffin. *Art of the Upper Volta Rivers*. Meudon: Alain et Francoise Chaffin.

Rutter and Philip 2008
Rutter, G., and G. Philip. "Beyond Provenance Analysis: The Movement of Basaltic Artifacts through a Social Landscape." In *New Approaches to Old Stones: Recent Studies of Ground Stone Artifacts*, ed. Y. M. Rowan and J. R. Ebeling, 343–58. London: Equinox.

Sacher 1995
Sacher, F. N. "The Striped Goddess from Gilat: Implications for the Chalcolithic Cult." *Israel Exploration Journal* 45: 212–25.

Scheftelowitz 2012
Scheftelowitz, N. "The Dove and the Gazelle: Representation of Animals at the Chalcolithic Cemetery of Horvat Qarqar South." Paper presented at the Forum for the Research of the Chalcolithic, Haifa.

Scheftelowitz and Oren 2004
Scheftelowitz, N., and Oren, E. *Giv'at Ha-Oranim: A Chalcolithic Site Near Nahal Beit Arif*. Salvage Excavation Reports 1. Tel Aviv: Institute of Archaeology, Tel Aviv University.

Schick 1988
Schick, T. "Nahal Hemar Cave: Cordage, Basketry, and Fabrics. *'Atiqot* (English Series) 18: 31–42.

Schick 1995
Schick, T. "A 10,000 Year Old Comb from Wadi Murrabba'at in the Judean Desert." *'Atiqot* 27: 199–202.

Schick 1998
Schick, T., ed. *The Cave of the Warrior: A Fourth Millennium Burial in the Judean Desert*. IAA Reports 5. Jerusalem: Israel Antiquities Authority.

Schick 2002
Schick, T. "The Early Basketry and Textiles from Caves in the Northern Judean Desert." In "Survey and Excavations of Caves in the Northern Judean Desert (CNJD)–1993 (Part II)," ed. L. Wexler. *'Atiqot* 41: 223–39.

Schick 2013
Schick, T. "Mat Impressions on Bases of Ossuaries and Platters." In "Peqi'in: A Late Chalcolithic Burial Site in Upper Galilee, Israel," ed. D. Shalem, Z. Gal, and H. Smithline. *Near Eastern Archaeology* 74: 196–215.

Schick et al. 1998
Schick, T., et al. Summary and Conclusions. In Schick 1998, 126–30.

Schmandt-Besserat 1998
Schmandt-Besserat, D. "'Ain Ghazal 'Monumental' Figures." *Bulletin of the American Schools of Oriental Research* 310: 1–17.

Schmidt 1999
Schmidt, K. "Frühe Tier und Menschenbilder vom Göbekli Tepe—Kampagnen, 1995–98: Ein kommentierter Katalog der Grossplastik und der Reliefs." *Istanbuler Mitteilungen* 49: 5–21.

Schroer and Keel 2005
Schroer, S., and Keel, O. *Die Ikonographie Palästinas/Israels und der Alte Orient: eine Religionsgeschichte in Bildern*. Vol. 1, *Vom ausgehenden Mesolithikum bis zur Frühbronzezeit*. Fribourg: Academic Press.

Seaton 2008
Seaton, P. *Chalcolithic Cult and Risk Management at Teleilat Ghassul: The Area E Sanctuary*. Monographs of the Sydney University Teleilat Ghassul Project 2; BAR International Series 1864. Oxford: Archaeopress.

Sebbane 1998
Sebbane, M. "Maceheads in Canaan from the 5th through 4th Millennia BCE: Typology, Technology, Use and Foreign Relations." Master's thesis, The Hebrew University of Jerusalem (in Hebrew).

Sebbane 2003
Sebbane, M. "The Kfar Monash Hoard: A Re-evaluation." *Eretz-Israel* 27: 169–84 (in Hebrew).

Sebbane 2009
Sebbane, M. "The Mace in Israel and the Ancient Near East from the Ninth Millennium to the First" Ph.D. diss., Tel Aviv University (in Hebrew).

Segal and Kamenski 2002
Segal, I., and A. Kamenski. "Chalcolithic Copper Objects from Cave VIII/28." In "Survey and Excavations of Caves in the Northern Judean Desert (CNJD)–1993 (Part II)," ed. L. Wexler. *'Atiqot* 41: 157–62.

Shalem, Gal, and Smithline 2013
Shalem, D., Z. Gal, and H. Smithline. "Peqi'in: A Late Chalcolithic Burial Site in Upper Galilee, Israel." *Near Eastern Archaeology* 74: 196–215.

Shalev 1991
Shalev, S. "Two Different Copper Industries in the Chalcolithic Culture of Israel." In *Découverte du métal*, ed. J. P. Mohen and Ch. Eluère, 413–24. Millénaires 2. Paris: Picard.

Shalev and Northover 1987
Shalev, S., and P. Northover. "Chalcolithic Metal and Metalworking from Shiqmim." In *Shiqmim I: Studies Concerning Chalcolithic Societies in the Northern Negev Desert, Israel (1982–1984)*, ed. T. E. Levy, 356–71. BAR International Series 356. Oxford: Archaeopress.

Shalev and Northover 1993
Shalev, S., and Northover, P. "The Metallurgy of the Nahal Mishmar Hoard Reconsidered." *Archaeometry* 35: 35–47.

Shalev et al. 1992
Shalev, S., et al. "A Chalcolithic Mace Head from the Negev, Israel: Technological Aspects and Cultural Implications." *Archaeometry* 34: 63–71.

Shamir 1996
Shamir, O. "Loomweights and Whorls from the City of David." In *Excavations at the City of David, 1978–85*, vol. 4, ed. D. T. Ariel and A. de Groot. Qedem 35. Jerusalem: Institute of Archaeology, The Hebrew University.

Shamir 2002
Shamir, O. "Textile Production in Eretz-Israel. *Michmanim* 16: 19*–32.*

Shamir 2007
Shamir, O. "Loom Weights from En-Gedi." In *En-Gedi Excavations I: Final Report (1991–1965)*, ed. E. Stern, 381–90. Jerusalem: Israel Exploration Society, Institute of Archaeology, The Hebrew University.

Shamir and Sukenik 2011
Shamir, O., and Sukenik, N. "Qumran Textiles and the Garments of Qumran's Inhabitants." *Dead Sea Discoveries* 18: 206–25. Leiden: Brill.

Sherratt 1981
Sherratt, A. G. "Plough and Pastoralism: Aspects of the Secondary Products Revolution." In *Patterns of the Past: Studies in Honour of David Clarke*, ed. I. Hodder, G. Isaac, and N. Hammond, 261–305. Cambridge: Cambridge University Press.

Shishlina, Orfinskaya, and Golikov 2003
Shishlina, N. I., O. V. Orfinskaya, and V. P. Golikov. "Bronze Age Textiles from the North Caucasus: New Evidence of Fourth Millennium BC Fibres and Fabrics." *Oxford Journal of Archaeology* 22: 331–44.

Shugar 2001
Shugar, A. N. "Archaeometallurgical Investigation of the Chalcolithic Site of Abu Matar, Israel: A Reassessment of Technology and Its Implications for the Ghassulian Culture." Ph.D. diss., University College, London.

Shugar and Gohm 2011
Shugar, A. N., and C. J. Gohm. "Developmental Trends in Chalcolithic Copper Metallurgy: A Radiometric Perspective." In *Culture, Chronology and the Chalcolithic: Theory and Transition*, ed. Y. M. Rowan and J. L. Lovell, 131–46. Levant Supplementary Series 9. Oxford: Oxbow.

Smith et al. 2006
Smith, P., et al. "Death and the Sanctuary: The Human Remains from Gilat." In *Archaeology, Anthropology and Cult: The Sanctuary at Gilat, Israel*, ed. T. E. Levy, 327–66. London: Equinox.

Stager 1992
Stager, L. E. "The Periodization of Palestine from Neolithic through Early Bronze Age Times." In *Chronologies in Old World Archaeology*, ed. R. Ehrich, 22–41. Chicago: University of Chicago Press.

Stekelis 1935
Stekelis, M. *Les monuments mégalithiques de Palestine*. Mémoire 15. Paris: Masson.

Stern 2009
Stern, E., ed. *The New Encyclopedia of Archaeological Excavations in the Holy Land*. Vol. 5, *Supplementary Volume*. Jerusalem: Israel Exploration Society; Washington, DC: Biblical Archaeology Society.

Sukenik 1937
Sukenik, E. L. "A Chalcolithic Necropolis at Hadera." *Journal of the Palestine Oriental Society* 17: 15–30.

Tadmor 1986a
Tadmor, M. "The Judaean Desert Treasure." In *Treasures of The Holy Land: Ancient Art from the Israel Museum*, 70–84. Exh. cat. New York: Metropolitan Museum of Art.

Tadmor 1986b
Tadmor, M. "Naturalistic Depictions in the Gilat Sculptured Vessels." *The Israel Museum Journal* 5: 7–12.

Tadmor 1989
Tadmor, M. "The Judaean Desert Treasure from Nahal Mishmar: A Chalcolithic Traders' Hoard?" In *Essays in Ancient Civilization Presented to Helene J. Kantor*, ed. A. Leonard Jr. and B. B. Williams, 250–61. Studies in Ancient Oriental Civilization 47. Chicago: Oriental Institute of the University of Chicago.

Tadmor et al. 1995
Tadmor, M., et al. "The Nahal Mishmar Hoard from the Judean Desert: Technology, Composition and Provenance." *'Atiqot* (English Series) 27: 95–148.

Tallon 1987
Tallon, F. *Métallurgie susienne I: De la fondation de Suse au XVIIIe siècle avant J.-C.* 2 vols. Notes et documents des Musées de France 15. Paris: Ministère de la Culture et de la Communication and Réunion des Musées Nationaux.

Tarlow 1999
Tarlow, S. *Bereavement and Commemoration: An Archaeology of Mortality*. Oxford: Blackwell.

Thornton 2009
Thornton, C. P. "The Chalcolithic and Early Bronze Age Metallurgy of Tepe Hissar, Northeast Iran: A Challenge to the 'Levantine Paradigm.'" Ph.D. diss., University of Pennsylvania.

Tsori 1958
Tsori, N. "Neolithic and Chalcolithic Sites in the Valley of Beth Shan." *Palestine Exploration Quarterly* 90: 44–51.

Twiss 2007
Twiss, K. C. "The Neolithic of the Southern Levant." *Evolutionary Anthropology* 16: 24–35.

Ussishkin 1971
Ussishkin, D. "The 'Ghassulian' Temple in Ein Gedi and the Origin of the Hoard from Nahal Mishmar." *The Biblical Archaeologist* 34: 23–39.

Ussishkin 1980
Ussishkin, D. "The Ghassulian Shrine at En-Gedi." *Tel Aviv* 7: 1–44.

Ussishkin 2012
Ussishkin, D. "The Chalcolithic Temple at En-Gedi: Fifty Years after Its Excavation." *Qadmoniot* 144: 71–78 (in Hebrew).

van den Brink 1998
van den Brink, E. C. M. "An Index to Chalcolithic Mortuary Caves in Israel." *Israel Exploration Journal* 48: 165–73.

van den Brink 2005
van den Brink, E. C. M. "Chalcolithic Burial Caves in Coastal and Inland Israel." In *Shoham (North): Late Chalcolithic Burial Caves in the Lod Valley, Israel*, ed. van den Brink and R. Gophna, 175–89. IAA Reports 27. Jerusalem: Israel Antiquities Authority.

van den Brink, Rowan, and Braun 1999
van den Brink, E. C. M., Y. M. Rowan, and E. Braun. "Pedestalled Basalt Bowls of the Chalcolithic: New Variations." *Israel Exploration Journal* 49: 161–83.

Vertesalji 1992
Vertesalji, P. P. "Le manche de couteau de Gebel el-'Arak dans le contexte des relations entre la Mésopotamie et l'Egypte." In *La circulation des biens, des personnes et des idées dans le Proche-Orient ancien: Actes de la XXXVIIIe Rencontre assyriologique internationale, Paris, 8–10 juillet 1991*, ed. D. Charpin and F. Joannès, 29–41. Paris: Éditions Recherche sur les Civilisations.

Vogelsang-Eastwood 2000
Vogelsang-Eastwood, G. "Textiles." In *Ancient Egyptian Materials and Technology*, ed. P. T. Nicholson and I. Shaw, 268–98. Cambridge: Cambridge University Press.

Weiner 2010
Weiner, S. *Microarchaeology: Beyond the Visible Archaeological Record.* New York: Cambridge University Press.

Weiss and Zohary 2011
Weiss, E., and D. Zohary. "The Neolithic Southwest Asian Founder Crops." *Current Anthropology* 52: S237–S254.

Winter-Livneh, Svoray, and Gilead 2010
Winter-Livneh, R., T. Svoray, and I. Gilead. "Settlement Patterns, Social Complexity and Agricultural Strategies during the Chalcolithic Period in the Northern Negev, Israel." *Journal of Archaeological Science* 37: 284–94.

Witten et al. 1995
Witten, A. J., et al. "Geophysical Diffraction Tomography: New Views on the Shiqmim Prehistoric Subterranean Village Site (Israel)." *Geoarchaeology* 10: 97–118.

Woolley 1934
Woolley, C. L. *Ur Excavations.* Vol. 2, *The Royal Cemetery: A Report on the Predynastic and Sargonid Graves Excavated between 1926 and 1931.* 2 vols. London: Oxford University Press.

Yadin 1963
Yadin, I. *The Art of Warfare in Biblical Lands: In the Light of Archaeology.* New York: McGraw-Hill.

Zagerson and Smith 2002
Zagerson, T., and P. Smith. "The Human Remains." In *Kissufim Road: A Chalcolithic Mortuary Site*, ed. Y. Goren and P. Fabian, P, 57–65. IAA Reports 16. Jerusalem: Israel Antiquities Authority.

Ziffer 2007
Ziffer, I. "A Note on the Nahal Mishmar 'Crowns.'" In *Ancient Near Eastern Art in Context: Studies in Honor of Irene J. Winter by Her Students*, ed. J. Cheng and M. H. Feldman, 47–67. Culture and History of the Ancient Near East 26. Leden: Brill.

Zohary, Hopf, and Weiss 2012
Zohary, D., M. Hopf, and E. Weiss. *Domestication of Plants in the Old World: The Origin and Spread of Domesticated Plants in Southwest Asia, Europe, and the Mediterranean Basin.* 4th ed. Oxford: Oxford University Press.

Zohary and Spiegel-Roy 1975
Zohary, D., and P. Spiegel-Roy. "Beginnings of Fruit Growing in the Old World." *Science* 187: 319–27.

Photography and Drawing Credits

Unless otherwise noted below, exhibition object photography from the Israel Antiquities Authority is © Israel Antiquities Authority and was photographed by Clara Amit, Yael Yolovitch, and Meidad Suchowolski; exhibition object photography from the Israel Museum, Jerusalem is © The Israel Museum, Jerusalem and was photographed by Meidad Suchowolski, Elie Posner, Yoram Lehmann, and David Harris; and exhibition object photography from the Pontifical Biblical Institute is © Pontifical Biblical Institute, Jerusalem, and was photographed by Elie Posner.

Inside cover, page 17: Base map based on the NASA SRTM-Data, compiled and designed by Matthias Gütte. Additional design by CoDe. New York Inc., New York © 2014 ISAW

Chapter 1:
Page 19, figs. 1-1, 1-3, 1-10, 1-18, 1-19: © The Israel Museum, Jerusalem by Elie Posner
Fig. 1-17: Yael Yolovitch © Israel Antiquities Authority
Fig. 1-20: Clara Amit © Israel Antiquities Authority

Chapter 2:
Page 41, fig. 2-2: © The Israel Museum, Jerusalem by Elie Posner
Figs. 2-3, 2-4, 2-5, 2-8: © Kenneth Garrett
Fig. 2-13: © The Israel Museum, Jerusalem by Meidad Suchowolski

Chapter 3:
Page 63, figs. 3-1, 3-3, 3-5, 3-7, 3-11, 3-13a-b: © The Israel Museum, Jerusalem by Elie Posner
Figs. 3-2, 3-4, 3-6, 3-9: © Israel Antiquities Authority

Chapter 4:
Page 79, figs. 4-6, 4-7, 4-8, 4-12, 4-18, 4-20: © The Israel Museum, Jerusalem by Elie Posner
Figs. 4-1, 4-2, 4-10, 4-23b: Ester Stark © The Israel Museum, Jerusalem by Ester Stark
Fig 4-3: © The Israel Museum, Jerusalem by Meidad Suchowolski
Fig. 4-9: © Osnat Misch-Brandl
Fig. 4-11: © The Israel Museum, Jerusalem by Nahum Slapak

Fig. 4-13, 4-15: Drawing after "Teleilat Ghassul I," Rome, 1934
Fig. 4-14: © The Israel Museum, Jerusalem by Pnina Arad
Fig. 4-16: courtesy of CRFJ
Fig. 4-17: © The Israel Museum, Jerusalem by David Harris
Fig. 4-22: © The Israel Museum, Jerusalem by Peter Lanyi

Chapter 5:
Page 101, figs. 5-4, 5-5, 5-10: © The Israel Museum, Jerusalem by Elie Posner

Chapter 6:
Page 115: © Werner Braun
Fig. 6-2: © Israel Antiquities Authority by Zevi Nogha
Figs. 6-3, 6-4, 6-5, 6-7, 6-11, 6-13, 6-14, 6-15, 6-18, 6-19: © The Israel Museum, Jerusalem by Elie Posner
Figs. 6-6, 6-8, 6-10, 6-16, 6-17, 6-18, 6-21, 6-22: © Israel Antiquities Authority by Clara Amit
Figs. 6-22, 6-23: © The Israel Museum, Jerusalem by Nahum Slapak

Chapter 7:
Fig 7-3a: © The Israel Museum, Jerusalem by Peter Lanyi
Fig 7-3b: © The Israel Museum, Jerusalem by Olga Negnevitsky
Figs. 7-4, 7-5: © Israel Antiquities Authority by Olga Negnevitsky
Figs. 7-9, 7-12, 7-15: © Israel Antiquities Authority by Clara Amit
Fig. 7-13: © The Israel Museum, Jerusalem by Meidad Suchowolski
Fig. 7-16: After Barber 1991, 47
Fig. 7-18: © Orit Shamir
Fig. 7-19: After A. Sheffer and H. Granger-Taylor, "Textiles from Masada: A Preliminary Selection," in *Masada: Final Reports; the Yigael Yadin Excavations, 1963–1965*, vol. 4, ed. Y. Aviram, G. Foerster, and E. Netzer, 164 (fig. 3) (Jerusalem: Israel Exploration Society, 1994)
Fig. 7-20: © Clara Amit

ANATOLIAN COPPER AGE
(5500-3000 BCE)

● Çatal Höyük

ERIMI CULTURE
(4000-2500 BCE)

COPPER AGE
(4500-3600 BCE)

Megiddo
● Pella
Jericho ●

Tell el-Magaṣṣ ●

Fayum ●

BADARIAN CULTURE
(4400-3700 BCE)

Nile River